Writer-Painters of Contemporary Spain

Twayne's World Authors Series
Spanish Literature

Janet Pérez, Editor
Texas Tech University

TWAS 721

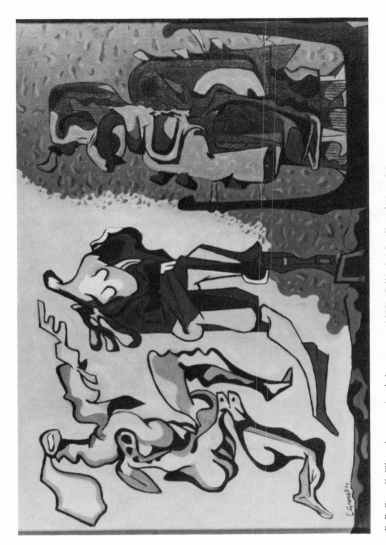

E. F. Granell: *The sculptor pursuing the bronze statue* (1977). Collection Estelle and Manuel A. Irizarry.

Writer-Painters of Contemporary Spain

By Estelle Irizarry

Georgetown University

Twayne Publishers · *Boston*

Writer-Painters of Contemporary Spain

Estelle Irizarry

Copyright © 1984 by G. K. Hall & Company
All Rights Reserved
Published by Twayne Publishers
A Division of G. K. Hall & Company
70 Lincoln Street
Boston, Massachusetts 02111

Printed on permanent/durable acid-free
paper and bound in the United States of
America.

Library of Congress Cataloging in Publication Data

Irizarry, Estelle.
 Writer-painters of contemporary Spain.

 (Twayne world authors series; 721. Spanish literature)
 Bibliography: p.
 Includes indexes.
 1. Spanish literature—20th century—History and
criticism 2. Authors as artists—Spain. 3. Artists—
Spain—Biography. I. Title. II. Series: Twayne's world
authors series; 721. III. Series: Twayne's world
authors series. Spanish literature.
PQ6073.A93175 1984 860'.9'006 83-22750
ISBN 0-8057-6568-9

Contents

About the Author

Estelle Irizarry, Professor of Spanish and Spanish-American literature at Georgetown University, holds a B.A. degree from Montclair State College, an M.A. from Rutgers University, and a Ph.D. from The George Washington University.

Professor Irizarry is the author of Teoría y creación literaria en Francisco Ayala (Madrid: Gredos, 1971), an annotated critical edition of Ayala's El rapto, Fragancia de jazmines y Diálogo entre el amor y un viejo (Barcelona: Labor, 1974), a scholarly edition of Martín Fierro (Zaragoza: Clásicos Ebro, 1975), La inventiva surrealista de E. F. Granell (Madrid: Insula, 1976), a critical edition of César Tiempo's Clara Beter: Versos de una . . . (Buenos Aires: Rescate, 1977), Francisco Ayala (Boston: Twayne Publishers, 1977), Rafael Dieste (Boston: Twayne Publishers, 1979), La broma literaria en nuestros días (New York: Eliseo Torres, 1979), La creación literaria de Rafael Dieste (Sada-La Coruña: Ediciones del Castro, 1980), and Enrique A. Laguerre (Boston: Twayne Publishers, 1981).

Professor Irizarry has written a monthly section on Hispanic culture in the United States for the Mexican magazine Nivel since 1970 and has contributed many studies of Spanish and Spanish-American literature to scholarly journals and volumes of collective criticism.

Preface

This century has witnessed a considerable number of major figures in Spanish letters who have cultivated the pictorial arts with success and recognition. It is not a phenomenon without precedents, since Juan de Jáuregui in the seventeenth century and Galdós, Angel de Saavedra, Hartzenbusch, and Bécquer in the nineteenth century were illustrious writers with artistic talent. The present study is based on the premise that a writer's work in another discipline can give us insights into his creation as a writer. His pictorial expression provides an additional artistic dimension which can prove valuable in understanding the writer who seeks similar or divergent expression in another medium. The study of the relationship between one creator's painting and writing can be a mutually enriching analytic tool to understand the total artist better.

My intention is to examine specific relationships between works in both disciplines rather than to comment upon each separately. Where this has been accomplished previously, as in the case of José Gutiérrez Solana, I offer additional perspectives to the body of work already in existence. For the majority of the writer-painters treated, this study represents a new perspective.

For the purposes of my discussion I consider as writer-painters those who have cultivated both disciplines. The placement of the writer designation before the other reflects the primary focus of my study rather than the actual preponderance of one activity over the other in the artists. Unfortunately there is no way to give the words equal weight even where this may be warranted, since one word must inevitably precede the other. I avoid distinguishing between writer-painters and painter-writers since the determining criteria would have to be such variable considerations as quantity of production in each medium, regularity of cultivation, professional commitment, public exposure, critical acceptance, fame, or excellence. Since such questions are difficult to resolve in many of the artists studied, I treat them

essentially as irrelevant before the larger fact that all the figures included in this study have cultivated both writing and painting in varying degrees (painting includes drawing, by Picasso's definition).

In an attempt to avoid superficiality, I decided to be selective, focusing upon fewer works in the interest of greater depth. Analyzed in individual chapters are well-known major Spanish authors who dedicated their talents to both the literary and pictorial arts. One chapter treats four Galician writer-painters and a final chapter provides views of a number of other artists in much briefer form. Only works written in Spanish or in the Catalan or Galician vernaculars are treated. Where possible I focus upon works available in Spanish or translated into English. Salvador Dalí is not included since his literary language is French. Each artist is studied in a different way, depending upon his individual personality as a writer-painter. I have selected what I feel are his most significant works or themes which may be best elucidated by relating textual and visual modes of expression.

In the context of my study "contemporary Spain" refers mainly to this century, including artists whose formation may have taken place earlier, but whose creative production is largely of the twentieth century. The writer-painters are for the most part presented in chronological order of birth, and the same procedure is followed in chapters that group several of them together. Translations, except where otherwise indicated, are mine.

Finally, it is hoped that others will continue to explore the fascinating relationship of the literary and pictorial arts in these Spanish creators as well as in others of the past and future.

<div align="right">Estelle Irizarry</div>

Georgetown University

Acknowledgments

I should like to express my appreciation to all the individuals and publishing companies listed in the Index of Illustrations whose cooperation was essential for the preparation of this volume. Special thanks are due to the writer-painters E. F. Granell, Tomás Barros, Isaac Díaz Pardo, Antonio Buero Vallejo, and Miguel Delibes for providing pictorial and/or textual material, as well as to María Elvira Fernández de Seoane for books and photographs. I am also indebted to the late Rafael Dieste and to Carmen Muñoz de Dieste for information and materials regarding Galician artists; to José Otero Espasandín for sharing his Seoane collection; and to E. F. Granell for placing at my disposition hard-to-find sources on various artists.

I am grateful to a number of friends and colleagues for their assistance: José M. Hernández, Associate Dean of the School of Languages and Linguistics of Georgetown University for facilitating support for this project; Paul B. Jones, formerly the University's photographer who skillfully prepared most of the illustrations; Abdullah Demirtas, whose efficient handling of interlibrary loans solved many a problem. My thanks also to Chefa Parisi for arranging for the reproduction of Buero Vallejo's art, to my former student Melissa G. Moyer for securing Rusiñol materials in Barcelona, and to Janet Pérez for allowing me to go ahead with what was in the beginning only an idea.

Chronology

1897	Opening of Els Quatre Gats in Barcelona, meeting place of Modernist artists and frequented by Picasso and Santiago Rusiñol.
1898	Darío de Regoyos's version of Verhaeren's Black Spain.
1908	Ricardo Baroja wins first prize in Spain's National Exhibition.
1910-1912	Innovations of Picasso and Braque launch Cubism.
1920	Rafael Alberti exhibits his art work in Madrid; Ricardo Baroja publishes his first novel, Fernanda.
1921	Federico García Lorca's first book, Libro de poemas.
1924	Alberti's first book of poetry, Marinero en tierra; André Breton's Surrealist Manifesto launches Surrealism.
1927	Lorca exhibits at the Dalmau Gallery in Barcelona.
1928	Juan Ramón Jiménez sketches a series of nudes.
1930	Cándido Fernández Mazas's illustrated play Santa Margorí.
1934	Buero Vallejo studies art at San Fernando School of Fine Arts, Madrid.
1942	E. F. Granell joins the Surrealist movement after meeting Breton.

1944	José Moreno Villa's illustrated Vida en claro published in Mexico.
1947	Buero Vallejo's Historia de una escalera, play and drawing, completed.
1950-1951	Tomás Barros's first book of poetry followed by first exhibit.
1952	Artist Luis Seoane's first book of poetry, Fardel del esiliado.
1957	Artist Isaac Díaz Pardo publishes his first plays in Buenos Aires.
1958	Max Aub's illustrated fictitious biography Jusep Torres Campalans.
1959	E. F. Granell's first novel, La novela del indio Tupinamba.
1960	Picasso's Trozo de piel; Granell wins Copley International Art Award.

Chapter One
Seeing the Light in Black Spain: Darío de Regoyos

That pessimism is contagious is illustrated by the case
of the painter Darío de Regoyos y Valdés (1857–1913),
whose jovial nature and natural bent toward postimpres-
sionist pointillism turned to more somber expressionism
when he accompanied the Belgian poet and art critic Emile
Verhaeren on a trip through parts of Spain in the year
1888. Verhaeren's romantic disposition searches for qual-
ities of sadness, truculence, savagery, and death in all
he observes in accordance with his preconceived ideas of
the picturesque. He recorded his impressions in articles
sent to L'Art Moderne. Ten years later Regoyos wrote
his own book about the trip, which was to exert a pro-
found influence in its time, particularly upon the writer-
painter José Gutiérrez Solana (1). Significantly,
however, Regoyos chose not to present a translation of
Verhaeren's account, but rather to write his own version,
contrasting on many occasions his own perspective with
that of the Belgian. This is something generally over-
looked by critics who refer to "the Black Spain of
Verhaeren, which is that of Regoyos" (2). While the
paintings inspired by the trip may reflect Verhaeren's
perspective, it is important to remember that ten years
elapsed before Regoyos wrote his book, "printed in Barce-
lona in 1899, when the artist was already in his new
clear and serene path" (3). Regoyos's biographer Rafael
Benet notes that its publication had a therapeutic
effect, leaving its author completely cured of the "black
illness." It is clear that when Regoyos wrote his
España negra (Black Spain), he was well on the road to
seeing the light in contrast to Verhaeren's tetrical
vision, which he observes with the same curiosity that
the Belgian exhibits upon observing Black Spain. Benet
acknowledges that "Black Spain is, as everyone recog-
nizes today, a literary work of Regoyos for the most
part" (4). He refers to many paragraphs and chapters
that are entirely original, but we must add that
Regoyos's view of Spain is different from Verhaeren's.
He provides us with a faithful yet critical rendering of

1

the latter's impressions, probably because his nature is decidedly less melancholy than his friend's and because in the intervening years he had discovered that "Spain was blue and could be blue" (5).

Retelling the trip from Cantabria in the Basque country to Madrid puts Regoyos in the role of writer rather than transcriber or translator, a role he regards defensively in the early pages of his book but later assumes more comfortably. The editor of a 1924 reedition, however, found it necessary to offer an apology for "our great painter": "The book is certainly not a model of literary correction; but it has all the vigor and style of Regoyos's painting" (6). Regoyos presents his book very cautiously:

> It is not my wish to make a book or even less, throw myself into literature, but rather simply to present to the public Emile Verhaeren, a great modern poet born in Flanders, unknown in Spain, who has written many volumes of poetry and, traveling some years ago through our country, far from seeing it in a happy light like the majority of foreigners who see us through a blue sky and the apparent joy of the bullfight, perceived a morally black Spain. (7)

He concludes the note with an apology for trespassing, as it were, the frontiers of the literary discipline: "Don't take me for a writer, but rather for the companion of the Flemish poet, as I most desire and beseech the public before reading these travel impressions" (p. 21). This request seems to have been heeded, for the book appears under both names, with the Belgian writer's name first. Black Spain, however, is in no way simply a translation of Verhaeren, but instead a creation of Regoyos. He does include a few lengthy quotes from the poet but they are punctuated by his own comments and restricted largely to chapter 6, appropriately entitled "The 'Black Spain' of Verhaeren."

Contrasting Perspectives

One of the most fascinating aspects of Black Spain is offered by the contrasting perspectives of two observers who look at the same scenes with different eyes, for as Regoyos says, "it is curious to follow him [Verhaeren]

in his way of seeing our country to the point of cre-
ating a Black Spain" (p. 29). Verhaeren's view is to
some degree contagious, especially in the year 1898,
of such sad remembrance for Spain with the loss of her
last colonies, but if at the end Regoyos seems to agree
with Verhaeren, such accord is more intellectual than
emotional, and represents a comment upon the sad events
of that year which launched a famous generation of writers.

In the introduction to the volume Pío Baroja charac-
terizes Regoyos, whom he first met in 1901 or 1902 in San
Sebastián, as jovial, happy, and impractical. Benet
says that he was talkative, happy, and trusting, and his
nature happily calm. How did he come to accompany
Verhaeren on such a trip? In 1882 Regoyos went to live
in Belgium where he was known for playing the guitar and
for his practical jokes. During the nine years he spent
there, he was influenced by a group of melancholy artists
who found their principal impulse in anguish, and he
allowed himself to be invaded by this climate of volun-
tary depression which provoked a crisis of neurasthenia,
as he later acknowledged in his conversation with Pío
Baroja. Soon after he moved to Belgium, Regoyos exhibit-
ed some nostalgic drawings of his homeland which prompted
several artists to accompany him to Spain with a melan-
choly program traced beforehand, and from that trip he
brought back some "black" paintings. A similar journey
undertaken with Verhaeren in 1888 is the subject of
Black Spain.

The fin de siècle melancholy spirit of Verhaeren
purposely leads him to spectacles that may be sad and
somber. Regoyos tries to please his friend and goes with
him to observe funerals, cemeteries, bullfights, coffin
vendors, and other similar sights which make him increas-
ingly aware of negative aspects of life in Spain, the
dissonance, cacophony, songs of death, and arid Castilian
landscape which "are extraordinary impressions for an
artist who comes from Flanders and very common for us,
who see them so often" (p. 29). Verhaeren is delighted
with the tetrical character of the Basques, their cloth-
ing, dances, songs, and landscape. He prefers the dark-
ness of the church interiors and arranges the itinerary
so that the two travelers always arrive at dusk or night-
fall and leave at dawn, so as not to interfere with the
dark impressions of the night before.

Regoyos, on the other hand, is able to see as "clear
notes" among the dark masses participating in a celebra-

tion in Guipúzcoa, a group of young children, although their aspect is sad. He concedes that the Spanish holy images found in Tolosa are badly proportioned, poorly modeled, and of unskilled workmanship, yet he finds them intensely penetrating (p. 33). Praying before such images, he reflects, is enough to make one laugh or hallucinate, but he finds them superior to modern sculptures in the French mode, insipid images which are invading the country. In Oñate Regoyos describes a procession which is "one of the most beautiful I have seen in Spain, with school children kneeling and forming a string in the wide plaza of old buildings, with the great purple of Mount Aitzgorri dominating the background" (p. 36).

Verhaeren finds life in northern Spain a constant memento mori ("reminder of death") and reacts enthusiastically to this as a picturesque attraction, while Regoyos says that his country is simply familiar with death. He observes with relative indifference "things which do not bother us because we are Spanish" (p. 38). Regoyos is capable of distinguishing these things but does not react to them in the same way as the Belgian visitor, maintaining a certain distance from his friend's perceptions. He finds his tetrical vision exaggerated but "it still holds much truth, above all his last article sent to L'Art Moderne, speaking of the funeral establishment, of the Prado Museum, and of the El Escorial site" (p. 39). Although he can understand Verhaeren's point of view, he is clearly aware of the fact that his friend is looking for dark experiences and that things seem to reinforce this view. Regoyos, however, is surprised at Verhaeren's enthusiasm for the bullfight, which he considers repugnant, and he finds his friend's pleasure in the cruelest aspects of the spectacle very strange indeed.

They are definitely of different temperaments, as Regoyos explains: "It was decidedly difficult to make him see Spain by way of the pretty girls or the happiness of the sky; behind that strong light he always found a black soul in all things, something sad or navrant, a word he repeated after all his impressions" (p. 52). If he sees the worst in Spain, it is only because they go to the places where the worst might be expected, such as Pamplona, where the bullfight turns into an undisciplined scramble in the streets; "in short, Pamplona had provided very artistic sensations and had aggrandized in the poet his Black Spain, as was natural, after having seen the

horses at the light of dusk and the terrorific encounter
of the gypsy that at night turned into a frightening
nightmare" (p. 52). "At my friend's insistence," ex-
plains Regoyos, they visit the cemetery of Zaragoza.
Attracted by the Moorish melancholy, Verhaeren asks an
Andalusian singer for songs about death and then comments
that "one must wear rose-colored glasses to see Spain
with happy tones," to which we might add "or be Spanish,
like Regoyos." The Spaniards' familiarity with death
makes Regoyos wonder at Verhaeren's fascination with an
All Saints Day celebration in Madrid, but he realizes the
spectacle must be surprising to foreigners.

In the concluding chapter Regoyos concedes the legiti-
macy of Verhaeren's view of Spain, especially in Avila,
where "even the Spaniard returning to these towns wonders
if it is possible for such desolation to be pleasing" (p.
75), and in Toledo, with its sad panorama. "But," inter-
rupts Regoyos, "this is getting to be enough <u>dance
macabre</u>" (p. 75). The travelers separated in Burgos,
and the painter comments, "The man, instead of raising
his spirit with the light of our sun, went away sadder
than when he came" (p. 76). Regoyos then describes and
denounces some of the practices he personally finds repug-
nant, such as the flagellants in religious processions,
and here it becomes clear that the purposes of the two
writers are very different. The Belgian takes delight in
a Romantic notion of a Black Spain for foreigners while
the Spaniard exhibits the critical inclination that the
"year of sad memory," 1898, would inspire in many Spanish
intellectuals.

Pío Baroja tells us that Regoyos believed in the
great importance of literature and painting in society.
While the artist evidently does not share the attraction
of his friend for the sad and somber, he does take advan-
tage of the occasion to point out some of the gruesome
aspects of Spanish society, such as the brutality fos-
tered by the bullfight and by religious fanaticism, and
in this way contributes to the revisionist effort of the
Generation of 1898. If he waited a full ten years to
realize the relevance of Verhaeren's observations, it was
no doubt because he found them more important to point
out in the year 1898, when the trauma of the definitive
loss of colonies abroad inspired intensive introspection
among Spain's writers and artists. If Verhaeren found
Spain's idiosyncracies beautiful, Regoyos on the other
hand finds them simply sad.

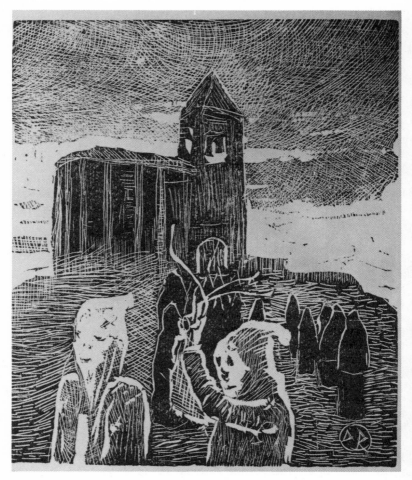

Regoyos, illustration from *España negra*, courtesy Taurus Ediciones, Madrid.

Light and Dark in Regoyos's Pictures

Regoyos provides illustrations for his Black Spain, some black-and-white etchings, others oil paintings in color. It is interesting to see how these illustrations fit into his pictorial work in general. The Spanish art critic A. M. Campoy sees him as a painter of varied aesthetics, among them Naturalism, a Corotian style "not exactly Impressionistic," Expressionism (in Black Spain), and above all Postimpressionism with an instinctive pointillism similar to that of Signac in the special juxtaposition of colors in small spots and expressive concordance of tones (8). For Campoy, Verhaeren's primitive, somber, unkempt, and fanatical Spain had little to do with the Spain Regoyos would paint subsequently, returning to "his first naturalist sensations (inspired possibly in Haes) that are always sweet, sometimes melancholy and sometimes happy, unequal, never again sinister" (9).

Pío Baroja tells of the artist's inviting him the first day they met to see his pictures. "There were some very good Impressionistic pictures and others that seemed somber to me and hardly pleasing. According to him, these were from his neurasthenic period and he didn't want to show them to people. These pictures were all curious and very tetrical. Showing them, Regoyos laughed like a madman" (pp. 13-14). The variation Baroja observes in Regoyos's painting evidently leads him to dub him "an anarchist of painting" (p. 17). Yet even during his years in Belgium, Regoyos did not yield completely to the dark and somber. Benet tells us that he was attracted by accidental effects of light from lamps or the moon, as was noted in a commentary about his 1882 exhibit there, and when the group called "The Twenty" introduced the adventure of Impressionism, Regoyos "escaped" into it at times, without abandoning his more somber browns and blacks. He experimented with pointillism in Belgium, becoming one of the finest cultivators of divisionism (allowing the eye to "mix" different colored brush strokes instead of mixing colors on the palette). Thus, while he had not yet found his particular style, his naturally happy spirit was not dominated by melancholy realism. By 1891 when Regoyos traveled to Paris, grays, browns, and sinister spectacles were no longer present and in their places were clean tonalities, fresh shades, openness, splendid suns, and wide, magnificent horizons.

His open and happy nature obviously felt more at home in
a subtle and harmonious luminism than in the tetrical art
to which he had been temporarily drawn during his years
in Belgium.

Regoyos's paintings seem less sophisticated than do
those of his French pointillist counterparts Seurat and
Signac, which may have prompted Campoy's judgment of them
as "sweet." Market in Irún, for example, shows bright
yellow trees shading the people below. Market at Dax
(in France) is a happy picture with orange rooftops and a
cart whose blues and yellows sugest green to the observ-
er's eye. A City Landscape exhibits Regoyos's favorite
baby-blue sky, with spires in purple alternating with
yellows. The tonality of these pictures is bright but
not drenched with light, coinciding with the artist's
comments to Pío Baroja about the impossibility of render-
ing authentically the impression of intense midday light.
Benet finds his "harmonious luminism" different from
Sorolla's "effectist luminism." Light seems useful to
the point that it brings out the colors.

The variation that Baroja and Campoy note in Regoyos's
painting is likewise present within this one book, Black
Spain, which includes sketches, etchings, and paintings.
A number of etchings depict landscapes of country or
street scenes, a typical Basque profile, a nearsighted
sacristan reading El Correo Español, or an Andalusian
guitarist. The illustrations that may be called "dark"
are so with regard to theme, but not particularly dark in
their coloration. "Dark" themes include dead and dying
horses from the bullfight, women in mourning, cemetery
scenes, and such, but these are not in the majority.
Only an engraving at the end of the book showing a skele-
ton's arm ringing a bell surrounded by bats falls within
the tradition of macabre art.

The painting in color of Slow Dance in Asturias
shows somber faces of women dancers, yet oranges, a touch
of scarlet, and a somewhat pointillist background of
green and yellow add notable touches of brightness.
Blue Hour: Burgos is simply a nocturnal landscape of
Gothic interiors and entrances, with a bright sky and
under a greenish cast. Sky and street are rendered
pointillistically. In The Plaza of the Clock, Irún
cool greens and blues illuminate the evening view of
stone buildings and noble palaces; there is a sense of
mystery but certainly not of sadness.

The theme of death is present in colored pictures of a

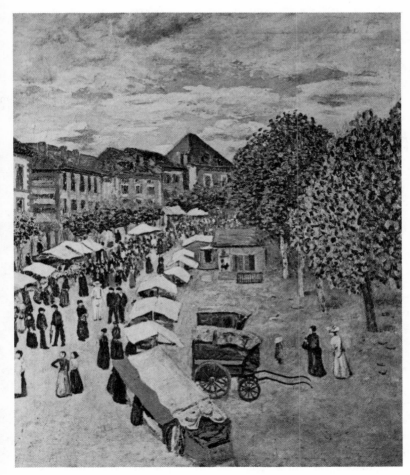

Regoyos: *Mercado de Dax*, from A. M. Campoy, *100 maestros de la pintura española contemporánea*, courtesy Ibérico Europea de Ediciones.

cemetery procession and of women in mourning with the
contrast of a chalk-white door and handkerchief of the
same color. The cemetery scene shows imprecise masses in
the background, one of a blood-red color, and in the fore-
ground a white-faced figure dressed in black with a
rosary held before a tombstone and gray cross. A grue-
some scene of dead horses appears in a black-and-white
etching and again in a painting called Victims of the
Fiesta, filled with ocher and yellows contrasting with a
baby-blue sky. As we have said, when the pictures
reflect Verhaeren's Black Spain, it is primarily because
of the subject matter and not the execution. There is no
attempt at distortion nor does the painter introduce
imaginative elements, with the sole exception of the con-
cluding etching recalling the tradition of macabre art.

The Painter in the Writer

The reader of Black Spain cannot help but be aware
of the principal vocation of its author, since he often
refers to painting and to himself as an artist. He
enriches his text with frequent allusions to the painters
Courbet, Monet, Rousseau, Corot, and Delacroix, whose
landscapes Regoyos observes in real-life Spain. He speaks
of a sort of ideal landscape, "something never before
painted; of the picture that each person carries in him-
self, original and fatal, which pursues at every turn and
from which fragments are seen in certain places, be they
villages, valleys, or coasts" (p. 25).
Regoyos is conscious of both similarities and differ-
ences between literature and painting and feels more sure
of himself in the latter discipline. In giving impres-
sions of summer in Guipúzcoa, he considers his descrip-
tive powers less effective than those of the poet
Verhaeren but asks "how not to put one's foot in litera-
ture? Let us limit ourselves to the sensations of a
painter, although they show a poor style of an unskilled
pen" (p. 29). Regoyos admits to spending time writing
alongside his poet friend but finds it necessary to
excuse his engaging in such literary pursuits by pointing
to the lack of light at dusk, "since the painter at that
beautiful hour has the misfortune of not being able to
utilize a long session of painting, for the short time
light lasts; and since it is so, how can he work if not
by writing notes about that fleeting effect?" (p. 40).
He finds that in fact some things lend themselves better

to literary treatment than to pictorial expression, such
as a procession in Riojas, "a procession purely for
artists; but since it does not lend itself to be painted
on canvas, I recommend it to the literary man who would
wish to write a hair-raising article, above all if he is
of Verhaeren's ideas" (p. 77). He asks, "How to trans-
port to a canvas a few fanatics who whip themselves be-
fore the stations in the procession?" Yet, contradicting
this contention that such processions are not for paint-
ing, he refers to Goya's painting of a similar scene,
found in the Academy of San Fernando in Madrid, and he
himself includes an etching of the flagellants. It is
also interesting to note that in 1908 Regoyos won a third
prize medal in the National Exhibit of Fine Arts in
Madrid with a painting called The Procession of Capu-
chins (Fuenterrabia). It is likely, however, that he
characterizes such scenes as unpaintable simply because
he would rather not paint them; he seems to consider
writing as the medium more appropriate to describing a
Black Spain.

Regoyos is quick to liken what he sees to paintings.
He compares a chapel in Vergara seen from afar to "those
old reliquaries and the landscapes in certain backgrounds
of the primitives" (p. 37). He sees a widow who reminds
him of a madonna right out of a triptych of Spanish paint-
ing and a view of dying horses as a picture Delacroix
might have painted (p. 48). He observes a wharf "where
an artist is never bored; there are boats that, seen
against the nets set out to dry, form strange drapes like
a painted pointillist picture" (p. 41). Indeed he
"paints" a number of scenes in words and frequently his
literary style seems almost pointillistic, with para-
graphs sometimes reduced to a single sentence, disconnec-
ted from one another, and with abundant rhetorical ques-
tions. In this rather anarchical structure there may be
some influences of Pío Baroja, whose writings Regoyos
admired, for the introduction to the book, written by
Baroja, is not too different from the style Regoyos uses.
Regoyos also tends to supply only nouns, thus eliminat-
ing movement: "Interiors and gothic entrances, seen at
mysterious hour, of joined masses, bathed in somber
tones, adorned with bas-reliefs with chimeras and fantas-
tic beasts," corresponding to his painting entitled Blue
Hour, Burgos (p. 56).

The reader is made aware of the fact that Regoyos is
painting in words. Sigüenza is for him "a rickety town
that seems made for a poet or a painter" (p. 61) and he

perceives "poetry for the artist" even in ruins (p. 27).
He uses the word painted as a synonym for explained:
"I painted for him the sadness that one breathes on such
days in those towns so different from those of his coun-
try" (p. 36). He similarly refers to the town of Sigüen-
za and its people as forming a "picture." Regoyos's
point of view is often panoramic, including a valley with
its houses and spires and a hermitage before which pray-
ing women are seen as immobile black dots (reminiscent of
pointillism). There are few seascapes despite the fact
that the travelers made their way along the Cantabrian
coast. Pío Baroja claims that the painter, like him-
self, had little pictorial interest in the sea. In one
of those rare seascapes Regoyos describes fishing boats
in San Sebastián in different shades of white, while the
sails for his pictorially oriented eyes take the form of
musical notes placed in a scale. He "paints" the scene
in white, significantly not in the dark shades of
Verhaeren's preference, and the white assumes varied
tonalities in "the dirty white sails in the distance
against the great blue, closer ones of ironed white like
immense swans of Lohengren, but dominated by another
white even more powerful, that of the waves breaking
below on the rocks, foaming against the glassy green of
the water, its complement of pinkish white" (p. 40).
 The presence of light in the descriptions of Black
Spain is in accordance with the painter's aversion to
full sun or excessive light as described by Baroja, who
agreed with him not only that one cannot give the impres-
sion of violent light but that in doing so there would be
no advantage. Regoyos himself tells us this in chapter 5
as he explains why he and Verhaeren left each town at
dawn:

> It was, in short, a journey for poets or dreamers of
> semi-darkness, for when the sun hurt the retina it was
> already during the train trip through arid deserts.
> It would be good to recommend this system of journeys
> to those artists fond of gray or adverse to the too-
> strong sun; for such people the first and last hours
> of the day are sublime for their harmony; at these
> hours everything becomes poetic and in tune. (p. 55)

The lights we see in Black Spain are vespertine, those
of candles, streetlights, or the silver disc of the moon.
 Regoyos would prefer some light that is neither too
tenuous, as is that which Verhaeren seeks, nor too blind-

ing as he contemplates the arid lands of Castile:

> In order to paint these fields it seems that a note of
> light is needed to serve as dominant, like the last
> ray of a reddish or orange sun that could form its
> blue complementaries or opposites, and if it is win-
> ter, a solar light, somewhat electrical, of a lemon
> yellow color with its violaceous complementaries.
> What is needed is a light of very marked tint to make
> the whole sing, entoning those incolorous and dead
> browns. If not, Castile is anti-pictorial, without
> sun because it doesn't say anything: everything is of
> a neutral coloration, and with the sun high because
> the palette is powerless to reproduce those vibrations
> of such brutal white light. (p. 44)

In Vizcaya Regoyos finds "the screeching of metallic
lights against a great blue mass" unpaintable (p. 40).
He reproduces Verhaeren's references to artists who paint
different lights of the day, but adds that few painters
have painted the moonlight that appears to alter the laws
of the vision of colors (p. 52). His pointillist tenden-
cies are evident in the paragraph cited above when he
points out the opposite or complementary colors which
appeal to him more than monochromatic coloration.
Regoyos also prefers colors that are not so brilliant as
those of a painted image of Saint John of "colors screech-
ing their crudeness to the delicate ears of the flowers
that surrounded it" (p. 32).

His awareness of colors is evident throughout the
book. He calls black the best color a painter can wish
for to make the face of a woman stand out "because black
is not a color, because it favors pallid women and avoids
the horrible combinations of bright colors produced by
poor taste" (p. 48). Regoyos particularly dislikes browns
and deplores the fact that yellowish tones turn brownish
or bone-colored in Toledo and the once-red roof tiles are
now a chocolate brown. He sometimes offers objects in
order to suggest color, such as cayenne pepper and pumice
stone to describe the colors of a church (p. 26).

The pictorial orientation of the artist leads him to
see things with intense or original visual imagery. In
an unusual flight of fantasy he observes great bonfires
and comments that "seen from the valley below, those
flames in disarray looked like blond heads, and with a
little imagination the stars that twinkled about could be
taken for magnificent hairpins for those uncombed manes"

(p. 32). Emotions also appear to him in visual form:
"If the happy line in painting is that which tends to
rise and the sad line that which falls or goes downward,
in these Basque dances it may be said that there are more
sad than happy lines in those formed by the arms in move-
ment. And for that absence of joy it was sure to please
the man of somewhat sad ideas" (p. 40).

Conclusions

Although Darío de Regoyos did not cultivate litera-
ture beyond this book about Black Spain, it was a very
significant contribution to Spanish letters in a year
that marked a new consciousness and desire for renova-
tion. This work undoubtedly made an imprint upon the
painter-writer Solana and the great Generation of 1898
novelist Pío Baroja, who considered Regoyos a good
writer. Despite Baroja's own pessimism, when he came
across Verhaeren some years after the publication of
Black Spain, he tells him that he lives in Spain but
"we don't find Spain as black as you did" (p. 16).
Regoyos's book is not limited either to illustrating
Verhaeren's articles or to reproducing them in Spanish.
The author-painter fulfills his desire to accompany the
pen of the Flemish poet with "the pen of a painter," even
if it means, as he so picturesquely puts it, "putting his
foot in literature" (p. 39). His success as a writer was
lauded by no less an authority than Pío Baroja who says
"he wrote well. Regoyos had grace and it is a pity he
did not write more, because it would have been worth
while" (p. 17). Although he was not by nature fond of
painting darkness, he tried for a time to see the dark
side of Spain, realizing that it was a partial picture.
If on the one hand he observes the country people in
Basque Vergara retire early, on the other hand he acknowl-
edges that at the same hour people in other provinces of
the country begin to have fun. For a while he lends his
palette and his pen to Verhaeren's vision, finding it
appropriate for Spaniards in a dark year of their long
history. Essentially, however, he feels a brighter voca-
tion as a postimpressionist pointillist who perceives
clear colors and light and who by temperament is not
given to such gloomy pictures, either in his writing or
in his art.

Chapter Two
Pen and Brush Meet on a Tranquil Isle: Santiago Rusiñol

Santiago Rusiñol (1861-1931), as prolific a writer as he was a painter, was equally celebrated in his native Cataluña and throughout Spain for his successes in both disciplines. According to his daughter María, "writing was for him a pastime. His real great love was painting" (1). It was, she tells us, more important to him than anything else, including his family, whom he affectionately called his "impediment" since his wife Luisa and daughter often insisted on accompanying him on his painting trips. His canvases were done out of doors while his writing was done in restaurants and cafés, often among friends, and the noise obviously did not distract the gregarious Rusiñol from his writing.

Gregorio Martínez Sierra, who translated a number of the artist's plays from the original Catalan to Castilian, noted that Rusiñol was at the same time a city man who felt at home talking the night away at the busy café and a painter whose work communicates peace, fresh air, and serenity (2). This does not, according to Martínez Sierra, mean that Rusiñol had a contradictory personality, but rather that he was capable of appreciating both people's company and nature's solitude. He reflected the latter best in his paintings of landscapes and gardens while his writings captured the busy world of people; only at times does his pen approach the more tranquil world of his paintings, and then it becomes obvious that he knows how to paint with words.

Rusiñol the Painter

Rusiñol was, together with Ramón Casas, principal animator of the Catalan Modernist movement in the 1890s, a school of painting inspired by the French Naturalists which proposed the "truthful recording of nature by the artist" (3). His paintings of this period are of landscapes and interiors, misty gardens and darkened rooms

15

evoking mood and emotional quality, according to the art critic Marilyn McCully, who has studied Rusiñol's association with Els Quatre Gats (The Four Cats) "beer-hall-tavern-inn" in Barcelona, frequented by prominent artists after its opening in 1897. Rusiñol painted "mood portraits" in which the atmosphere interacts with or influences the figure, chosen for its expressiveness rather than individuality. McCully tells us that after the closing of Els Quatre Gats at the turn of the century Rusiñol directed his energies to writing while continuing to paint, particularly Spanish gardens. As in his Modernist paintings, these landscapes communicate mood and emotional feeling, depicting, as Eduardo Marquina noted in a lovely poem:

> Silent paths, sleepy arcades,
> immobile pools and closed windows,
> nothing lives in the midst of the intense greenery,
> for your sad pictures not a figure remains.
>
> (JE, 13-14)

J. M. Sert found Rusiñol's Jardines de España (Gardens of Spain) mysterious, Miguel S. Oliver elegiacal, Pompeyo Gener sad, and Jean Lorrain melancholy in spite of the bright, clear Spanish sun (JE, 17-25). J. Maragall says sadness is Rusiñol's aesthetic resort in the gardens and in his scenic poem "El jardi abandonat" (The abandoned garden), but, in general, critics do not find in his work the decadence usually attributed to Modernist writers and artists in the 1890s (4).

Rusiñol's fame as a painter of gardens coincides with the image he himself preferred. María Rusiñol tells how King Alfonso XIII offered her father a title of nobility to which the artist simply responded that he was proud to be the only person named "gardener general" of the king's gardens. When he felt death near, he had his wife pack their bags and they went off to the Royal Gardens of Aranjuez where he painted until he could no more. He won many honors for his paintings: second place medals in the National Exhibitions of 1890 and 1895; first place in 1901, 1908, and 1912; and various other prizes in Barcelona, Paris, Berlin, and Chicago (5).

Rusiñol as a Writer

Rusiñol's early writings were travel impressions whose realism is tempered by "more or less symbolic Romanticism," according to Carlos Soldevila (6). In 1890 he began writing for the theater. His copious literary production includes some fifteen full-length dramas, thirty-three farces, sainetes (one-act plays), and comedies; seven poetic compositions; thirteen monologues; six long prose works; and several books of travel impressions, all written in Catalan. A number of his plays were translated into Castilian by the finest dramatists of the era, Gregorio Martínez Sierra, Eduardo Marquina, and the Nobel Prize winner Jacinto Benavente. Rusiñol's most frequent genre was theater, which eliminates description and presents characters directly before the eyes of the observer, this in bold contrast to his landscapes from which the human figure is absent. Rusiñol seemingly confined his expression of contemporary life, conflicts, and values to his writings, generally marked by fast-moving dialogue and good-natured irony. Only sometimes do his pen and brush meet, and it is to some of these cases that we direct our attention.

Señor Esteve, his novel published in 1907 in Catalan and two years later in Spanish, is still widely read in multiple editions and in play form. It presents the largely autobiographical story of several generations of "Esteves" from the founding of the family drygoods store "The Punctual" in 1830, which became the family treasure to be served by grandfather Esteve's son Ramón—destined by birth and disposition to be the perfect shopkeeper—and his sons after him. Ramón and his son Estevet obediently fit into the Esteve mold, but Estevet's son Ramonet turns out to be a rebel whose inclinations lead him to be a sculptor, to the dismay of his businessman father. The author offers good-natured criticism of the mercantile ethos of the Esteves which encouraged the growth and development of modern Barcelona but which conflicted with his artistic temperament.

It is significant, recalling Rusiñol's vocation as a painter of nature, that nature intervenes rather decisively, albeit briefly and somewhat facetiously in the novel. Only emphasis on nature can explain how Ramonet came to be born in a series of Esteves or Ramóns that were carbon copies of one another, for his father had proposed to his mother in a garden and after their first and only

outing in the country, his mother became pregnant with
him.
 In contrast to the figures that appear in Rusiñol's
Modernist paintings, who are not caricatures in any sense
of the word, the characters of Señor Esteve are. They
are basically flat and the author does not take pains to
round them out. An idiosyncracy, a pose, or a way of
speaking is enough to identify them and they become types
in the costumbrista tradition, either "Esteves" or
"Ramonets." Also notable in Señor Esteve is the fact
that there is little real communication among the charac-
ters, which is also true of Rusiñol's Modernist paint-
ings, such as Paris Studio of 1891 in which his figures
do not communicate, though they fill the space of the
darkened interior, as McCully observes. The same unity
of the human figure and its setting which this critic
applauds in Rusiñol is also the outstanding quality of
Señor Esteve, where the drygoods store complements the
character of its owners and shapes their lives.

The Tranquil Isle, Compendium of Aesthetics

 As we have stated, Rusiñol's plays and novels deal
with people while his primary vocation after Els Quatre
Gats is as a landscapist. When some Italian fliers dur-
ing World War I took Rusiñol on a test flight of a rick-
ety plane which was shot at by the enemy, his daughter
says he protested, "I am a painter of gardens and gardens
are usually very tranquil places. We painters don't like
battles" (p. 152). Some of his writings seek tranquility
also, among these his early Oracions (Prayers, 1898),
prose poems dedicated to ruins, abandoned gardens, and
elements of nature, and his mature work La isla de la
calma (The Tranquil Isle), translated to Spanish by
Marquina in 1925, which presents striking similarities to
his landscape paintings in theme and techniques.
 In The Tranquil Isle Rusiñol frequently expresses
aversion toward sameness and symmetry, lamenting that
"today everything has to be symmetrical, straight, small,
and numbered" (p. 57) (7), that windmills are replaced by
"houses of stone cardboard with that ugly symmetry that
all sheds that go up in the suburbs usually have" (p.
37), or that "palaces of stone are torn down and houses
raised up in a style so universally ugly and uniform as
if dictated in some congress of Esperanto" (p. 94). Of

the freely winding streets of one small town, he ex-
claims, "May God preserve them and free them from urbani-
zation and symmetry" (p. 104). Unless we understand "sym-
metry" as "sameness" it is difficult to correlate his
attitude that "symmetry destroys everything" (p. 94) with
José Plá's assertion that Rusiñol as a painter had
"the obsession of symmetry; the left part of the canvas
has to be equal or almost equal to the right; . . . one
object on one side, another object of the same type on
the other, and water, if there was any, in the middle"
(8).

Rusiñol's series of thirty-two Spanish gardens re-
veals a tendency toward composition that is rigorously
centered and balanced, as if the symmetry he abhors
in artificial creations were somehow desirable in
painting, and he imposes it upon the view rather than
accepting that the view should impose it upon him. He
favors the symmetry of balance but not that of sameness,
observing that "There is nothing sadder . . . than a
marvelous view that is always the same" (p. 183). The
monuments and arcades of his gardens are all unique, just
as the Esteves' store "The Punctual" became a unique
anachronism among the new look-alike shops of an urban-
ized Barcelona. The sameness of buildings and streets
is as bad as that of the mold that produced generations
of Esteves. Rusiñol is attracted by variety, uneven-
ness, and detail that is not overdone, for in his descrip-
tion of the cathedral of Majorca he praises the structure
for its harmony and art achieved by simplicity of means
and without superfluous lines. Perhaps this reflects
lessons in simplicity and thrift learned from his busi-
ness family.

Although Rusiñol, in the Modernist tradition, aspires
to paint directly from nature, his literary portrait of
Majorca is not photographic. He is as attentive to the
magic and enchantment of the atmosphere as to the con-
crete aspects he describes, remarking that "In this
respect islands are good: what they don't have, they
suggest" (p. 38). He claims that windmills never tire
the eyes of those who know how to see, intimating that a
scene itself is not so much the source of delight as the
creative look of the observer who can capture what is
suggested rather than explicit. This is akin to "that
quality of poésie lauded by Rusiñol's critics" of his
art and which for McCully remains the fundamental charac-
teristic of his pictorial work (9).

Painting and Painters in *The Tranquil Isle*

In The Tranquil Isle Rusiñol paints a series of
pictures in words. Again and again he looks at views of
the island and reproduces them for us as he sees them.
Often this is as if they were in fact paintings of scenes
before his eyes. He calls the town of Deyá a little
town of Bethlehem and proceeds to "paint" each component
of the landscape, a church on the top of the hill, a lit-
tle cypress tree in front, a handful of houses around the
church as if placed there by chance, others below stag-
gered and cut off, and still others above "riding upon
those below, and all looking at us with the same face of
cork color and open eyes, which are the windows" (p.
133). "If Giotto or another primitive had to invent a
town," he continues, they "would have created it in the
image of Deyá. Nothing more is needed other than the
frame and then to cut it out like a retable." Rusiñol's
description reduces the scene to the size of a canvas,
while the use of terms like above, further below, and
below rather than nearer or farther gives it a two-
dimensional quality rather than the three dimensions
suggested by the retable image. He calls this an "inter-
twined landscape" and, begging the pardon of those who
live in such towns, asserts that figures are of little
importance and do not stand out in the landscape; a man
simply disappears, overcome by it:

> Plastically considered, he is a black point, a brush
> stroke, and a dot of color, where there are many,
> disappears in the atmosphere. So it is that a town
> in the country always seems uninhabited. The human
> presence reveals itself by a light at dusk, a cloud
> of smoke that rises in the sky, a silhouette that
> slips by. What dominates are the walls; behind the
> walls, the trees; over the trees, the mountains, and
> at the foot of the mountains, the sea. The landscape
> of these little towns is so vast and grandiose that
> the people sheltered in them pictorially do not exist.
> (p. 134)

Rusiñol has described what might be any one of his
painted landscapes. His attitude toward the majestic
scene he observes in Deyá may best be called reverent;
for that reason he probably sees the nativity scene just
asking to be painted or executed in a tapestry, reduced

to the size of a retable or a canvas. This is not the
only time he deliberately reduces or eliminates figures
from his literary landscapes in The Tranquil Isle. In
Palma he facetiously excuses himself for not saying more
about the women because in addition to being an out-of-
towner, he is a landscape painter and doesn't do por-
traits (p. 66). Taking leave of the cathedral at Palma,
he describes the bay, houses, forests, mountains, and the
city itself so reduced in size that they seem set in a
picture.

One of the most fascinating chapters in the book for
the reader searching for Rusiñol, the painter, is that
which treats the cathedral of Majorca, because it permits
us to observe how he paints with words, adding and mixing
elements until the picture is completed. The artist com-
municates not only the visual images but also the tech-
nique of painting. First he cites in impressionistic
form the diverse visible parts of the cathedral: "a door
with Gothic glasswork, with a small frontal atrium; an
arch of stylized leaves, a line of apostles at each side;
a solid form of golden stone scaling the blue of the sky,
a yellow mass that penetrates the clouds" (p. 29). He
describes its immense gray mass and notes that few cathe-
drals "give the impression, like this one, of having been
built with one hammer stroke only, in only one moment of
creation, of one solid block" (p. 29). This completes
the impressionistic presentation of masses and general
colors with emphasis on the unified final effect. Now
the artist adds some details of columns, windows, naves,
and altar, and begins to apply color:

> Now add a severe color, greenish patina like that of a
> reliquary, color of a gravestone, of a blackened pearl;
> color of old armor; add the reflection of algae from
> the waves of the sea and the sparks of cadmium blue
> that descend from the windows; add the little lights
> of the processional candlesticks and of the lamps,
> like a procession of prayers for souls in purgatory,
> and the mist of incense and the brilliance of the
> altars and the darkness of the chapels; and all togeth-
> er they will form the most impressive and fantastic
> saintly ark that can exist on earth. This temple is a
> great flower of the garden of Humanity. (p. 30)

The above description possibly tells us more about how
Rusiñol paints than about the Majorca cathedral. We can

picture him mixing colors on his palette to achieve the
exact "severe color" he is looking for by imagining cer-
tain objects; then he adds the brighter colors and lights
against the darker background and observes the painted
cathedral that complements the previously painted sky and
clouds as a beautiful flower in one of his favorite
gardens, which is precisely the image he uses.

Rusiñol tends to take the view that nature presents
before his eyes and instantly gives an artist's rendering
of it. In the chapter called "The Watchtower" he creates
a diorama:

> Imagine that as in a diorama, you are brought from
> semi-obscurity to a terrace and the sea is placed in
> front of you extending to infinity, all the blue of
> the Mediterranean waters spilled, all the clarities
> lit up, the golden and purple lace of all the clouds
> released and over the waves a flight of little boats
> with wings, you are seated before a wall, moldy with
> time and salt under the shelter of the cathedral most
> kissed by the setting sun, most illuminated by the
> fire of the sky, and blackened by the centuries, and
> you are told, "Sit down and admire." (p. 26)

There is such harmony between nature itself and every-
thing it touches that Rusiñol sometimes resorts to inter-
changeable perspectives, describing the cathedral "so
drenched with the sun that one does not know if it is
taking the sun or the sun is taking it" (p. 6) and wonder-
ing whether the "water is listening to the people or the
people to the water" (p. 14). This same harmony exists
between painter and landscape; one does not know whether
the artist discovers nature's secrets or whether, as
Martínez Sierra says, "the whole garden, the whole land-
scape, tells him its secrets" (JE, 9).

Rusiñol, who occasionally employs painters as charac-
ters in his plays, also mentions painters in The Tran-
quil Isle. He tells of the artist Mir and others who
unnerved the residents of Deyá with their strange pic-
tures and created a madhouse in this little Bethlehem
town of peace and tranquility. A different sort of artist
is his friend Terrasa, quiet and serious but with a mania
for cleanliness and neatness that belied the reputation
of painters. Imagine how clean he was, explains
Rusiñol, "for in order not to dirty the brushes he
almost didn't paint" (p. 147). (Perhaps this was the

inspiration for Jusep Torres Campalans's obsession for cleanliness in Max Aub's novel, studied in chapter 6 of this book.) In the chapter of The Tranquil Isle entitled "Hermits of Today" Rusiñol treats artists like himself who paint landscapes, the "mystics of nature" who with their easels, paints, and palettes, spend days, months, and even years in solitary communion with nature. The outside world, friendship, and love are forgotten, Rusiñol tells us; only the forces of interior faith and of exterior landscape move the artist. Accompanied by his own thoughts, he never feels alone or foreign "because he carries in his interior a perennial language: that of vision" (p. 175).

Colors and Composition

Rusiñol has many ways of dealing with colors. Sometimes, as in the previously mentioned decription of the cathedral of Majorca, the color conforms to some ideal object. Thus we find the color of a gravestone (p. 30), stones which are "wood colored" (p. 33), a moon of the "yellow of the ill" (p. 59), a fusion of greens called "tree colored" (p. 134), and fruits of cadmium, gold, fire, and live coals (p. 160). Atmosphere and mood project themselves in colors, like a "gray calm, white calm, golden calm" (p. 198) or the "dead blues" and "agonical greens" of penitents' robes suggesting that "happiness has fled from the color, leaving death faded" (p. 85).

The predominant colors in The Tranquil Isle are blue and white. In "El Terreno," summer resort of the residents of Palma, Rusiñol describes "an amphitheater with sea, sameness of the sky and one same splendor of blue, one of those blues that in the same way that the sun darkens the faces of those who bathe in it every day, must make the faces of those who look at it blue" (p. 48). In "Miramar" he tells of a child who didn't want to be bathed in the water for fear of turning blue, and he observes the meeting of sky and water in an ultramarine blue so intense that it could turn the ships blue. The view of the town, however, is invaded by white, and the diversity of the composition is held together by the white tonality, characterized by "smoothness."

The chapter entitled "The Long Walls" could very well be taken for a description of Rusiñol's painting The

Rusiñol: *The Blue Patio*, from A. M. Campoy's *100 maestros de la pintura española contemporánea*, courtesy Ibérico Europea de Ediciones, Madrid.

Blue Patio, which is also the title of one of his plays,
about an artist and a sickly young woman who dies in the
melancholy setting, contrasting with the sun-filled
patios of both works from which people are absent.
Rusiñol speaks of the mysteries of walled gardens from
which the fragments of nature that peer out invite the
imagination to jump the wall. "Sometimes a tree seems to
escape from the enclosure and, extending its flowered
branches, gives light to the whole street" (p. 56). The
painting likewise shows a blue wall and behind it a win-
dow and the visible part of a blue house. Some yellow
chrysanthemums in a flowerpot and a yellow tree are in
the foreground, but behind the wall a flowering tree
sends out its white blossoms as if it were a street light
illuminating the pale yellow sky seen between the houses.
It is an extraordinary case of correspondence between
verbal and pictorial images, both communicating a sense
of mystery, inviting us to imagine what lies behind the
walls that enclose the patios.

Rusiñol was not an Impressionist and he did not revel
in light in his paintings; even though he painted scenes
of Granada filled with light, several critics found that
his palette did not lend itself well to painting full
light (10). Perhaps for this reason he invites us to
imagine "The Valley of the Oranges," to close our eyes
for a moment and think of an exuberant green landscape
while inhaling orange blossom perfume or eating an orange
(p. 153). He calls the oranges "pills of light," "cir-
cles of gold," and their colors are of gold, fire, and
live coals. When the light is blinding, details are not
distinguishable and the effect is decidedly impressionist-
ic. A last look at Majorca leaves "an impression of white-
ness of a dust storm" and imprecise masses of color are
seen: "That whiteness is Molinar, that green is the sea"
(p. 45). These are undoubtedly unpaintable scenes,
better depicted in words.

Darkness definitely depresses the artist, leaving him
with a sensation of anguish and emptiness. He asks him-
self on a visit to the Caves of Artá why he ever left
the light to descend into these dark interiors. In this
"parlor of inferno" he sees "a black of dead coal, of
mahogany in mourning" and concludes that the best part of
such caves is leaving them (p. 190). There are few noc-
turnal views and, when they do appear, emphasis is placed
on the light provided by the moon, the stars, and the
boats' lamps.

Rusiñol sometimes uses musical imagery, for as his daughter tells us, he was very fond of music, but he is primarily a visually oriented person who "sees" things either painted or inviting the artist to paint them. He asserts that "little towns are blond or brunet. Pollensa is brunet . . . Pollensa is a decoration for putting on mystery plays or to serve as a frame for the processions of Holy Week" (pp. 177-78). He imagines gardens of twisted and contorted olive trees painted, but notes that no one would believe the paintings (p. 100). He claims that "only painters can see certain things" (pp. 174-75); we might very well add that only painters see things as if they were already transported to a canvas. Each chapter of The Tranquil Isle focuses upon a specific subject or view, yet his literary landscapes are often panoramic, and he leads our eye from one detail to another. He uses impressionistic techniques without being an Impressionist, for he is as interested in detail as he is in re-creating general sensations.

General Considerations

Many correspondences can be noted between Rusiñol's painting and writing. First of all, there is real enjoyment in the act of writing itself without dependence upon anything beyond that. His plays may have plots and themes but The Tranquil Isle does not, paralleling his joy in painting without any message or theme beyond the subject itself. There is delight in the act of writing or painting as an end in itself, like the sun bathers of Majorca whose purpose, according to Rusiñol, is not to get a tan but simply to enjoy the sun, or like those who wait for the boat from the mainland without expecting anyone at all, or like the almond trees of the island that are there not to give almonds but to delight the eye.

The Tranquil Isle is without doubt the literary work that most closely parallels Rusiñol's work as a painter. One problem that an artist faces is that of movement, for a moving model is difficult to capture, but the natural calm and immobility of Majorca preclude any frustration in trying to keep moving subjects still. It is a painter's delight because nothing moves. Rusiñol humorously says the constant derailment of the streetcar is intentional so that the people "can see the view, which

they have already seen but is good to see again" (pp. 44-
45). "Saint Do-Nothing" reigns supreme at the appropri-
ately named Café Paz (Peace) and "if soups get cold they
can be eaten cold and will taste like pies" (p. 42).
Rusiñol's literary humor contrasts with the melan-
choly that critics find in his gardens and in occasional
writings, such as El jardín abandonado (The abandoned
garden), a one-act "poematic picture" about a young woman
abandoned by suitors who cannot understand her voluntary
cloister in her beloved garden, "an unkempt garden, a
classical garden of noble plants, ill from abandon, that
conserves the distinguished mark that improvised gardens
do not have; a garden with the patina of age, modeled by
the kisses of time, and sad" (11). It is surprisingly
like the garden José Plá finds typical of his paint-
ings: "When Rusiñol finds an abandoned garden—but not
so abandoned that it has lost its form—he gets enthusi-
astic. When the garden is new, he knows how to give it
the patina of years" (12). For Rusiñol, as for the
painter Ernesto of The Abandoned Garden, "the empti-
ness, the quietude that comes forth from these gardens is
emptiness only for one who does not know how to feel"
(13). Yet María Rusiñol insists that her father was
not melancholy by nature and cites the "spark of his
humor." This spark which is so evident in Señor
Esteve and The Tranquil Isle must have its pictorial
counterpart in the light that illuminates Rusiñol's
pictures and saves even the most abandoned garden from
darkness.

Chapter Three
Ricardo Baroja:
Writings and Etchings

Although the writings of Ricardo Baroja (1871-1953) have been eclipsed by those of his famous Generation of 1898 brother Pío, his fame as a master of etching is firmly established. On the occasion of an exhibit-tribute to the artist offered by the National Museum of Modern Art in Madrid in 1957, Enrique Lafuente Ferrari wrote in his introduction to the catalog that "his work as an etcher . . . deserves the first place among Spanish aquafortists of this century. If art is sensitivity, capacity for invention and poetry in the interpretation of the world and not mere scholastic exercise, Baroja is the most modern and authentic etcher that Spain has produced since Goya" (1). Baroja's vocation as a writer did not wholly reveal itself until he was about fifty years old, but once he began to write, he continued to do so quite fervently and in his later years combined his fictions with illustrations of his own creation.

Ricardo Baroja's prestige as a pictorial artist was established as early as 1906 and 1908 when he was awarded national prizes for his etchings but, as his nephew Julio Caro Baroja tells us in his biographical notes, he did not follow art as a profession (2). Born in Basque country in 1871, Baroja lived for long periods of time in Madrid and took part in literary tertulias of the Generation of 1898. In 1931 he lost an eye in an automobile accident, an experience that embittered him and probably led him to do more writing than sketching for a while until he reeducated his remaining eye. Faced with economic difficulties brought by the Civil War, he again took up painting, this time professionally, now drawing more on memory than from real life. Writing was for Ricardo Baroja an intermittent vocation. His first novel, Fernanda, was published in 1920 and followed by plays, novels, and essays published at different times and continuing into his old age. His novel La nao "Capitana" (The "Capitana") won the national Cervantes Prize in the year 1935. Several novels treating sea adventures were illustrated by Baroja himself, his literary and artistic

skills complementing each other with perfect harmony in
black-and-white etchings or sketches which were character-
istic of his early career as an etcher. While not so
prolific a writer as his novelist brother, nevertheless
Ricardo Baroja's literary creation is quite substantial.
The volume of his Obras selectas (Selected works) in-
cludes thirteen major works in different prose genres.

Self-portraits

The self-portrait is always a difficult genre since it
involves turning the eye inward with a certain degree of
objectivity which is not easily achieved. Ricardo Baroja
has left us with several such portraits in both the pic-
torial and the literary media. Two pictorial self-
portraits in different periods of his life provide an
interesting contrast. The first, dated 1920, which hangs
in Spain's Romero de Torres Museum in Córdoba, is a dis-
quieting portrait on several counts. The clean-shaven
artist is seen almost in profile, his eyes turned as far
as possible to the side opposite that which he is facing,
resulting in a very penetrating look. In addition the
canvas is horizontal rather than vertical, which would
seem more natural in a portrait, especially since the
space on each side is essentially empty. The effect is
that the face stands out alone and solitary against the
light background with a certain starkness that implies
restlessness and defiance. Another self-portrait, this
time a xylograph, appears in the frontispiece of the
novel El Dorado. Dated 1941, it is a full-face picture
of the now-bearded artist with a patch over the impaired
eye, glasses, beret, scarf, and a coat whose lapels are
visible. It would seem more logical now to paint a pro-
file similar to that of the earlier portrait in order to
hide the injured eye, but the painter faces us directly,
the expression of his left eye as intent as it was in the
previous self-portrait, but the overall impression is
softer and much less stark, as in a similar 1933 portrait.
Ricardo Baroja also provides some self-portraits in
his writings. In his extraordinary science fiction play
which preceded Aldous Huxley's Brave New World by six
years, El pedigree (The pedigree, 1926), there is an
autobiographical interlude in which the author says he
fully expects the play to be ignored or disdained by the
press. He calls it a pessimistic work about an imaginary

R. Baroja: *Self-portrait*, from *El Dorado*, courtesy Julio Caro Baroja.

society which is good but ineffective and which requires
the grafting of man's defects and even crossbreeding with
a monkey to produce after thousands of years a new
Zoroaster (Nietzsche's character). Comparing his play to
those of other Spanish dramatists, he acknowledges that
it has neither common sense nor verisimilitude, but he
says he would rather have theater that is immoral, sexu-
al, tragic, absurd, unbelievable, and arbitrary, since we
encounter more than enough ordinary happenings in every-
day life (p. 312). This would correspond to the change
in his aesthetic concept during the same time; Julio Caro
Baroja tells us that he compared landscapists who painted
from life to cows grazing in a field, dominated by the
obsession of eating all the grass found there, and that
he preferred to paint from memory or the imagination of
his fictions (p. 22).

In the same interlude in The Pedigree Baroja con-
fesses to an inability to handle tragedy or satire well
and laments his bad fortune in this sense in a half-
facetious tone. He tells of Pirandello's interest in
showing the play in Italy and wonders why it didn't turn
out. He criticizes his style as "frankly bad" and
"rather vulgar. I write the way one speaks, and one who
does it badly. I repeat gerunds like a notary" (p. 314).
He also finds fault with his assonance, long paragraphs,
poor vocabulary, confusion with regard to commas, peri-
ods, semicolons, and syntax. He "confesses" these faults
unabashedly in the same way he exhibits the eye patch in
the aforementioned portrait, but the style is conversa-
tional and sufficiently facetious to make us realize that
he is not all that serious, recalling the expression of
the 1920 portrait which Julio Caro finds somewhat Mephis-
tophelian and sardonic.

Of Art and Artists

As Julio Caro Baroja notes, there are few Spanish
novels about artists, as is Ricardo Baroja's first novel,
Fernanda (1920), "written by a painter about painters
and etchers of his era" (p. 24). The novel concerns a
mediocre painter named Don Claudio who has always dreamed
of winning a gold medal in the National Exhibition and
finally is on the verge of doing so thanks to the good
auspices of rich Senator Don Leandro, motivated by his
interest in one of the artist's daughters, Fernanda. Don

Claudio's former student, Julio Ferrante, who is in love
with Fernanda, has also submitted an entry that appears
likely to win on its merits despite the senator's tamper-
ing with the jury. Pressured by her father's aspirations
and by Don Leandro, who has assured the financial securi-
ty of the struggling artist's family, Fernanda convinces
Julio to drop out of the contest but after a very diffi-
cult decision destroys his letter of withdrawal. Julio
wins on his merit and is launched on a career as an
artist. He gives Don Claudio the proceeds of the prize
to assuage his anger and then marries Fernanda. Some of
the characters are based on real people, and according to
Julio Caro Baroja, the etcher Don Remigio Vasares, a
rather sarcastic observer who scorns exhibitions and
recognizes the talent of Julio in the novel, is an alter
ego of Ricardo Baroja. Since the latter had just mar-
ried, Remigio's preoccupations with the effects of mar-
riage and familial responsibilities on an artist may be
seen as those of the author.

A description of Julio's farmer father toward the end
of the novel seems actually painted as "a larger reproduc-
tion of his son" (p. 229). "His energetic suntanned
face, of strong cheeks and jaw, appeared sublimated by
the golden rays of the dying star" (p. 228). Here, as in
various other descriptions of people and landscape, the
author prefers the effects of partial light upon his sub-
ject. Caro Baroja explains that his uncle was not fond
of excessive light or of full sun. This is evident in
the novel where light comes from the setting sun or from
an artificial source, as in this description of Fernanda
which constitutes a veritable portrait:

> In the angle of the studio the lace shade of a large
> lamp cast golden light on Fernanda's hair. Bust re-
> clined on a divan, hands crossed, feet in patent leath-
> er shoes brilliant as jet at the tip of very fine
> ankles that showed the skin through the silk stock-
> ings. Her hair, black and naturally curly, combed back;
> some curls danced on her forehead and two ringed curls
> descended on her temples, covering the ears to the mid-
> dle of the pale cheeks. Her large greenish eyes, deep-
> ly brilliant, seemed black in the artificial light un-
> der her long lashes curved slightly upward. (p. 178)

The artist obviously "sketches" his subject attentive
to minute details to create a black-and-white composition

in which even Fernanda's "greenish eyes" appear as black.
Only the golden light from the lamp provides contrasting
highlights. Baroja's tendency toward dark coloration
rather than bright, brilliant hues is further illustrated
in the catalog descriptions of the paintings included in
the aforementioned exhibit-tribute in 1957, which are
filled with blacks and grays. The cataloger, Joaquín de
la Puente, uses such phrases as: "Black makes the color
sing," "gray intonation," "palette with great interven-
tion of black," "palette tries to be luminous," "gamut
generally gray," and "rather dark intonation."

Another novel about the art world is the 1930 Los
tres retratos (The three portraits), which the dedica-
tion tells us is based on real people the artist knew.
The plot, a bit overdone and romantic, concerns the
eighteen-year-old model Antonia who is secretly in love
with Basilio Honrubia, a friend of her employer, the
artist Miguel Torralta. Basilio, however, is in love
with a rich American woman, Elena Morgan. The model's
scorn for her childhood sweetheart leads to her death at
his hands, exacted by the blood pact they had made as
children. Elena fears she cannot marry Basilio with the
memory of Antonia's death between them but everything
works out happily.

Baroja is an exceptionally able painter of women in
his novels, while the male characters are much less graph-
ically convincing. Elena is projected against a reddish
light of sunset coming through the window, which is so
typical in Baroja. She is seen first in profile, then
full front, and finally in full figure; "her mouth is
strongly sketched" (p. 866).

Antonia is described as she looks in "real life" and
in a portrait Miguel has painted which in the semi-
darkness of dusk is "illuminated by a lamina of golden
light that penetrates through a window between two large
curtains of green velvet" (p. 411). A discussion takes
place in the novel about the effects that can be achieved
by the use of artificial light and reflectors, with a
shade covering a lamp which can yield effects previously
impossible in painting; "there is something of the tonali-
ty of Goya in certain effects of electric lighting" (p.
417). In one scene Basilio Honrubia contemplates his
beloved Elena, her back to the light and slightly below
it. There is a detailed description of her pose and the
effects of the lighting. Baroja also finds occasion to
criticize the discordant color "favored by most imbecilic

modern postimpressionist painters" (p. 432) and to poke
fun at the art critics in the person of the ridiculous
and unscrupulous Pepito Andueza. Baroja obviously wanted
to give the novel an artistic title, but "the three por-
traits" are not clearly explained in the text, sometimes
appearing to refer to different poses of Elena or at the
end to Miguel's portrait of Antonia, a literary portrait
of Basilio's father, and a small picture of Basilio bur-
ied alongside Antonia.

Baroja expresses his disdain for modern artistic move-
ments through the painter Miguel, who responds to the
critic Pepito Andueza's observation that he seems to be
neither an Impressionist nor a Naturalist with a continua-
tion of possibilities, "I am not a Cubist or Futurist or
Symbolist or Constructionist or Cezannist or Gauguinist
or Expressionist" (p. 371). He is proud of following his
own way of painting and particularly criticizes Pointil-
lism and Cubism: "I don't want everything in my pictures
to appear through a shower of confetti nor do I wish to
pave my canvases with square brush strokes or cover them
with crusts of the ugliest colors I can mix on the pal-
ette, or border outlines with black like on death certifi-
cates, or draw figures that have elephantiasis" (p. 371).

In The Three Portraits again Baroja's preference for
etching reveals itself in the predominance of black and
white, as in his description of Elena, commencing with
the outline of the profile and then proceeding to the
jaw, mouth, black eyebrows, and pupils. Another black-
and-white literary etching describes Antonia's childhood
sweetheart walking at night through the streets where gas
lamps create intense dark spaces, and the silhouette is
seen against El Retiro Park, "a black, mysterious for-
est."

Surrealistic Inclinations

Despite his avowed hostility to the "new art" of the
1920s, Ricardo Baroja shows some decidedly Surrealistic
tendencies, more so in his writing than in his painting.
Nevertheless, the procedures he employs in creating an
etching as described in a letter to the editor of Europa
Magazine show that even his pictorial work was subject
to Surrealistic inspiration and suggestion. He explains
that he usually begins by scratching a sheet of copper
with no previous sketch in mind, "perhaps without the

least suspicion of what I am going to do" (p. 362).
Reluctant to waste an expensive piece of copper and moved
by anger and hope, he begins to scratch more freely so
that what began as a figure may disappear or an incipient
landscape may turn into a broken wall. Brush strokes of
varnish applied to the scratched surfaces produce open
spaces which, outlined in strong, stark lines, begin to
reveal possible features which the "murderous iron point"
submerges in shadows or allows to survive. At this
point, he confesses, he hates his work and pours the mix-
ture of water and nitric acid onto the plate.

> It is then that I believe most in the unexpected cor-
> rected, in taking advantage of accident, in chance
> adapted, that something of genius will appear, some-
> thing that is above mere correctness.
> That hope exists in me to such a degree that at
> times I have thrown the lamina to the floor and then
> lifted it with the expectation that the scratches
> suffered by the metal and modifying its surface would
> give me a means of correcting what I was incapable of
> rectifying before. (pp. 362-63)

Baroja has described here the Surrealist's reliance on
chance and automatic, spontaneous creation which in liter-
ature or painting frees creation from the tyranny of the
conscious mind. He never mentions Surrealism as such but
even his novels of fantasy seem inspired in a way similar
to that described in "How to Do an Etching." The Pedi-
gree takes us to "the year 201 of the Fourth Era on the
planet Earth," La tribu del halcón (The tribe of the
falcon) to a prehistoric caveman era, and El Dorado to
a strange and ironic utopia; all three attest to the
tremendous imagination of the author. There is also the
prophetic element of Surrealism in The Three Portraits
in which the red carnations Antonia holds at her breast
in Miguel's painted portrait anticipate the wound that
later causes her death, and in El coleccionista de
relámpagos (The lightning collector, 1938), where a
storm scene makes the artist "painter and prophet" (p.
674).
Baroja's splendid novel El Dorado (1942) is an exam-
ple of his incursions into Surrealistic worlds, and since
it is profusely illustrated by the author, provides an
excellent opportunity to examine the degree of correspon-
dence between his writing and etching (3). The novel

concerns the sailor Santiago Ruiz Montoya, narrator of
the first two parts, who is fascinated by an old steam-
ship called El Dorado whose crew always paid for its
cargo in gold and spoke a strange dialect of Spanish
reminiscent of Galician and medieval ballad Castilian.
Santiago finds out in conversation with its captain,
Martín Montoya, that the two are related, and in an
unusual outburst of loquaciousness the captain tells him
about his country, El Dorado, which lives under a tyranny
worse than any political one, since it comes from the
sky. Realizing that he may have said too much, Captain
Montoya asks Santiago to forget what he has told him and
leaves.
 Obsessed with the mysteries of El Dorado and anxious
to find this place where his unknown relatives settled,
Santiago hires a schooner to follow the El Dorado,
which throws him off its trail. Exploring an area near
where he last spotted the ship, he and his dog Dingo come
upon a panorama of ruins, and after a fierce electrical
storm they discover a huge metallic rooftop a kilometer
square into which they gain entrance through a postern
with ladder. Santiago finds a long passageway illumina-
ted by a candle and continues to a room where he and
Dingo are provided with food on golden utensils through
an opening in the wall. Exploring the area, he finds
niches of family members buried after being killed by
"celestial cholera." After eight days of quarantine to
assure that he has no cold that could be fatal to the
residents of El Dorado, he is allowed to speak to Captain
Montoya who explains that the outside world is mortifer-
ous for them; to survive they must remain underground
except during the severe electrical storms which make the
atmosphere lose its pernicious effects and which made it
possible for Santiago to reach the city.
 Here live a thousand people who do not know how to
read or write and whose language has degenerated by isola-
tion from the outside world. Santiago notes animal
regression in the old men of this matriarchal society in
which no one knows who his father is and women nurse
their children until they are seven or eight years old.
The people dress in blue robes and smoke pipes through
their noses. Having lost the habit of working, they
spend fifteen days twice a year unloading the El Dorado
which brings provisions. Storerooms keep an extra six
months' supply of food. Santiago meets Captain Montoya's
lovely granddaughter Antonia who sings old Spanish bal-

lads by rote and is admired for her swimming ability.
When she insists on going to his room, Santiago takes
vows with her before a statue of the Virgin in an unused
chapel in order to sanctify their relationship. He teach-
es Antonia to read and to think, both unknown occupations
in El Dorado. When the El Dorado with a new captain is
months overdue, Santiago is sent in an old schooner to
procure a new ship, but complications arise which keep
him away for several months.

Antonia's account of the events that occur in Santia-
go's absence tells of the scarcity of provisions in El
Dorado, her efforts to hold off attacks of the hungry old
men who would resort to cannibalism with her baby Santia-
guito, and her decision to try to reach her mother's
home. The narration resumes with Santiago's return to El
Dorado's hidden harbor where he finds Captain Montoya's
corpse and a grisly sight of empty barrels and bodies.
Antonia and the baby appear, suffering from severe malnu-
trition, and in his desperation Santiago cuts his arm to
offer her his own blood for nourishment.

An epilogue provides an explanation for the fantastic
adventure story. Antonia returns a manuscript to the
narrator, Santiago, berating him for all the "fabrica-
tions" about her family and for portraying her in some
"dirty" scenes. Her husband explains, "these ideas are
undoubtedly suggested by my rheumatism and those drugs
you make me take to relieve it" (p. 1205). He defends
his manuscript as an account of what he has dreamed, but
Antonia replies that it is bad enough to dream such
things and worse yet to write about them: "In that cave
you invented everything is gold, even the garbage cans.
Only the devil could imagine a whole town covered by a
golden roof! Don't you see that it makes no sense?"
Santiago says such fantasies were caused by medicines
with names too long (one is given which is almost a full
line), and he decribes the results as "a dialogued drama
which unfolds with the special logic of dreams and ends
with a ridiculous conclusion or doesn't end at all
because you wake up" (p. 1207). He has followed the
Surrealist procedure of letting the mind wander into a
state somewhere between dream and wakefulness: "I
haven't dreamed everything; what I have done is link the
dreams and lend some verisimilitude to the narration" (p.
1207). He agrees to change the manuscript a little in
order not to compromise Antonia's family and insult her
great-grandfather, but insists that "after all, it would

not be the least strange for Homo Sapiens to indulge
himself a little in cannibalism."

The novel contains features typical of dreams: figura-
tions of nudity, abyssal places, and frightening experi-
ences involving both known and unknown people. Baroja's
particular brand of Surrealism alters the verisimilitude
of situation but not that of character, in consonance
with his illustrations, which are of very real-looking
people and objects poised in the highly fantasized situa-
tions proposed in the novel. Basically the illustrations
strike us as realistic, showing scenes aboard ship,
draped women with a child and a dog, caves and ruins,
groups of people who do not look unusual, and a patio
with crypts in the wall. The figures are even a bit
ingenuous and cute, corresponding to the same ingenuous-
ness apparent in the novel. No attempt is made to alter
the recognizable human form; only the situation is clear-
ly absurd, and if we are late in noticing this, it is
only because the first-person narrative in the early
parts of the novel tends to transmit the illusion of a
real-life narration confided to the reader.

Ricardo Baroja's illustrations for his brother Pío's
dialogued novel La casa de Aizgorri (Aizgorri's house)
also reveal his tendency toward the imaginative since he
depicts ghosts and skeletons only alluded to in the text
as imagined by the characters (4). Here too the little
figures in white tunics and cute little skeletons are not
intimidating, especially if we compare them to José
Gutiérrez Solana's all-too-human skeletons. The illus-
trations show that Baroja prefers dark interiors, rainy
evenings, night scenes, and similar dark atmospheres.

Julio Caro Baroja tells us that his uncle was violent-
ly opposed to abstract and Surrealist art (p. 18), so it
would seem that he was unaware of his own Surrealistic
creative procedures. He is more explicit in his denuncia-
tion of Cubism in El Dorado, suggesting that a golden
bust which Captain Montoya gives Santiago be melted down
into a gold ingot and recommending the same for all
Cubist sculpture and painting. The latter, he suggests,
should be burned to heat the museums, while the sculpture
could be turned into gravel and covered with tar to pave
highways!

The Surrealists have too often been unjustly accused
of evasive art, which at first glance might seem to be
the case in El Dorado, published in 1942, soon after
the Spanish Civil War and only one year before Camilo

R. Baroja: Illustration from Pío Baroja's *La casa de Aizgorri*, courtesy Julio Caro Baroja.

José Cela's novel La familia de Pascual Duarte (The
Family of Pascual Duarte) shook postwar Spain with its
tremendismo or emphasis on horror and violence. An
earlier version of El Dorado was destroyed during the
war; Baroja rewrote it in various stages corresponding to
the different parts of the book (5). The tremendismo
of the later chapters may well reflect the effects of the
war and its aftermath, for there seems to be a criticism
of Spain in El Dorado, visible in the degeneration of a
society that has isolated itself, feeds upon traditions
long vitiated, and has no goals or purpose capable of
inspiring efforts beyond those of elemental subsistence.
In fact, the novel recalls some of Spain's problems iden-
tified by José Ortega y Gasset in his España inverte-
brada (Invertebrate Spain, 1921), such as the lack of a
mission contrasted with a once-heroic past, recalled in
El Dorado by the ruins of the great cities that the
early Spaniards had erected there centuries before.

Sea Etchings

In his dedication to Los dos hermanos piratas (The
two pirate brothers, 1945) Baroja says he has always been
in love with the sea and that he finds the architecture
of a simple fishing vessel more beautiful than any land
monument or cathedral. His cultivation of marine paint-
ing and novels is unusual in Spain. He illustrated both
La nao "Capitana" (The "Capitana") and El Dorado with
sketches and etchings as he educated his remaining eye
after his accident. The "Capitana" involves a mysteri-
ous fugitive stowaway, his adulteress lover Estrella, a
planned mutiny, a sea battle with pirates, and other
adventures. The fugitive and Estrella both turn out to
be descendants of a long-lost Moorish brother and sister
separated in the Middle Ages and reunited in the persons
of Abdalá the Blue and Estrella in the depths of the
sea. Baroja's references to Estrella's forehead as a
"lamina of dull silver" (p. 493) and the sea as "laminas"
of water and lead (p. 494) remind us of the materials of
his art. Scenes and characters are almost exclusively
executed in black and white, with "greenish" water or
"bluish" skin, but no true colors. When one of the women
aboard wants to see the colors of a magnificent sunset,
she is ordered below by the captain who is about to pun-
ish a crew member, so we never get to see that sunset.

The captain's eyes are described as "two ink blots on a white paper," as if they were painted (p. 563).

In the opening scenes of the novel some passengers take leave of their country with great sadness but recognize that they can no longer live there. In retrospect it seems strangely prophetic that Captain Arcaute says about his ship, "It is for me something like a mother, like my nation! My ship, dear friar, is a piece of Spain fallen off, that driven by waves, winds, currents, passes the sea and comes to these shores" (p. 471). Perhaps Ricardo Baroja, like his artist in The Collector of Lightning, was not only a painter but a prophet.

Chapter Four
José Gutiérrez Solana's "Visions" of Life and Self

Solana's fame as a painter of "Black Spain" was well established before his writings were studied by serious scholars who found an uncanny correspondence between his expressions in both media wherein he projects a somber and macabre vision of Spain, which for some critics places him in the Generation of 1898. The novelist Camilo José Cela treated Solana's literary work in his speech before the Spanish Academy in 1957, noting that "Solana writes like a painter" and that "all the ideas and figurations of Solana had at least two versions, one plastic and the other literary" (1). With reference to the pictorial qualities of Solana's literature, Cela finds that his predominant colors are black, red, and white and that colors are often described by objects they suggest, for example, as salmon-colored or cinnamon-colored. Cela explains how the painter-writer achieves strong sensations of smell, sound, taste, and even touch in both disciplines and describes his heliophobia and claustrophilia which seek out dark themes and darkness itself.

In 1967 Weston Flint dedicated an entire book to the subject of Solana as a writer, exploring his personality and aesthetics. He notes the tendency to treat human beings as objects and purposely confuse them with inanimate facsimiles such as mannequins, masks, and dolls both in writing and painting, but claims that Solana felt piety and tenderness toward the human creature besieged by illness, death, and his own inhumanity toward his fellow man. Solana's aesthetics, Flint finds, lean toward irony, bent on presenting moral and spiritual truth, however ugly it may be. He finds that expressing things like smell, sound, and movement are suggested as well in the artist's paintings as in his writings but that his heavily impastoed paintings convey a tactile feeling that the printed word is incapable of transmitting, which may be why Solana turned away from writing in his later years (2).

Perhaps the most comprehensive study to date of the

strong correspondences between both sectors of Solana's
production, including chronological relationships, is
José-Luis Barrio-Garay's 1978 book José Gutiérrez
Solana, Paintings and Writings, magnificently illustra-
ted by an ample selection of photographs. Barrio-Garay
traces the artist's familiar iconography: popular scenes
(carnival, tauromachy, circus, sideshows, and sports),
the wretched (brothels, the prostituted, madmen), still
life and bodegones (humble scenes), inanimate figures
(mannequins, wax figures, masks, devotional figures),
religious processions and flagellants, eschatological sub-
jects (deathbed scenes, convent ossuary, torment, murder,
execution), and, in general, a macabre picture of death
in life. The "literary content" of his paintings as a
statement about man's condition and mortality makes him a
highly "literary painter." Barrio-Garay carefully stud-
ies Solana's pictorial and literary work through differ-
ent periods of his life and gives us valuable insights
into how the artist achieved his original expression of
"disquieting reality" within the costumbrista tradition
of depicting mores and customs (3).

The bibliography of books, chapters, and articles
about Solana himself, his tetrical vision of Spain, his
relationships with members of the Generation of 1898, and
the nature of the grotesque in his paintings and writings
is extensive. The last two subjects have been open to
discussion, but one thing that all critics seem to agree
on is that for Solana "to paint or to write is one and
the same thing: both signify life," a statement he made
ironically when he had stopped writing, in 1944, shortly
before his death (4). The themes, titles, and even the
colors of his writings and paintings are notably inter-
changeable; the degree of correspondence between the two
modes of expression is extraordinary.

The Visual and the Visionary in Solana

Solana is generally considered a descriptive writer,
capable of awakening emotions in the reader, but essen-
tially attentive to what the eyes can see. José Moreno
Villa, who knew him personally, says that "one notes that
the writer is a painter, a painter who observes meticu-
lously" (5). This is probably what makes him a master
costumbrista in a descriptive genre cultivated in
nineteenth-century Spain by Ramón de Mesonero Romanos,

Serafín Estébanez Calderón, and Mariano José de
Larra, who sometimes fictionalized situations to depict
traditions of their time more graphically, each with the
imprint of his own particular tone and vision of life.
Solana is above all in his writings the observer, but
he selects subjects and details that focus upon the most
negative aspects of life, with the result that he has
most often been considered a realist, albeit an
"expressionist-realist" or a "disquieting realist."
Flint categorically asserts, "Nowhere in his writings
does Solana permit himself the free play of imagination
necessary to create the fantastic, but he discovers it as
already existing in the form of masks that are grotesque
creations derived from a normal human body joined to an
immobilized and deformed face—sometimes an animal face"
(6). Gregorio Marañón offered a reply to Cela's afore-
mentioned speech to the Spanish Academy (which spoke of
Solana's ideas and "figurations") that also seems to deny
the presence of fantasy, for he finds that in contrast to
Pío Baroja who "created a world with his fantasy,"
Solana "could only create with the limited material that
his implacable eyes captured, that only saw that which we
men do not see in passing because we have learned in many
centuries of civilization not to see the sinister except
when we look for it" (7). It would seem that for some
critics Solana's peculiar expression of the grotesque is
more a matter of selection than invention.
 Barrio-Garay quotes a review by Guillermo de Torre
entitled "Realismo y superrealismo" (Realism and Surreal-
ism) which appeared in El Sol, March 8, 1936, and is
especially revealing in that the critic evidently per-
ceives something in Solana that most others refuse to
recognize. He is not particularly attracted to the real-
ism of the artist's paintings but precisely to what is
not realistic in his work:

> I prefer other virtues less explicit: his escapes
> from reality, his jumps to the absurd, his possible
> frenzy of the imagination. Because of this, his more
> imposing paintings—some processions, ossuaries—are
> those which come closer to the super-realist aim of
> the disparate and the nightmare. It is not a matter
> of asking something new of Solana, an artist who has
> given so much, but we would like that violence of his,
> that withholding of the imagination to go unbridled
> into the absolutely imaginary. Only in that way will

his art remain situated on a genuine expressionist plane. He has more than enough of thematic violence and constructive command; now he may place the accent on the imagination to go beyond the realism of the event. (8)

Guillermo de Torre is speaking here only of Solana's paintings, but many aspects of both the writings and paintings which show that the artist's creative faculties include the imagination and fantasy may not have been noticed because of the traditional association of negative themes and eschatological subjects with the then still-recent effects of late nineteenth-century Naturalism, based on objectivity, observation, and selection that tended toward the negative.

A careful scrutiny of Solana's paintings and writings reveals that a great deal of what he appears to register as simple visual observation is actually the result of an imaginative projection of "visionary" images incited by his fancy. His ability to "see" the skull peer out, barely hidden by the outer cover of life in the human face, and sad parodies of life in inanimate mannequins, orthopedic devices, wax figures, clothes hanging on a line, and dolls which ironically may last longer than a real person, involves much more than just the exercise of vision. Cela rightly affirms that Solana is "not logical but illuminated, possessed" (9). For us what is most extraordinary about his art is that while it appears to be a realistic rendering of what he saw with his eyes, it is in fact a hallucinatory view of what he saw with his heart, his own vision of "reality." If Quevedo was able to make his Sueños (Dreams) seem like real adventures for the reader, Solana on the other hand is able to make his real adventures seem like dreams, nightmares, and hallucinations.

The artist's writings and paintings provide very clear examples of a hallucinatory nature which are unreal in the sense that they depict what the eye cannot see and are taken from the imagination rather than from observable reality. Paintings of this sort include The Burial of the Sardine (1912), The War (1920, the same year his Black Spain was published), and a number of later works done from 1929 to 1932 after Solana had stopped publishing his writings: Death's Procession, The Mirror of Death, Still Life of the Final Judgment, and The End of the World.

A brief description of two of these paintings will
give some idea of Solana's imagination. Death's Proces-
sion displays prominently a skeleton that presides over
a ghastly procession while two hooded penitents carry
tiny coffins with skeletons in them. Signs read "memento
mori" and "pulvis, cinis, nihil" ("dust, ashes, noth-
ing"). Skulls wear a king's crown and a bishop's miter.
The dominant tonality is dark, with black, ochers, and
reddish tones.

The "mirror of death" featured in a painting of that
title, also appears in The Bishop's Visit and Tertulia
of the Café Pombo, where it is more a mirror of time.
In The Mirror of Death it is placed between the two
main figures, framed in skulls and bones, showing abso-
lutely nothing, as may be expected, in its reflective
surface. To the observer's left a female figure whose
arms are grotesquely elongated places a huge skull in an
open box upon whose edge a child's skeleton is seated.
On the right another figure appears half in the flesh and
half as a skeleton. Two severed hands, one masculine,
the other feminine, clasp in the foreground.

The moments that might be considered parallel to these
fantastic paintings in Solana's writings are likewise
relatively few but constitute some of the most unforget-
table episodes in his books España negra (Black Spain,
1920), Madrid callejero (The streets of Madrid, 1923),
and Florencio Cornejo (1926), the last work he pub-
lished, and París, possibly one of the last things he
wrote. Such moments do not occur in separate composi-
tions but rather within the pages of his more usual
costumbrista works. In any case they provide examples
of Solana's ability to create, not only to observe.

The most outstanding of such writing is the prologue
of España negra (Black Spain), employing a genre culti-
vated imaginatively by Gonzalo de Berceo and Cervantes—
the prologue. Flint, in spite of denying Solana's
imaginative faculties, calls the prologue "a fantastic
and grotesque dream" (10). The author, in direct conver-
sation with the reader, speaks of having announced six
years before a more than fifteen-year-old project of a
book entitled Black Spain, but having almost completed
it, he noticed that the principal thing was missing,
notably the prologue. He wonders whether he will be
capable of writing it, for he dislikes the idea of asking
someone else to do it for him. A chilling voice warns
him that he will not see his book published because edi-

tors, booksellers, and academicians are idiots. The
"other" admonishes, "But I see you looking bad; your
health is very sad; each day you drink more wine, more
beer, more alcohol and smoke more, and the day you least
expect, you will 'crack,' like an old book; in short, you
will see; the best you can do is go to bed early and take
care of yourself" (11). These words have come true, he
tells the reader, "I think I have died."

The dead author laments that his book will have no
prologue. He describes his coffin and his corpse lying
within it. His eyes are closed but he can smell the wax
candles burning and can see and hear outside noises. His
jaw is clamped shut with a handkerchief tied about his
head which prevents him from moving or making a sound.
He feels the veins in his temples resound to the beat of
an old clock in the room, which fills him with utter hor-
ror. He perceives through the glass of a long black case
the presence of a scornful and almost human smile on the
face, white and brilliant like that of a clown, of a
"primitive virgin" he has known. The wind pushes over a
candelabra and he feels panic at the threat of being
burned but cannot move no matter how he tries. Suddenly
a grotesque little man who resembles a dwarf grabs him
out of the coffin, removes the handkerchief, and stands
him up as if he were a doll, berating him for not being
ready, at the same time as a funeral car arrives to take
him to the cemetery of "illustrious men." The small
intruder knocks over the priest and old men who come to
mourn and, against the insistence of the funeral direc-
tor, shakes the author until he regains consciousness,
and having saved him from being buried alive, puts him to
bed. In the morning the author finds his clothes filled
with dust as if from the cemetery and prepares to go back
to sleep, but a curtain rises and a little man gets him
up. Shortly afterward he finds himself aboard a train to
Santander, feeling gratitude toward the man for getting
him on his way.

There are three separate incidents of going to sleep
in the prologue, the first when the author feels himself
lying in the coffin, the second when he is put to bed
afterwards by the dwarf, and the third when he is again
about to go back to sleep the next morning and sees a
curtain rise. It is curious that the detail of the
rising curtain is repeated in his nightmare in Oropesa,
later on in Black Spain. In the Oropesa nightmare a
curtain goes up and the silhouette of the town, which had

seemed before "of great beauty and fantasy," moves toward him threatening to crush him. He sees it pictorially, in two dimensions; as if stuck to a sheet, it "looked painted" (p. 389). He sees dark-hooded and masked people with laughing, scornful gestures, then a procession of penitents and poor people (very much like the subjects of many of his paintings). Then he sees the boots of civil guards, their ears—for they have no eyes, and then their noses and fingers which at first appear separated and afterwards join the figures as if by magic and point rifles at him "as if I were a terrible criminal." The random appearance of human figures recalls the act of painting which also requires that each detail be done separately, so it may be said that he "paints" the intimidating guards in fragments that finally articulate themselves into a frightening vision.

These visions of death and threats of self-destruction are not at all visual testimonies of observations or realities. Perhaps if Solana did not allow himself more of these visionary moments which Guillermo de Torre appreciated in his paintings, it is because of Solana's fear of madness, which afflicted his mother and which he feared was hereditary. It was a reason why neither he nor his brother ever married. It may be that he made an effort in his writings not to let himself go imaginatively lest such loss of logical control encourage a tendency toward madness he felt so present. Maybe he only permitted himself the luxury of giving vent to his fantasy in the form of what can be explained as nightmares. Yet there are other instances of invention in his writings that are more subtle in that they present themselves in the form of comparisons or similes. He describes watchmen in Segovia with their cloaks and pikes as "ghosts, whose lanterns are luminous eyes that project, on the ground and on the homes, luminous circles" (p. 374) and views Avila "closed and walled as if separated from the world, like an immense sepulchre" with clouds stuck to its houses (p. 384).

The reader becomes so accustomed to expressions like "I saw" or "I see" throughout Solana's books that he may take it for granted that he is referring to only what his eyes register, but just as Ezekiel saw the wheel, Solana likewise "sees" some very strange sights. Sometimes his vision transcends time, projecting into the past or the future. In Black Spain, for example, he gives us a conventional "realistic" description of the president of

the Audiencia ("tribunal") in Medina del Campo as a tall old man who drags his feet but then he goes on to imagine that "this old bird, bald and with white sideburns, is asking for a coffin, very long and tight, made for his mummy, and after his death his old frock coat, sold to a rag dealer, may end up in the hands of the town money-lender who will take as much of a liking to it as the dead man, since it was like his skin" (p. 351). Certainly there is nothing before the eyes of an observer to warrant this fanciful conjecture about the man's future death, except that for Solana, as for Quevedo, "all things speak of death." In the Patio of Arms of the same town, filled with ruins, again Solana's imagination takes over, this time to re-create an auto-da-fé held in 1559.

The epilogue to Black Spain also contains an element of fantasy in the "prodigious mirror of Pombo, this cine-matographic mirror" situated in the café where Solana attended the tertulias ("social and intellectual meet-ings or get-togethers") presided over by Ramón Gómez de la Serna and depicted in one of his most famous paint-ings. He says the glass of the mirror changes its expression constantly revealing scenes from the era of Larra or visions of streetcars and automobiles. It is a mirror of time, he affirms. Gómez de la Serna was impressed by "the ingenious Solanesque blow in those ancestors who appear in the depth of the mirror" in the painting; the verbal description of the mirror is no less impressive (12). Also in this epilogue Solana pictures Daumier in his mind. "I see him," he assures us, in his description of the French artist's arriving home after a night of hard work and getting into bed.

The objects and their possible meanings or symbolism both in Solana's paintings and writings have been discussed in numerous books and studies but have not been resolved, probably because they respond to irra-tional, unconscious, and inexplicable impulses as the products of his imagination. What is called mysterious, disquieting, and hermetic in his work is basically that which cannot be explained logically in terms of realism. In fact, much of the discussion about the functions of wax figures, dolls, robots, masks, and other representa-tions of the human figure strikes us as being an attempt to find meaning and purpose behind those things that many critics find grotesque, others "disquieting" (Barrio-Garay) or "mysterious and disturbing" (Flint), but that

are not about to yield any explanations to an intellectu-
ally logical analysis.

Self-portraits in Prose and Picture

A constant in Solana's writings is the presence of the
author-guide who leads us on journeys through towns and
villages, fairs, processions, carnivals, and wax museums.
Most of the time the singular or plural first-person nar-
rative suffices to give the impression of the author's
presence as he directs our eyes toward the sights he
finds interesting. Sometimes, however, Solana gives us
intimate glimpses into his personal likes and dislikes,
way of life, and oneirical experiences. These literary
self-portraits, as may be expected in an artist whose
writings and paintings are so closely related, have their
counterparts in some of Solana's paintings of himself.
In Madrid. Escenas y costumbres (Madrid. Scenes and
customs) he tells us in a sort of introduction to a chap-
ter describing a visit to "the dissecting room" that ever
since childhood he felt a certain attraction toward what
people generally consider horrible, such as accident
scenes, hospitals, and the morgue. This attraction was
initially stimulated by some unfortunate scenes to which
he was an involuntary witness but it later developed into
a morbid curiosity to see such sights.
In the prologue to Black Spain, as we have seen,
Solana pictures himself caught in the helpless immobility
of death. This vision has its counterpart in his strange
Self-portrait executed twenty-three years later, in
1943, shortly before his death, in which he is posed with
a mannequin "family." His pale, motionless face, eyes
wide open in a rigid frontal stare, is less lifelike than
that of the mannequin "wife" at his side and that of the
mannequin "daughter" upon whose head the painter rests
one hand while holding a palette in the other. In compar-
ison with a younger self-portrait included in Cela's book
in which the artist appears alive and well, and even with
the somewhat stiff figure seen in the Café Pombo pic-
ture, this Self-portrait appears to be a death mask.
Juan López Ibor noted in the Self-portrait that the
left half of the face is filled with the primitive vio-
lence of the insane while the right side expresses fear
and anxiety in facing the other half. Barrio-Garay
speaks of Solana's search for "that permanence which

Solana: *Self-portrait*, collection Emilio Botín Sanz de Santuoia y López, Santander; from José-Luis Barrio-Garay's *José Gutiérrez Solana, Paintings and Writings*, courtesy of Associated University Presses, Inc.

shortens the distance between passing life and still
life" expressed in the stiffness apparent in the Pombo
figures and in Self-portrait (13). Here the painter's
visage is absolutely still and immobile as if he too were
a mannequin with an empty stare, reminding us of the self-
vision in the prologue to Black Spain.
That Solana was prone to imagining himself dead not
only literarily but also pictorially is further evidenced
in his Still Life of the Final Judgment, which accord-
ing to Barrio-Garay is a macabre self-portrait in the
form of a skull. The same critic sees autobiographical
content in Maker of Masks (the glasses and ever-present
cigarette are Solana's as is the vocation of mask maker),
in the floor covering and furniture from the artist's
home in A Visit of the Family which contains a portrait
of Solana as a child, and in the hidden head of the
artist formed by the folds of the pillow upon which the
Girl Asleep rests her head. Done in the tradition of
the "hidden portrait," an extremely popular genre during
the eighteenth and nineteenth centuries, not only is the
"savage" Solana present in the painting, but also the
heads of his brothers as Manuel Sánchez-Camargo, a
biographer of Solana and owner of the original painting,
pointed out (14). It may be, too, that the mask that the
Maker of Masks is working on is also a death mask of
Solana, so that the mask maker painted by him is in turn
painting him.
There are a number of fascinating self-portraits in
Solana's writings in which he not only imagines himself
threatened by death or in a similar state, but also fan-
cies himself in future old age. A sort of double self-
portrait appears in the 1926 novel Florencio Cornejo,
which begins with his recalling a time in the past when
he was staying in the old family house almost in ruins,
alternating reading with working in the garden, trout
fishing, and listening to the noises of the rats in the
house. He describes the living room where he sought
refuge when it was stormy, filled with souvenirs—wax
figures, rag dolls, and such—of his Uncle Remigio. He
haggles with his "horrible" and disagreeable servant
named Gila (reminiscent of the Gila monster), who accord-
ing to José Moreno-Villa's testimony was in real life
every bit as horrible-looking as Solana would lead us to
believe (15). To end the argument he jumps into bed.
The author later portrays himself before the fire, smok-
ing, when a message arrives directing him to go to his

relative Florencio Cornejo's bedside, so he sets out on the journey and witnesses the death of Cornejo. The novel ends with an epilogue when "years have passed" and "the author of this book looks very old and ailing, and for the worst of evils, a syphilitic chancre has come out; now near the advanced age of seventy years, his head is becoming bald like a cheese and he doesn't have even one tooth . . . The ancient writer only gets along thanks to stuffing himself with wine" (p. 653). The novel is dated February 1926, when "the ancient writer" was only forty years old. What he has done is project himself in time, imagining his appearance and physical ills in old age, approaching death. In the bald, toothless head is the suggestion of a skull, the same skull that represents him in the painting Still Life of the Final Judgment.

In Black Spain Solana is very conscious of his aging. In Oropesa he says that a barber left him looking like an old man (p. 398) and the epilogue registers some aging: "After this long trip I find myself at home at last, a little tired, looking older, some gray hairs shine on my temples and it seems like youth wants to take leave of me" (p. 452). The book was published when Solana was only thirty-four years old! In both Black Spain and Florencio Cornejo the author observes himself in future old age, wracked by the miseries which he has observed in others and now attributes to himself, carrying out the terrible decree that captions his drawing of a skull filled with worms: "Today me, tomorrow you."

Another interesting self-portrait may be found in the prologue to The Streets of Madrid. Here Solana is fictionalized in a sort of "hidden portrait" in a personage he calls "the master" who as he prepares his mule for work on a bitter cold day ponders "the instability of human things in which we are no more than perishable dust" (p. 463). He launches a diatribe against the Generation of 1898 and the Spanish Academy without mentioning names for fear of losing his place in the Pantheon of Illustrious Men "where I lie per insoecula soeculorum, as can be seen if some idiot doubts it, in my book Black Spain" (p. 465). He also speaks out against the Cubists, Futurists, and Dadaists of the new generation and explains that since "no one knows where he is going, the master has said that he must write a book to channel a little this crazy and rebellious youth that can, if it continues on this road, hit its head on a manger" (p. 465).

While Solana generally maintains the role of author-guide outside of his prologues and epilogues, he sometimes takes a more active role and recounts experiences of a personal nature, not only dreams, but also "adventures" in contact with people he observes in <u>Black Spain</u>. In the town named Tembleque he sees a ragged man who rests his bald head on his belly and kisses his hands. Noting the man's incoherence, the author realizes his need and helps him to lower his pants and relieve himself, as if he were a small child. "'How can this man be helped?' I said to myself; I will take him to an asylum; no, it cannot be; I will take him with me; no, I am a traveler; 'What can be done?' I said. And a voice answered me: 'Continue on your way; you might find yourself the same way one day in the future'" (p. 406). This is followed by a meeting with a disappearing trumpet player.

The two adventures in which the author participates personally may or may not be authentic. In any case they take on the air of being symbolic encounters with the visionary specter of his own helpless old age and with a trumpeter who could be the one who summons the dead for the last judgment.

Solana is basically a descriptive writer but his encounters with the grotesque are not always representative of realism, since his imagination influences what he "sees." His "visionary" exercise of fantasy and penchant for portraying himself as either decrepit or in a death-like state seem to respond to what was evidently an important preoccupation for Solana: the summons to which he would eventually have to answer and which he repeatedly visualizes in his writings and paintings, the "still life of the Final Judgment."

Chapter Five
Writing and Drawing Poetry:
Federico García Lorca

Lorca was a many-talented artist whose astonishing versatility revealed itself in poetic, musical, amd pictorial creation. He began sketching as a child and painted decorations for his own puppet shows, maintaining close friendships with painters, among them José Caballero, José Moreno Villa, Gregorio Prieto, and Salvador Dalí. The latter encouraged him to exhibit in 1927 twenty-four of his drawings in the Dalmau Gallery in Barcelona, an event attended by a distinguished group of artists and intellectuals (1). Lorca's work was praised by the respected art critic Sebastián Gasch, who invited him to submit drawings to his magazine L'Amic de les Arts, published in Sitges. After Lorca's tragic death in 1936 interest in his writings naturally overshadowed his image as an artist. Gregorio Prieto, however, who collected his drawings, wrote about them as early as 1943, but although over fifty samples of Lorca's art work appear in the 1973 edition of his Obras completas (Complete works) and others have been shown in recent books and articles, this aspect of his creativity has attracted limited critical attention and is seldom treated in relation to his literature (2).

Lorca's letters to the Catalan critic Gasch during the years 1927-28, when he produced many of his drawings, reveal some interesting facts about his own view of his art work, which he considered very personal and private. It seems to have been an alternative to writing: "When a matter is too long or its emotion is poetically trite, I resolve it with pencils. This pleases and entertains me enormously." (3). Gasch sent Lorca essays for his magazine El Gallo Sultán and the latter in turn sent him drawings for his art magazine, encouraged by Gasch's estimation and finding in him an understanding critic. In one letter written in 1928 Lorca announces that he is sending some art work and adds, "you are the only person with whom I do this because I feel understood by you . . . My drawings appeal to a very sensitive group of people but are little known. I have not worked on repro-

ducing them and they are for me something private"
(2:1212). In other letters he acknowledges that without
the encouragement of the Catalans, he would not have
continued sketching. He considered the project of edit-
ing his drawings in Barcelona in book form with poems
interspersed, accompanied by drawings and poems by Dalí
and a prologue by Gasch. He tells his friend that such a
book would be "a precious book of poems" and asks him to
keep the drawings he sends him for publication in
L'Amic as a gift. In that way, he jokes, "you will be
making a collection of little trivialities" (2:1219).

Even without the stimulus his Catalan friends provid-
ed, it is likely that Lorca would have continued drawing,
but probably without aspiring to exhibit or publish his
work, for he very spontaneously illustrated his own texts
and letters and notes to his friends with scrawled pic-
tures of fruits or flowers, some of them tied in with his
signature, others as if they were designs decorating the
stationery. Gallego Morell observes that in this type of
pictorial activity Lorca was impelled by literary stimuli
or simply by feelings of friendship. When he gives his
Romancero gitano (Gypsy Ballads) to Emilia Llanos, he
adds two colored drawings without the least artistic
pretense, "more like a hug or a kiss on the cheek" (4).
In any case Lorca went beyond purely personal and private
art when he made his public debut as an artist in his
1927 exhibit in what was the art capital of northern
Spain, Barcelona, and he felt sufficiently self-confident
to consider publishing his drawings, although not without
the support of his poems. He tells Gasch in a 1927 let-
ter that he writes and draws poetry; he obviously does
not distinguish between the poetry he creates in words
and that of his drawings. He was right; both would have
formed a wonderful "book of poems" but it never material-
ized.

Lorca's Childlike Primitivism

The first serious study of Lorca's literature in the
light of his activities as a painter was done by Gregorio
Prieto, himself an artist, who points out pictorial ele-
ments present in the poetry but finds Lorca's artistic
technique inadequate to express his meaning in drawings.
Comparing Lorca's colored sketch of the Virgin of the
Seven Sorrows to his poem "Procesión" ("Holy Week

Procession"), he praises the poet's clear mastery of his material while affirming that "the drawing has no such mastery, but it has poetic feeling; it is the work of a painter who has inspiration but little skill." Prieto says that Lorca's poetry and painting show the influence of the postwar artistic movements and that Impressionism, Cubism, neoclassicism, etc., may be found in his poetic imagery. Prieto prefers those drawings of Lorca "in which he forgets about schools and puts down, with child-like innocence, whatever comes into his fancy, as if he were secretly escaping into the world of his dreams," yet criticizes his later drawings as too modernistic, belonging "to the period when Surrealism exercised a strong influence on many painters and poets." The mode of expression is then affected and confused, as in the illustrations to Poeta en Nueva York (Poet in New York), but Prieto does not comment upon how these respond in fact to the Surrealistic expression in the poems (5).

Prieto prefers the drawings of Lorca done "with child-like innocence" yet accuses him of technical inadequacy, which is the most common characteristic of childlike expression. To a skilled craftsman of painting it might appear that stylistic ingenuousness indicates a lack of ability, but, on the other hand, it may very well be—as we are convinced it is in Lorca's case—intentional. In one drawing included by Prieto, Legend of Jerez, the figures are full front but the feet point sideways like ancient Egyptian figures (6). Perhaps Egyptian influence is present also in an untitled drawing of numerous pyramids behind a stiff, fettered figure with eyes closed while fanciful free-form figures dance on the tops of the pyramids.

Gallego-Morell sees great charm in Lorca's "childlike technique, his simplicity, his elemental sense of composition," characteristics that he finds present in his art even before coming into contact with Dalí and Surrealism (7). Primitive techniques are visible in the very elemental rendering of eyes and other features solely by line, the seeming lack of regard for symmetry or perspective, four- or six-fingered hands (in Only Mystery Makes Us Live and Angel, respectively), and the uneven application of colored pencils or crayons in outlined areas— all of which remind the observer of children's art. Whether this primitive quality that seems so natural in Lorca stems from inability or from intention is yet anoth-

er matter, but certainly the artist could have drawn a
five-fingered hand if he wanted to.

In this sense it is interesting to note what Juan
López-Morillas calls Lorca's "lyrical primitivism" in
his poetry, especially in <u>Gypsy Ballads</u>:

> An imaginative and ingenuous man, his eyes open before
> the world as before a brilliant cascade of spontaneous
> forms. He is free from the intellectual insistence
> upon changing the nature of reality, upon reducing
> nature to the lines of a preconceived structure. He
> couldn't care less about what the metaphysician and
> the scientist call "natural order." He has the simpli-
> city and impulsiveness of the child, and we would
> almost dare to call him <u>puerile</u> were it not for the
> pejorative connotation that often accompanies this
> word. (8)

According to López-Morillas, Lorca is attracted by the
spontaneous and the concrete, by the figure of the gypsy
which represents for him the <u>enfant contrarié</u> ("vexed
child"), the primitive myth against modern civilization.

In the poet's concrete visualization of the elements
we are reminded of the child's tendency to depict the sky
as a strip of blue far above the ground, as Lorca does
also, "Through the blue path, / tamer of somber / stars /
I shall continue my way" (<u>Curva</u> ["Curve"], p. 698). He
often sees the wind as something concrete and solid, or
in colors as arbitrary as those children sometimes
choose, in "Tres historietas del viento" (Three anecdotes
of the wind) where it is red, green, violet, and yellow.
Another technique suggesting childlike tone is the poet's
frequent use of diminutives, which might find its explana-
tion in his essay "Granada":

> Granada loves the diminute . . . The diminutive has no
> mission other than that of limiting, enclosing, bring-
> ing to the room and putting in our hand the objects or
> ideas of great perspective.
>
> One limits time, space, the sea, the moon, distan-
> ces, and most prodigiously, action.
>
> We don't want the world to be so large or the sea
> so deep. There is a need to limit, to domesticate
> immense terms. (p. 936)

The pictorial artist also tries to capture life-size

objects in a limited space and enclose them within the confines of his canvas. The same feelings communicated by the diminutive, by infantile repetition, and by schematic simplicity that reduces reality to only the most essential lines are transmitted by the childlike stylization of Lorca's drawings as well as by his poetry.

López-Morillas relates Lorca's primitivism to violence, that of the bloody episodes and images present in so much of his writing, Bodas de sangre (Blood Wedding), Gypsy Ballads, and Poet in New York, to mention only a few. This too is evident in his drawings Bandolero (Highwayman), where the hands resemble hooves or claws; Degollación (Throat-cutting); the tortured saints Sebastián, Joseph, and the Virgin of the Seven Sorrows; Cut-off Hands, replete with falling drops of blood and lines suggesting ropes, and Rua das Gaveas, in which only one such hand appears. Perhaps these hands are somehow related to the "poem for dead people" entitled "Omega":

The grasses.
I shall cut my right hand.
Wait.
The grasses.
I have a mercury glove and another of silk. (p. 784)

Arrows, dangling eyes, and tears give additional evidence of violence in Lorca's drawings.

Lorca as a Colorist

Gregorio Prieto's previously mentioned study of Lorca almost entirely focuses upon his use of color in his poetry. Prieto points out that Lorca names colors even when it is unnecessary or redundant (calling trees green, milk white, and lemons yellow). While color is perhaps the pictorial aspect that most easily lends itself to analysis or conjecture in the artist's poetry and painting, it is not necessarily the mark of a painter who writes since so many poets are verbal colorists without being painters.

In his study Prieto cites green as the poet's favorite color—associated with the olive-skinned gypsies, followed by red (or crimson, carnation, or raisin-color), then yellow which "disguises the red wounds with its

cheerful tone." In addition to the "strong positives" of green, red, yellow, black, and white, Prieto finds sober colors which set off a multitude of "smiling shades" and half-tones. Llanto por Ignacio Sánchez Mejías (Lament for Ignacio Sánchez Mejías) is constructed only with white, black, and red.

In a highly original and fascinating examination of Lorca's play Así que pasen cinco años (When five years pass), E. F. Granell, himself a painter and writer, finds that the poet's use of color in that work is quite Expressionistic in that yellow, the color of a macabre and grotesque mask, is a "mortal cry of desperation" when the green of hope is fragmented into its blue and yellow components, signifying the destruction of that hope. According to Granell, "in Lorca's whole poetic creation colors sparkle. Green predominates" (9). The drama is principally sustained in black, white, and red, with the latter color visible in blood, letters, a fan, suit, handkerchief, chest, throat, hands, and moon. There are white and black suits, shoes, silk ribbons, handkerchiefs, gloves, faces, hands, capes, braids, fans, desires, roses, a crown, screen, and landscape. Blue represents the fleeting air, the firmament, and water. White, which Prieto says Lorca usually associates with purity, pretty girls, and the happiest visions, in the play becomes the color of the shroud and of death as Granell points out.

Lorca's colors, then, are not always static in their significance, and while the bright clear colors like red and green are impressive in his poetry, much of his earlier poems have a heavy dose of gray. In his colored drawings the tones are clear, definite, shades of yellows, reds, blacks, blues, browns, grays, and greens, but he uses color sparingly, to fill only some spaces, and in some pictures he prefers to use a pointillistic technique, short lines, longer strokes, or dots to fill outlined forms and suggest texture at the same time. Red and black almost invariably fill space tightly and evenly, heavily applied; other colors usually are applied with only the point of the crayon or colored pencil in short strokes that do not overlap so that the paper shows through.

The use of color is not always unusual and in fact may help identify a spherical form as a lemon if it is so colored. Trail of a Wasp in My Room, however, is distinctly Fauve in its arbitrary coloration, largely in

purples and golds which obviously do not intend to re-
flect reality, as in Lorca's poetry where a woman's voice
may be purple and the wind just about any color other
than blue (10). His illustrations of settings or charac-
ters for his dramas are more realistic in their colora-
tion, which corresponds to visual effects he wishes to
suggest. In general it may be said that color is no more
ubiquitous in Lorca's drawings than it is in his poetry.

Lines and Threads

Lorca's pictorial works are fundamentally line draw-
ings in ink on white or colored paper, occasionally
serving somewhat like a child's coloring book, to be
filled in with colored pencils or crayons, at least in
part. The lines are single ones and there is no evident
attempt to retrace or correct. The execution of so many
drawings by means of one single line which meanders about
the paper until it begins to take some discernible form
suggests the reliance on chance or automatic creation
characteristic of the Surrealists. These drawings may be
considerably more Surrealistic than his writings of the
same period, for he wrote to Sebastián Gasch in 1928
that he considers his poems more "spiritualistic" than
Surrealistic in that he allows chance to enter and elimin-
ates logical control but retains what he calls "poetic
logic." "It is not Surrealism, be careful!" he warns,
"The clearest consciousness illuminates them" (2:1219).
Such increased control is not evident in those sketches
that appear to be a combination of automatically traced
lines illuminated somewhere along the way by the discov-
ery of a form or subject which then may be embellished by
symbolical elements or a verbal title. In any case, the
posterior illumination of an initially unconscious
impulse is not at all uncommon in Surrealism in practice,
although André Breton in his First Manifesto of Surreal-
ism specified that reason should be limited to register-
ing and appreciating the luminous Surrealist phenomenon
arrived at by unconscious means.
 The continuous line becoming forms may be observed in
Lorca's sketches, Lyre, Angel, Cut-off Hands, and
The Eight in which the major part of the drawing is
realized in a single line, the title evidently suggested
by the uneven form resembling an "8" to one side. With
lines zigzagging about one another, additional eights are

formed. One must search for the Bird and Dog of the
drawing of that title since the animals appear only
incidentally and in relatively small size, perhaps by
accident rather than design. It may be that in Urban
Perspective with Self-portrait the idea of the self-
portrait was an afterthought to fill a balloon-like
circle which emerged at the center in a loop formed by
the continuous line.

Line functions as a unifying factor connecting dis-
perse forms into one configuration, holding the composi-
tion together much as plot functions as a linear element
in literature. J. M. Aguirre speaks explicitly of a
"narrative thread" in Lorca's "Romance sonámbulo"
("Sonambule Ballad") (11). In his poems as well as in
his plays there is generally a thread, be it a plot, an
emotion, an episode, or a person, connecting the elements
of the composition. In his more Surrealistic works the
thread meanders, as it does in his pictures, but it is
always there. Lorca actually seems to see things linked
by linear threads, not only in his sketches, but also in
his poems: "The merry-go-round whirls / hanging from a
star" (p. 277). In "Prendimiento de Antoñito el Cambo-
rio" ("The Taking of Antoñito el Camborio") he sees the
afternoon hanging from a shoulder and in "Herbarios"
(Herbaria) he sees the night hanging from the sky. The
breeze also takes linear form: "The breeze / is undu-
lated / like the hair / of some girls" (p. 665), and this
can be appreciated in Lorca's drawings where hair is
represented by undulating lines emanating from the heads
of his figures.

Lines achieve several interesting effects in the draw-
ings. Lorca uses broken or dark lines to express move-
ment of an object similar to the way this is done in
comic strips. In the colored drawing Trail of a Wasp
through My Room a strongly traced line marks the trajec-
tory of the yellow wasp seen in two places, where it
started out and where it rested. The double view of the
wasp joined by the line of its movement communicates
dynamism and simultaneously a sense of time lapse other-
wise difficult to transmit in a single picture. In other
drawings dotted lines indicate the movement of leaves
falling to the ground or tears flowing from the eyes of a
clown. This desire to render movement and action pictori-
ally recalls many scenes from Lorca's dynamic plays and
poetry.

By means of line Lorca shows one form behind another

as in <u>Love</u>, where the two superimposed faces coincide at the lips, and in <u>Legend of Jerez</u>, where a shaded figure rendered in broken lines embraces another. Both pictures find a literary parallel in the poem "Confusión": "My heart / Is it your heart? / . . . Everything is a crossroads" (p. 637). Not all forms that emerge from the spontaneously meandering lines are recognizable. Sometimes a delicate line simply occupies space without defining an object or it produces a fanciful form. Lorca is obviously not preoccupied with copying nature but rather with allowing his imagination or subconscious mind to express itself through the instrument of line. This was so much a part of him that often the same lines that form the initials of his name go off on their own to trace loops and designs that fill the page.

Lorca's Iconography

It is a well-known fact that Lorca employs certain images and objects insistently in his works; many of these appear also in his drawings. The horse, for example, ancient symbol of passion, instincts, and the male rider, is repeated in his writings. J. M. Aguirre relates the symbol in Lorca to Jung's view of the horse as representing the nonhuman psyche, the animal drives, and he cites such poems as Lorca's "Burla de don Pedro a caballo" (Deception of Don Pedro on horseback), "Reyerta" (Brawl), and "Diálogo del amargo" (Dialogue of the bitter man) among others (12). Horses are present in the drawing <u>Urban Landscape</u>, a highly unlikely place to find horses, among skyscrapers in the big city. Strongly colored in black, they suggest a symbolical conflict between civilization, represented by the buildings, and primitive passions, while in the middle is a schematic self-portrait recognizable by the thick eyebrows and wisp of hair. Civilization is further suggested by the windows in one building which are letters of the alphabet from the world of books and words, as in the poem "La sombra de mi alma" (The shadow of my soul), written in 1919 in Madrid:

> La sombra de mi alma
> huye por un ocaso de alfabetos
> niebla de libros
> y palabras.

> (p. 32)

> The shadow of my soul
> flees through a sunset of alphabets
> mist of books
> and words.

Another symbol that appears frequently in Lorca's drawings and in his writings is the flower, particularly different types of lilies. Pictured in vases, they are a well-known symbol of the Virgin Mary. In a number of sketches flowers resembling Easter lilies hang downward with their long slender stamens exposed, suggesting the same "stylized eroticism" Lorca finds in the Polifemo (Polyphemus) of Baroque poet Góngora: "One might say that he has a floral sexuality. A sexuality of stamen and pistil in the exciting act of the flight of the pollen in spring" (p. 1021). The slender exposed filaments of the drawings with their anther tips that emit the pollen to fertilize the flower are probably related to the same type of erotic imagery in the 1919 poem "Madrigal":

> Y se abrió mi corazón
> como una flor bajo el cielo
> los pétalos de lujuria
> y los estambres de sueño

(p. 115)

> And my heart opened up
> like a flower under the sky,
> the petals of lust
> and the stamens of sleep.

The same lily-like flowers appear in several drawings of sailors in which they are depicted falling from one eye, suggesting both violence and the erotic. Circular sailor hats with a doughnut-type hole in the center exhibit ribbons flowing outward which are similar to the stamens of the lilies.

Sailors are repeated again and again in Lorca's drawings, although they seldom are found in his writings. Exceptions include the poems "Dos marinos en la orilla" ("Two Sailors on the Beach") and "Canto nocturno a los marineros andaluces" (Nocturnal song to Andalusian sailors), and the short play La doncella, el marinero y el estudiante (The maiden, the sailor, and the student), of

Lorca: *Only mystery makes us live,* from *Obras completas,* 2d ed, courtesy Aguilar, S. A. de Ediciones, Madrid.

erotically suggestive dialogue. In the pictures they are usually found before a tavern or balcony and they face full front. Lorca, although fond of curving lines, employs sharp angular forms to draw his sailors, related to the masculine imagery of knives, spurs, and horns in his writing. Knifelike shapes in Eye and Burrs and Still Life are notably phallic.

Arrows are one of the most frequent elements of Lorca's iconography, not only in his poetry but also in his drawings. Related to violence in "Poema de la Soleá" (Poem of the soleá, a gypsy song), "Land / or death without eyes / and arrows" (p. 167), they imply a connection between eroticism and violence in other poems: "Love, / whose arrows are tears" ("Canción menor" [Minor song], p. 20); "What will become of the heart / if love has no arrows?" (Canción otoñal" [Autumnal song], p. 16). In the sketch entitled The Eye twisted arrows emanate from a dark eye and in Face with Arrows and Face in the Form of a Heart they are employed as part of the facial outline or features. Judging from Love, Nostalgia, and Figure, it is evident that Lorca is reluctant to leave long lines dangling in mid-air and that the arrow tip provides him with a convenient ending for such lines, which at other times may have a large dot or flower instead.

Fruit and fish are also quite common in Lorca's drawings, as they are in his writings. He illustrates a letter to Manuel de Falla in 1922 with three lemons hanging from their stems and another letter to Fernández Almagro in 1927 again with lemons, which are also present in Lunch and Still Life (13). Perhaps the best-known literary reference to the same fruit occurs in the poem "The Taking of Antoñito el Camborio" in which the gypsy cuts round lemons from a tree and throws them into the water which turns golden. Fish as a religious symbol may be found in Hermitage Saint but since fish in Lorca's writings are related to sexual imagery, it is not surprising to find that the same is true in his drawings. In Vignette fish take the place of the more common lilies growing out of a vase, and in Still Life a red fish, with a circle in its mouth, is placed in the midst of rather explicit masculine symbolism.

The eye, alone or in pairs, is another reiterated form in Lorca's drawings, as it is for the Surrealists. The living eye denotes life, for as he sings to the dead Ignacio Sánchez Mejías, "no-one will want to look at

your eyes / because you have died forever" (p. 558). In
The Eye a shaded almond-shaped form springs, roots
below and wavy lines above, looking more like a seed than
an eye. An eye appears in Nostalgia, Faces in the
Form of a Heart, and Vignette, and seems to be used
more as an afterthought than as a symbol. In Eye and
Thistle Burrs, for example, a phallic form is a lot more
evident than the tiny eye which can only be noted if the
horizontal picture is viewed vertically or if the black
three-quarter moon set in a small triangle is considered
the main eye. Lorca can't seem to resist the temptation
to place an eye in several of the quarter moons he is
fond of showing or to complete the partial moon with a
full face in broken lines.

A haunting theme in a large part of Lorca's literary
creation is death. Just as he personifies and solidifies
intangibles in his poetry, he pictures death in a drawing
of that title as a skeleton torso with empty eyes above
the body of a moving man, recalling the verses in Lament
for Ignacio Sánchez Mejías,

> Por las gradas sube Ignacio
> con toda su muerte a cuestas . . .
>
> (p. 554)
>
> Through the tiers climbs Ignacio
> with all his death on his back . . .

Other familiar elements of his iconography are also
present in this drawing of death: the lily with its
exposed stamens and anthers, an eye springing from a
flower stem, slender threads that connect the head in the
air above to the body below, undulating lines represent-
ing the skeleton's hair and ending in forms resembling
human hands, broken lines extending in double file from
the mouth of death to a severed hand held only by a
thread. We are reminded of "Canción de la pequeña
muerte" (Song of small death), "Alone my left hand /
crossed mountains without end / or dry flowers" (p. 777),
for the severed hand of the drawing holds a flower. The
sketch, oddly enough, was done the same year that "Song
of Small Death" and the poetic elegy to Ignacio Sánchez
Mejías were written, 1934.

Lorca: *Death,* from *Obras completas,* 2d ed., courtesy Aguilar, S. A. de Ediciones, Madrid.

Metaphor and Metamorphosis

Lorca's imaginative use of dynamic metaphor, lyrical symbolism, and personification have long been recognized as hallmarks of his literary creation. Andrew P. Debicki finds as the outstanding poetical procedure of Cante jondo (Deep song) the transformation and elaboration of the appearance of things as a product of the poet's vision which transforms what it sees and effects a metaphorical interchange of human and natural elements (14). A similar tendency can be observed in Lorca's drawings when his favorite iconography assumes more than one identity, achieving a quality of "iridescence" or ambiguity, since it can be perceived as one form and another at the same time or in successive viewings. This is so pervasive in the sketches that it becomes one of Lorca's fundamental characteristics as a pictorial artist. In Face with Arrows bent arrows form the outline of a human face while the mouth looks like a leaf. The fusion of face-arrows and lips-leaf provides the same visual effect as a metaphor does for the intuition in poetry, for in both media the observer is left to ponder the lyrical implications of the implied relationship. Here too, as Debicki finds in Lorca's poetry, there is a metaphorical interchange of human with natural elements. The ambiguity of lips-leaf is repeated in several drawings.

Face in the Form of a Heart is in fact two things at once, a face and a heart, while the eye may also be a fish. A leaf in Death becomes an open eye. In Park (No. 4) lines suggest pine leaves, seeds, or teardrops, while in another of the same title (No. 18) wavy black forms resembling eels may be leaves, tree trunks, or human shadows. The same ambiguity between trees and other forms in these two drawings of parks occurs in Lorca's poem "Arboles" (Trees):

> ¡Arboles!
> ¿Habéis sido flechas
> caídas del azul?
> ¿Qué terribles guerreros os lanzaron?
> ¿Han sido las estrellas?
>
> (p. 113)
>
> Trees!
> Were you once arrows
> fallen from the blue?
> What terrible warriors hurled you?
> Was it the stars?

In another poem the human figure and the trees are as
one:

> Eco de sollozo
> sin dolor ni labio.
> Hombre y bosque.
>
> (p. 384)
>
> Echo of a sob
> with neither pain nor lip.
> Man and woods.

The arrow is a reiterated motif that lends itself to
transformation in Lorca's drawings as in the poem "Trees"
cited above and in the "Poema de la saeta" ("Poem of the
Saeta," meaning both arrow and ejaculation, a short
sudden prayer which during religious processions of Holy
Week in Seville pierces the night as an arrow). The
saeta in different poems is referred to as a constella-
tion, as a river shot from the bow of the sky ("Sevilla,"
p. 181), and as the song shot by archers as blind as love
("Madrugada" ["Early Morning"], p. 186).

The pictorial outline of Lyre is at the same time
that of Spain, which also appears as part of a drawing of
a vase with flowers. The tile roofs in Rua das Gaveas
and Column and House are spider webs and in the latter,
the staircase balustrade is formed by feminine-shaped
vases which together with the spider web and an insect-
like creature similar to one in Epithalamium, suggest
sexual imagery. In Urban Landscape with Self-portrait,
as we have previously seen, letters of the alphabet are
also the windows of a skyscraper. In many of the art-
ist's personal notes to friends the calligraphy of the
signature extends upward to transform the letters into
flower stems or designs. The o of Federico in a note
dated 1915 is the ring of an open fan while the A of
the dedication "To Adriano" rises into a spike crossed by
an arrow. Lettering and words mix with other forms in
Air for Your Mouth and in Bedroom, where the exclama-
tion "Ay" is written again and again.

In a picture which Prieto calls "perhaps the most beau-
tiful still life a poet's hands ever executed" it is not
clear whether the fish is painted on the vase or is
swimming in it (Flower Vase, p. 1278) (15). Ribbons
flowing from sailor hats look like worms or the leaves
which make the flower of Air for Your Mouth look more
like a cross, despite finger-thorns and the repeated word

"Muerte" ("death") forming the grass below. There is such ambiguity in the sketching of lines with forms on the end in many pictures that they may be seen as stems with lilies hanging, drape pulls, sashes with bells, or threads with hands.

Lorca uses spheres in his drawings which are as ambiguous as they are in his writings where they may be breasts, necklaces, rings, a "moon-tambourine" (<u>Gypsy Ballads</u>), "the round silence of night" (p. 101), or a hat-sun symbol (<u>When Five Years Pass</u>). Sphere-shaped forms in <u>Still Life</u> visually suggest male sexuality, but color is introduced to identify them as lemons. Pictorial images such as the leaf-lips, face-heart, spiderweb-roof, and others previously noted are often left uncolored, therefore intensifying the ambiguity or metamorphosis that is so similar to that of poetical metaphor in Lorca.

Chapter Six
Max Aub: A One-man Art Show

In his biographical novel Jusep Torres Campalans (1958)
Max Aub (1903-1972), a Spanish writer exiled in Mexico,
combined literature and art to create a magnificent hoax
which was not only a successful novel but also gave him
exposure as a painter. The book was announced as the
biography of a Cubist painter and friend of Picasso who
became discouraged during the First World War, left paint-
ing, and went to live among the Cholula Indians in Mexi-
co, where supposedly Aub met him quite by chance. The
publication of the book was accompanied by an exhibit of
the works of Jusep Torres Campalans in the Excelsior
Gallery in Mexico City, which, in addition to the paint-
ings, included postcards, photographs, and references to
Picasso. The paintings were sold, some viewers boasted
of having met the painter personally, and afterward Aub
revealed that the whole thing had been his invention.
Campalans was a fictional character and the paintings
were done by Max Aub himself. Carlos Fuentes and Jaime
García Terres, who knew about this previously, fabri-
cated a collection of critical quotes attributed to well-
known people, first published in a literary supplement
and later edited by Aub in a handsome booklet (1).

Since communication with Spain was not the best, the
truth of the hoax was late in arriving there with the
result that for a while critics continued to be fooled,
although there was some doubt—that Aub did little or
nothing to dispel. The flyleaf of the edition in English
published by Doubleday in 1962 presents the book as "a
fully documented biography of the Catalan painter Jusep
Torres Campalans (1886-1956), illustrated with color and
black-and-white reproductions of his work." The only
hint about the true nature of the work is in the form of
an observation and question: "He brings Torres Campalans
and the moral and intellectual history of his times to
life as if in a picaresque novel. (Is it, in fact, per-
haps, a sort of novel?)" The publication in New York was
celebrated also with an exhibit in the prestigious Bodley
Gallery which Art News in November 1962 reviewed,

mentioning that the painter is the creation of Max Aub.

Much more than a novel, <u>Jusep Torres Campalans</u> is simultaneously a theatrical experience staged by Aub with the same innate sense of theatricality that made him a superb playwright. Torres Campalans acknowledges that "Painting was décor, adornment . . . décor for the work that like it or not we are presenting in the great theater of the world" and that "all art is like the theater, great art, made up of three elements: the author, the actor, the public" (2). Aub is not only the author of the book and the illustrations which accompany it, but also the creator of a one-man art show reaching all facets of the "art game"; he is painter, biographer of a painter, spectator of his own art, subject of some of the paintings, critic, commentator, cataloger, and—by extending his activities beyond the confines of the book—art dealer and exhibitor!

Cubist Structures

The concept of providing multiple views to capture the subject in as many simultaneous aspects as desired is one of the hallmarks of analytical Cubism and is put into practice literally in the structures of the novel. As an epilogue a quote from Baltasar Gracián (a famous Spanish writer, 1601-58, author of <u>El criticón</u>), refers to the ingenious painter who in order to depict unseen views of perfection placed a clear fountain to reflect the opposite side, a gleaming mirror to capture the righthand profile, and a bright corselet for the left. The novel's prologue asks, "Which is the correct view, yesterday's or today's? Who can tell the whole truth about anything if a human being is involved?" (p. 15). Thus the use of multiple perspectives alludes to unseen aspects in time as well as in space.

Aub describes the components of his book, explaining, "This is, then, a de-composition, with the biography appearing from several points of view—perhaps unintentionally, in the style of a Cubist painting" (p. 15). "Will anyone recognize him here?" he asks rather mischievously, in view of Campalans's true identity, "The others, who are everybody—will they see him as he' was? Perhaps a different kind of book would have been better— a face-to-face account that would have resembled a novel without being one" (p. 15).

The structure of the book is complex and ambitious.
First there are epigraphs, a dedication to André
Malraux, expressions of thanks to well-known people, and
an "Indispensable Prologue" explaining how Aub met
Campalans, followed by a long section of "Annals" regis-
tering historical, political, and cultural events from
1886, date of the painter's birth, to 1914, when he disap-
peared from view. We find articles indicating his place
in the history of Cubism and a biographical section also
constructed Cubistically with data from diverse sources—
personal interviews with acquaintances, letters, and
research. This section tells of Torres Campalans's run-
ning away from his home town to Gerona, where his obses-
sion with verticality begins. At the age of fifteen he
goes to Barcelona in pursuit of an actress and there
meets Picasso. On his return to Gerona he tries various
occupations and becomes an anarchist. To avoid the
draft, he goes to Paris where he visits the Louvre every
Sunday in an orderly fashion, renews his friendship with
Picasso, lives with a miniaturist, Ana María Merkel, and
meets important artists of the day.

The biography is followed by several articles in
magazines and the artist's "Green Notebook," which
presents a miscellany of his thought and aesthetics, and
which because of its own chaotic structure, composed of
parts of other people's notes and written in different
languages, is like a collage within the larger collage of
the novel. A chapter entitled "The San Cristóbal Conver-
sations" brings us to a more recent perspective of the
artist who has lived forty years among the Indians,
completely retired from the art world and dedicated to
the creation of children. Included in the book is a
catalog of his works prepared by Henry Richard Town.
There are copious footnotes in various parts of the text
and iconographical material, whose selection varies in
different editions of the book. Aub's intention is to
mystify, to encourage the reader to participate intellec-
tually, and in this sense his novel is a forerunner of
the so-called "New Narrative" of the 1960s. "Reconstruct-
ing this story has been like doing a puzzle," he asserts
(p. 21). This message applies equally to literature and
the visual arts, for in the words of Torres Campalans,
"Let the looker work too" (p. 249).

The various "views" in the Cubistic decomposition of
the subject are also reflected in onomastic transforma-
tion. A bookdealer in Mexico tells Aub, "More than forty

years ago, in the beginning, when he first arrived, he
called himself 'José Torres' and signed himself 'José
T.' People called him 'Don José Té,' then simply 'Don
Jusepe'—and 'Don Jusepe' he has remained" (p. 13).
Lafitte calls him simply Campalans, a French interviewer
Monsieur Campalans, and for Aub he is Jusep Torres
Campalans. The painter signs his works with a combina-
tion of a capital T̲ elongated into a J̲ and crossed in
the center by a C̲ which examined from the right side
forms an A̲, the initial of the real author, Aub. The
novel itself has more than one aspect since it is at the
same time a biography, a fiction, and a hoax. Indeed it
may be found in libraries cataloged among biographies of
painters and not as a novel. In our book La broma
literaria en nuestros dīas (The literary hoax in our
day) we explain the importance of the fact that it is a
hoax in that it invites a first ingenuous reading as if
it were a genuine biography, followed by an informed read-
ing enriched by the clues and irony the author has pro-
vided at every turn (3).

An Art Book to End All Art Books

In his "Indispensable Prologue" Aub refers to
Cervantes's Don Quijote, suggesting that a great part
of his purpose is to ridicule the practice of writing
about art and giving us a hint that what he has written
is a novel. "It is amazing how many biographies of paint-
ers are read now, just as in Cervantes's time they read
books about Amadīs de Gaula" (p. 19). Talking and writ-
ing about painting makes it into a science instead of an
art; one of the reasons Torres Campalans is so hostile to
Juan Gris is that he is more the theorist and spokesman
than the painter, exemplified by Picasso. This is why
Campalans paints the Head of Juan Gris as a bookcase
filled with books.

Aub parodies art commentary and criticism in several
articles included in the novel and in the descriptive
texts of the catalog attributed to Henry Richard Town.
He evidently agrees with his invented chronicler Miguel
Gasch Guardia in the latter's 1957 article entitled "A
Founder of Cubism, Jusep Torres Campalans":

It is significant that so many books about modern
"painting" are sold. Five hundred about Picasso, to

mention the Spanish case, but few about Domingo,
Solana, Zuloaga, Sorolla. The explanation is that
before everything else the values in him are not picto-
rial, but intellectual. What matters to the buyers is
the text included in the canvas.
Torres Campalans, whose name is beginning to be
heard again, saw this clearly. "If anything of Gris
or Gleizes lasts," he wrote in a terrible sentence,
"it will be their theories." (p. 127)

Gasch, whose name is so similar to that of Sebastián
Gasch, the real-life art critic who encouraged García
Lorca's sketching activity, that one might easily think
they are one and the same, says many things that make
sense, but the parodic intent of Aub shows through. He
says that Campalans "has not the quality of Matisse, Pi-
casso, or Mondrian (to cite the peaks of Torres Campa-
lans's productive years), but his intentions —and they
mattered even though not rescued up to now from the infer-
no of forgetfulness—were as pure as those of the others"
(p. 129). Certainly intentions are a strange criterion
by which to measure a painter's merits as "significant."
Town's catalog may seem to elucidate some aspects of
the plates reproduced in the book, but once we know that
these are creations of Max Aub, the catalog becomes an
effective parody of such writings, fond of citing "influ-
ences" not infrequently erroneous; for example, that of
Matisse noted by Town in The Teardrop Before the Mir-
ror, which is in fact taken directly from Picasso's Les
Demoiselles d'Avignon. While Campalans himself belit-
tles the value of his art, Town, on the other hand
(another Cubist perspective), is sometimes overly enthusi-
astic, even when noting occasional weaknesses. An early
painting of Campalans entitled The Cathedral of Gerona
is "technically still insecure, above all in the torment-
ed sky" but in any case "extraordinarily enchanting
because of its strong structure" (p. 116). A watercolor
of Saint Lawrence with a grill painted across his face,
supposedly influenced by Picasso, evokes utter admiration
in Town: "But what an idea, that of applying the grill
to the face! That feat of the neck, that decision!"
With exquisite irony it is identified as the "property of
Max Aub." Town notes the artist's "slightly caricatur-
esque manner" in one painting, the "unusual delicacy" of
another, as well as a "savage technique" and touches that
reveal "a born painter" (p. 117). He finds The Crea-

tion of Campalans superior to that of Kandinsky in its profundity and <u>Pierrot</u> one proof of his mastery even of realism. "Profundity" is the quality Town most often praises in the Catalan artist's work. In <u>Sunset</u>, for example, "the profundity of earth and sky is supernatural, metaphysical" (p. 117).

One of the funniest comments concerns <u>The Eternal Husband</u>, which is perhaps one of the worst pictures, but is described in superlatives as "an important work of the epoch for two reasons: technique and psychology. The woman's nose is one of the final manifestations of the 'Negro' mode—alternating wide strokes of blues and reds—and the effigy of the man is almost completely hidden by the woman. Her face, in brown and black tones, belongs to J.T.C.'s best work" (p. 119–20). The humor in the painting is its "literary" side, the title's reference to "the eternal husband" as one who is overwhelmed by his wife to the point that he cannot be seen.

For Town the work of the "Catalán painter of genius" is profound and well constructed; only rarely does he register a criticism, as in calling <u>Homage to Van Gogh</u> confused and poorly balanced, "perhaps because it was not conceived and carried out all at one time" (p. 122). One wonders to what extent the catalog influenced the spectators at the artist's first exhibit. It was probably instrumental in convincing them of the worth of Torres Campalans's paintings and certainly proved the theory behind Aub's creating an art book to end all art books— that painting must be judged on its visual merits and verbalizing it results in some ridiculous conclusions.

Town calls our attention to the fact that Torres Campalans is prone to painting one-eyed characters in his portraits and asks where this Cyclops complex comes from. The answer of course is that the one-eyed expression, found for example in <u>Neptune</u>, one of several portraits in which Aub's own features are present, is simply the author-artist winking at us, one more clue to the spurious nature of the "biography." The catalog becomes even funnier unwittingly when alongside the footnotes provided by both Town and Max Aub, we find additional notes entered by the publisher Doubleday noting that <u>Head of Juan Gris</u> is used as the frontispiece and by the translator explaining a pun in the Spanish text!

Inspired by Cervantes's great parody of books about knighthood, Max Aub parodies the way people write about art and artists to prove that the real value of an art

Aub: *The Wise Man,* from *Jusep Torres Campalans* (Madrid, 1975), courtesy Perpetua Barjau de Aub. Evidently a self-portrait of Aub.

book resides in making available to the public reproduc-
tions of the artist's paintings. In this sense Aub, an
amateur painter, managed to realize his greatest achieve-
ment, for the continued publication of his novel Jusep
Torres Campalans guarantees the continued showing of his
paintings unhindered by the art critics. Max Aub the
painter enters the Elysian Fields on the coattails of Max
Aub the novelist.

Convincing Lies, an Exercise in Cubism

One aspect of Cubism reflected in the novel in addi-
tion to the structures already cited is the close rela-
tionship between the arts acknowledged in Campalans's
statement that "painting is literature or it is nothing"
(p. 131). The aesthetics of Jusep Torres Campalans as
a novel seem inspired directly by those of Cubism in its
three main phases, analytical, hermetic, and synthetic.
The structure is analytical while the importance of
change as an important element of a reality which is a
product of the mind to reflect the universal dynamism of
life is associated with Hermetic Cubism developed by
Apollinaire, Gleizes, and Metzinger. Campalans, for
example, changes his name, places of residence, jobs,
women, country, ideas, etc. Synthetic Cubism, whose
spokesman was Juan Gris, holds that art is the product of
aesthetic judgment not dependent upon reality at all.
The artist neither copies nor deforms but rather creates
an original reality, a new experience to enrich life (4).
Picasso expressed this in terms of truth and lies in the
disjointed verbal style of Cubism:

> We all know that art is not the truth. Art is a lie
> that makes us realize the truth, at least the truth it
> is given us to understand . . . The artist must know
> the manner of convincing others of the truthfulness of
> his lies. That those lies are necessary to our mental
> selves is beyond any doubt, as it is through them that
> we form our aesthetic point of view of life . . .
> Through art we express our conception of what nature
> is not. (5)

We also recall Max Jacob's famous aphorism, "Art is a
lie, but a good artist is not a liar" (6).
Torres Campalans's "Green Notebook" provides us with

similar thoughts and, significantly, the author claims
that the painter evidently copied the section entitled
"Aesthetics" from some unknown source.

Does any other action better define the condition of
being a man than that of saying that something is true
while knowing that it is false? Invent a lie and let
the others believe it . . . lie, invent, but don't
falsify . . . Don't say one thing as though it were
another, but rather another thing born out of nothing,
out of imagination. (p. 26)
 Lie to good purpose and thus help man be at home in
his own being . . . There are masks of a thousand
sorts; the question, as always, is to know how to
choose. (p. 260)
 Language and painting lie innately . . . Lie to
achieve, but never to sell—even less, to sell oneself
. . . What is a likeness? A figure, a representa-
tion . . . , one thing pretending to be another. (p.
261)

All these observations serve as justification for the
"lie" that gives life to Jusep Torres Campalans in the
novel of Max Aub. The author, however, believes in warn-
ing the readers of the fiction by leaving copious clues:
"Lie, but never be mendacious. Do not deceive anyone.
Offer to whoever really wants it; veil your intention,
but don't hide it. Never believe that the others are
fools. On the contrary; speak to them as equals. If you
mix the supposedly true and false, leave tracks, give
signals so that everyone can find the way of the soul"
(p. 261). Aub does precisely that; right from the begin-
ning he leaves sufficient signals for the wary reader to
recover with an epilogue that alludes to a supposed
Santiago de Alvarado's question, "How can truth exist
without falsehood?" and in the prologue when a man
informs Aub that Don Jusepe is "a fantastic type" and
Jean Cassou exclaims on hearing of his meeting with the
artist, "But that's fantastic" (p. 14).
 Aub is quite explicit about the use of lies as crea-
tion: "lie, do not deceive; pretend, do not falsify;
disguise (what other way?), do not counterfeit; invent,
do not plagiarize; feign, if you like—but only feign, do
not defraud, hallucinate, do not make fun—but if making
fun is necessary, at most make fun of ourselves" (p.
261). This may be considered a guide to the perplexed

reader who should not feel particularly piqued at the
hoax, since Aub, in line with his painter's "Aesthetics,"
makes himself the butt of much of the humor in the text
of the novel as well as in several pictorial self-
portraits. Like it or not, we are to be victims of the
joke one way or another because it becomes impossible to
separate truth from fiction. There is so much erudition
in the footnotes and bibliographical references that if
we tried to corroborate these data we would be falling
right into the hands of the author. Aub places the read-
er in the role of intellectual opponent in contrast to
the age-old custom of collusion between narrator and read-
er in which the former passes off his fiction as truth
and the latter pretends to believe it. In the same way
Cubism is demanding intellectually on the viewer. A
final similarity to Cubism involves the deliberate use of
ambiguity and suggestion rather than clarity, which is
comparable to the quality of color iridescence in Cubist
painting making it impossible to distinguish objects from
space and seeking to confound them rather than to set
them off.

Aub-Campalans as a Painter

Jusep Torres Campalans has been universally praised
by the critics as a novel, but they tend to consider the
hoax as an added attraction and fail to comment upon the
art work, which, nevertheless, is extremely important,
for without it the hoax would probably not have been
either successful or spectacular. In view of the quanti-
ty alone of the pictures in the Town catalog (fifty-
eight) and of those reproduced in the several editions of
the novel, it is a topic that deserves some attention.
Outside of this novel the only hint as to Aub's interest
in art is a sketch dedicated to the fictional protagonist
of his novel Luis Alvarez Petreña, dated 1929, which
appears in Novelas escogidas (Selected novels) (7).
It is significant to note the varied media Aub employs
in his pictures: watercolor, oil, gouache, charcoal,
lead pencil, crayons, colored pencil, colored ink, China
ink, and varnish, with combinations of several media at
times. It is impossible to determine whether the
pictures are arranged in order of their actual execution
because they seem to be ordered to reflect the develop-
ment of the art movements of the time, from the Fauve and

primitive art influences, toward the beginnings of Analyt-
ical Cubism, then toward progressive abstraction and the
transition to Synthetic Cubism. All of this shows how
well Aub understood these movements and how they pro-
gressed.
 The earliest pictures attributed to Campalans include
a 1907 portrait of J. Avillac, reproduced in Novelas
escogidas, a simplified but realistic rendering of the
subject except for the Fauve use of brilliant and arbi-
trary coloration. A similarly realistic line drawing of
a woman, dated 1906, is linear and tends toward carica-
ture, in fact, resembling Max Aub. A line drawing of Ana
María Merkel of 1907 shows some angularity, the eyes
simplified to squares, indicating a tendency toward
Cubism. Cubist subject matter introduces itself in The
Radish by Its Leaves of 1908, with the prominent place-
ment of a guitar, present also in Tribute to Van Gogh
(1912) and in an undated papier collé, as well as in
the harlequin found in Campalans's Pierrot (1908),
which Town attributes to the influence of Picasso. The
Coal-Dealer's Daughter of 1908 has Fauve coloration but
the facial treatment of Picasso's Les Demoiselles
d'Avignon of the year before. The Teardrop before the
Mirror, supposedly inspired by Matisse, is in fact a
direct transposition of the central figure in Picasso's
famous Demoiselles, recognizable in the posture of the
raised right arm held behind the head, except for the
treatment of the eyes and the added parodic details of
underarm hair and a teardrop flowing from the breast,
both notably realistic. Two landscapes, The Factory of
Romeo (1908) and Landscape (1912) are plainly Cubist
and quite similar in style to Georges Braque's Houses at
L'Estaque (1908) and Picasso's The Reservoir, Horta de
Ebro (1909), with the elements of the landscape present-
ed in geometric forms. Chimneys and Heat (1910), how-
ever, shows a transition from the sphere, cone, and cylin-
der favored by Cézanne toward angularity of forms.
 Portrait of M(ax) J(acob) with a Phlegmon (inflamed
gums) (1909-10?) is strikingly similar in conception to
Picasso's 1909 portraits Woman with Pears, Seated
Nude, and Portrait of Braque, although Picasso's forms
are more angular than those of Campalans. Elégante
(1912), supposedly a tribute to Toulouse-Lautrec, shows
the monochromatic color schemes favored by the Cubists
and the lack of differentiation between form and space or
"iridescence" typical of the second phase of Cubism.

Aub: *Landscape*, from *Jusep Torres Campalans* (Madrid, 1975), courtesy Perpetua Barjau de Aub. Anthropomorphic picture with hidden profile.

Letter abstractions, introduced in 1910-11 by Braque and Picasso as elements of collage, are found in Campalans's 1912 Montage, while multiple views, developed from 1909 to 1912 in Cubism, appear in the Catalan's portrait of Guillaume Apollinaire dated 1910. Campalans's collage Sunset, if the dating is correct—1909-10?— would predate the Cubist collages by one or two years, since Still Life with Chair Caning by Picasso, done in 1912, is generally considered the first Cubist collage.

The paintings in accordance with their dates are progressively more abstract, developing into Campalans's characteristic "Trames" (French used in the English translation of the novel, for tramas ["trams"] meaning "web," "woof," or "fraud"), which by 1914 are pure abstractions, paralleling the work of Picasso during those years. If one covers the lips in the Campalans portrait of Forestier (1913), the rest of the picture is a complete abstraction, in the same way that covering certain portions of Picasso's Girl with Mandolin (1910) yields an abstract dimension beyond that of the subject (8). Suffice it to say from these observations that Max Aub was more than knowledgeable about the modern art movements and works produced at a time when he was still a child. No doubt that is why his invented painter was so convincing, not only on the basis of his life as described in the text, but also because of the development of his painting, paralleling or even anticipating the recognized masters of the time.

In view of all these "influences" we may very well ask what is Aub's particular style of painting? While Ortega y Gasset saw the art movements after World War I as leaning toward art as a diversion, there is little humor present in Cubism, and that is precisely where Max Aub's art is original. Gasch calls Campalans a forerunner of the Surrealists, perhaps because of his humor, evident in the hidden man of The Eternal Husband, the bookcase Head of Juan Gris, and the multiple locks of Hotel, with the keys missing (like the keys to the novel, perhaps).

There is also tremendous humor in Campalans's plagiarism from Picasso's Demoiselles previously noted, and in his Short Portrait of Picasso (1912), which is exactly that—a cut-off enlarged detail of Picasso's 1907 self-portrait. He achieves a somewhat different effect with the brown cardboard showing through but captures the same intense look or stare of Picasso's picture. At least Aub

is honest and adds in Town's catalog that it is the "property of Pablo Picasso," as indeed it is. It is not at all surprising that Campalans asks himself in his "Green Notebook" from whom he robs what he paints and acknowledges that what he paints and writes he owes to others.

Another example of Aub's humor is the use of "hidden portraits." Self-portraits may be discovered in Portrait of a Woman, The Wise Man, Neptune, and even in his portraits of Forestier and of Apollinaire.

As for pictorial qualities, Aub's own style is definitely less angular than that of Picasso or Braque, especially his portraits, which tend toward rounded lines. With regard to color, it is true, as Town notes, that Campalans favors "violent contrasts of color" (p. 318) rather than the monochromatic hues toward which Cubism evolved. His use of color is decidedly Fauve, with pure, intense, high-key colors used as a personally expressive element rather than reliant upon the actual color of objects.

The novel may reveal some of Aub's own feelings about his art work. Gasch notes in his article that "each painting was a problem to him. He had to suffer through the thousand missteps caused by the heaviness of his hand. But in all his work there is not a trait that does not demonstrate his urge to advance" (p. 129). This insecurity about Aub's "avocation" may be reflected in Campalans's confessions in the "Green Notebook," "I am ashamed when I show what I paint. Not because it is good or bad (that is not important), but because it is mine. If others look at it, it stops being mine; they take part of it away with them and it loses some of its value" (p. 243). Showing one's paintings in public for the first time must be a traumatic experience, especially when the painter is known as a writer. Campalans affirms that he paints for himself but recognizes that "no art without a public is worth anything" (p. 299). Perhaps that is why the painter Max Aub decided to "come out of the closet" under an assumed identity.

Aub protects his self-image by indulging in some self-ironic commentary, diminishing the merits of his painting in Campalans's words:

In the last analysis, I was a failure as a painter. Not one who failed. God simply didn't summon me along that road. I painted nothing, nothing at all (p. 296)

[which is true, since it was Max Aub who painted the pictures].

Any road is good. The question is to come to an agreement with yourself. To accept one's own mediocrity costs one lots of blood, lots of bad blood, until one ejects it. It hurts. But why does a mediocrity have to be inferior to one who isn't? To accept oneself as one is costs a lot of effort, but it's the only way that pleases God. (p. 297)

The only way for the dilettante to show his paintings and save his self-esteem is by calling them mediocre and criticizing them before others do. Aub doesn't have to face the professional art critics; he becomes his own critic, commentator, and judge. Max the writer grants immortality to Max Aub-Torres Campalans the painter and guarantees him a prolonged public exposure every time his novel is read, and that is no small feat.

Chapter Seven
Luis Seoane: Galicia Abroad in Word and Picture

Luis Seoane (1910-1979) was born in Buenos Aires of Galician parents who subsequently returned to their homeland in Spain where Seoane went to school in Santiago de Compostela and began a career as a lawyer in La Coruña. The outbreak of the Spanish Civil War in 1936 forced him to emigrate to Argentina where after great struggles he became famous as a painter while carrying out an untiring campaign to keep alive Galician culture in exile. He was instrumental in establishing and encouraging publishing companies and magazines to promote the reading of Galician authors of the past and present, some of whose works had been forgotten or ignored. He himself wrote books while continuing his work as a painter and illustrator, achieving successful exhibitions in America and in Europe. His two nationalities, Argentine and Galician (more exact than "Spanish" in his case), were as harmonious as his two vocations as a painter and a writer. He found no difficulty or contradiction in developing these disciplines simultaneously, and his awareness of the close relationship between them is illustrated in two of his essays, "Concerning the Integration of the Arts" and "Father Feijóo and the Visual Arts" (1).

Because of the huge number of pictorial works done by Seoane, we prefer to consider his literary works, fewer in number, as the point of departure for an examination of similarities and differences between both sectors of his artistic production. In order to represent the most original vein of Seoane's literary creativity, which is at the same time the most comparable to his painting, we have chosen his theater—for its plastic qualities as a visual experience which make it the genre most closely related to painting—and his poetry. We shall consider his two plays, La soldadera (The soldiers' minstrel) and El irlandés astrólogo (The Irish astrologer), of 1957 and 1959 respectively, and his four books of poetry, Fardel de esiliado (The exiled man's baggage), of 1952; Na brétema, Sant-Iago (In the mist, Santiago), of 1956; As cicatrices (The scars), of 1959; and A maior

abondamento (With all the more reason), of 1972, all
written in the Galician vernacular. As recently as 1977,
Seoane's work as a poet was virtually unknown in Galicia,
as the publisher of his Obra poética (Poetic works),
Ediciós do Castro, acknowledged when presenting the vol-
ume that year. The reasons for this are rooted in biogra-
phical circumstance since much of Seoane's journalistic
and literary work was subject to the same kind of restric-
tions in Spain as most publications by Spaniards in exile
and therefore did not circulate until new editions were
published with the easing of Spanish censorship.

Relevance of Galicia's Past

Seoane was well known as a painter in Argentina when
he wrote his first play, La Soldadera (The soldiers'
minstrel), which, published in Buenos Aires in 1957, was
already the mature work of an author who was in the term
coined by Unamuno, "viviparous" in that the play is born
completely formed without the need for nurturing a prelim-
inary "egg" as in the case of an "oviparous" author.
The Soldiers' Minstrel reproduces the story of a
fifteenth-century rebellion of artisans and peasants led
in Galicia by the nobleman Ruy Xordo and betrayed by
foreign spies serving the exploiters of the poor. While
the play is based on historical fact, the protagonist
Minia, a sort of entertainer who accompanied soldiers in
the Middle Ages, carries messages to the peasants and at
the same time is guide to some peasants from the twenti-
eth century who, thanks to her magical powers, are able
to observe these medieval events. At the end of the play
the heroine dies, but she has succeeded in making the
present-day peasants realize that the struggle of their
medieval counterparts is still very much a contemporary
one.
Minia belongs to both the material world and that of
magic and mystery in a tradition long associated with
Galician literature. She tells the modern Young Peasant
that she could be a fairy and she does in fact seem to be
a fanciful creature simply disguised as a minstrel. The
mystery of her unknown origin and her free and graceful
air fascinate the young man. She would belong perfectly
in the pictorial world of Seoane which Lorenzo Varela
describes as a place "where reality is not divided, where
a newborn baby is no more certain or true than an appari-

tion, where poetry is no different from truth just for
being less real, but simply because one is to the other
as the soul is to the body" (2). Another character in
the play, the Blindman, perceives that Minia represents
fantasy, legend, and the eternity of her people. She
transcends time and is able to live in two centuries sepa-
rated by five hundred years of history but joined by com-
mon abuses of justice. She announces to the twentieth-
century peasants, "In the past you will be able to see
your present" (3), an observation that could well be a
motto for Seoane's paintings, for their sensation of evok-
ing intemporality and the living past, as Varela also
noted: "Time is . . . and so it is felt in Seoane's
painting, 'the mystery of remote eras' and of the times
we live, and of those which have remained as if frozen in
the air, and of those which are ahead, coming upon us."
His pictures, according to the same critic, are filled
with "past things in which there existed, especially if
we discover or contemplate them for the present, the
essential elements of all that surrounds us right now,
today." If Varela does not mention The Soldiers' Min-
strel, it is only because he wrote these words nine
years before the play was published, but he sees very
clearly that the accent of Seoane's painting is on "both
its old and modern air, its devotion to characters and
places which are legendary and still modern," an observa-
tion also true of his theater. Another character in the
play who belongs to this intemporal world is the Prophet-
ic Madman who hieratically repeats excerpts from the
"Epístola de Santiago" (Epistle of Santiago or Saint
James) and "A las doce tribus de la dispersión" (To the
twelve tribes of the dispersion)—also written by Saint
James, Galicia's patron saint—which are surprisingly
timely with relation to the circumstances in the play.
 The figure of the enigmatic and paradoxical protag-
onist is traced very vividly. She moves among the master
artisans with complete freedom and naturalness, as only a
woman who is a wandering minstrel can in medieval socie-
ty, but at the same time she preserves all the freshness,
innocence, and candor which capture the love of the
modern Young Peasant who would like to take her away with
him to his village. The female figures painted by Seoane
produce similar paradoxical impressions. Lorenzo Varela
finds that in Seoane's nudes "the fruit is presented
before our senses with a sensuality penetrated by ingenu-
ousness, virginity, innocence, almost unattainable in its

happy and clear existence" (4). Nudity in his painting, just as the minstrel occupation in Minia, suggests liberty but not libertinism. Rafael Dieste, commenting upon the sketches of Homenaje a la Torre de Hércules (Tribute to the Tower of Hercules) in 1944, describes "faces of girls who live on the river banks who are sirens but have husbands who are fishermen," and other women who are goblins, tutors of the home, large matrons, or sweet empresses (5). This book, chosen by the Institute of Graphic Arts of New York and the Pierpont Morgan Library as one of the ten best books of drawings published worldwide between 1935 and 1945, is largely an eloquent tribute to the Galician woman, as Dieste puts it, "the daughter of Vigairo, the Virgin of Always, who passes and returns like the light of the day." Seoane knows how to create female figures of great vigor, pensive peasants, on horseback, or busy at their daily chores, strong women unafraid of work, like those who in The Soldiers' Minstrel leave the city in which the intimidated artisans cower and hide to go to Ruy Xordo's camp and offer to fight alongside the peasants.

Seoane painted the nobleman leader Ruy Xordo thirteen years before he made him a character in his play, in an album of sketches entitled María Pita y tres retratos medievales (María Pita and three medieval portraits), which consists of four wood etchings and poems by Lorenzo Varela. He pictures the leader in a pose that is hardly warlike, seated on a rock before a sea of dark waters. The serene and noble profile and the sword resting on one shoulder illustrate perfectly his characterization in the play as a compassionate man whose kindness in wartime can be considered a weakness. Another etching of the same portfolio pictures María Pita, the heroine of La Coruña, standing in a window in an attitude of alert, slightly inclined, resolute and martial in her bearing but with facial features and expression clearly feminine. Another etching depicts María Balteira, who was a famous "soldiers' minstrel."

Seoane describes Minia in the play dressed in a skirt of crimson mulberry edged in black plush, a doublet of brown damask, and a bodice of yellow taffeta. These colors are the same ones that appear frequently in his paintings, particularly yellow, while the black edging recalls the accentuation achieved in his pictures when black markings are superimposed on patches of color, a characteristic of his style, especially in the 1970s.

Seoane: *María Balteira*, courtesy María Elvira Fernández de Seoane.

Another element that links the characters of the play to
those of Seoane's paintings is their presentation in
groups. Although the artist painted solitary figures
also, many of his pictures show groups of two, three, or
more people at work or communicating in some way, as
illustrated by titles such as Discussion, Conversation
on the Beach, The Dialogue, Women Talking, and The
Conversation. In the play the artisans, medieval peas-
ants, modern peasants, and women form compact groups. In
this sense his paintings and writing reveal deep respect
for association and fraternity, qualities evident in
Seoane as organizer and promoter of Galician cultural
activities in Buenos Aires.

The play, however, contains a note of violence and
theatrical sensationalism that is generally absent from
Seoane's painting in the hanging of "four richly attired
gentlemen" (p. 27). A few similar scenes taken from
Galicia's past are depicted, however, in Imágenes de
Galicia (Images of Galicia) (6).

The play denounces the causes of Galician emigration—
an insistent theme in Seoane's writings—both in the past
and present. The Municipal Councils that overburdened
artisans and peasants in the fifteenth century are
compared to the modern-day Provincial Congress. A histo-
rical event also inspires Seoane's second play, El
irlandés astrólogo (The Irish astrologer), which
portrays the plight of the emigrant (in this case an
exiled Irishman in the seventeenth century), and is based
on the Inquisition trial of Patricio Sinot, professor of
Rhetoric at the University of Compostela. "In this work
may be found only an occasional detail from his life and
none from his indictment which was rather mild as almost
all those of the Inquisition in Galicia, where this insti-
tution did not acquire as much importance as in other
parts of the peninsula" (7).

The play is enclosed in a sort of frame as if it were
a picture, provided by a marginal character, a Dealer in
Unguents who addresses the public at the beginning and at
the end. He and the buffoon who accompanies him are
described in full color, as if painted. The Inquisi-
tion's torture chamber is of "black walls with spots in
lines and red blotches in the style of Pollock" (p. 21),
as if it were a painting of the American artist Jackson
Pollock, known for his action-painting technique of drip-
ping paint on canvases stretched on the floor. Another
aspect relating to Seoane's painting is the impression

that the play is a series of engravings or a portfolio
about a theme, since there is little movement and even
less action. Scenes portray characters in conversation
and all the tension is internal. Many of Seoane's canvas-
es of the same period are of figures seated, lying down,
pensive, or asleep. Julio E. Payró, in his informative
prologue to the artist's retrospective exhibit at the Art
Gallery International in Buenos Aires in 1956, discusses
dynamic and static qualities in his work, referring to a
statement of Domingo García Sabell which recognizes the
predominance of emotion over intellectualism and of the
dynamic over the static in Seoane's painting (8). Payró
distinguishes between the dynamism of the energetic execu-
tion and the static results. While the situation and
flow of dialogue in The Irish Astrologer are dymanic,
the scenes lack movement and tend toward the static. The
inquisitorial scene, for example, is not one happening in
a chain of events, but rather a static situation which is
represented several times in the play. In the second act
we see the torture of Sinot filled with theatrical ef-
fects with the wheel torture and a drop of water that
falls incessantly. In the third act there are three more
versions.

There is much irony in Sinot's being persecuted for
heresy in Spain when he was exiled for orthodoxy in Ire-
land, and in the fact that the astral wheel which is his
consolation in exile is the "crime" that moves the wheel
of the Inquisition's torture. Perhaps all emigrants are
destined to be strangers in the world.

The Galician Emigrant in Verse

Seoane's great concern with the problems of Galician
emigration is also very evident in his poetry, which is
not introspective but rather an expression of a collec-
tive experience in which he feels deeply and personally
involved. In all of his books of poetry alter ego paint-
ers appear, sometimes speaking in the first person,
others viewed from an outside perspective. An artist-
poet frames Fardel de esiliado (The exiled man's bag-
gage), of 1952, appearing in the first and last poems.
"In his head are mixed the forms, the memories / of the
light and colors of the distant land" (9). In the clos-
ing poem the old emigrant artist, inspired by his dreams
and remembrances, elaborates his tapestry of saudades

("nostalgia and melancholy") to re-create scenes from his
beloved homeland to see before he dies. "The old emi-
grant / did not etch, weave, or sketch / men or women by
themselves, but crowds / of them at work or play" (p.
70), just as Seoane so often does in groups whose styl-
ized faces show the resemblance that springs from a
common caste, heritage, or homeland.

The Exiled Man's Baggage, like Seoane's theater, is
related to his muralistic art or tapestries that reach
out to a collective audience. Guillermo Whitelow sees in
his Argentine murals "the vigor of medieval banners and
the aggressiveness of contemporary posters" (10), which
also describes the climate of these poems that trace the
epic of Galician emigration to Argentina and their strug-
gle with the land and Indians, reminiscent of José
Hernández's Argentine epic Martín Fierro. We see the
Galician colonist Ramón Cernadas in three moments, first
filled with illusion, then besieged by Pampa Indians and
deceitful constables of the Viceroy, and finally lying
under a black cross blown down by the wind. Repetition
of the first verse of each five-line stanza in the last
part lends a solemn and elegiacal tone. Cernadas's wife
and daughters have no time to cry because they must till
the land, plant crops, and attend to the cattle, but they
never lose hope. We have seen such women in Seoane's
paintings, strong humble heroines at work, conversing, or
waiting, perhaps for better times.

In this first book of poems, some of which have a
softer, costumbrista tone, Seoane raises a song to the
everyday heroism of humble farmers, miners, and workers,
to the hundreds of thousands and even millions of Gali-
cians of the past and present who help other countries by
"their soft, nostalgic invasion," an anonymous people
without bards to celebrate their struggles and sacrifices
in other countries where they carry their homeland as
part of "the exiled man's baggage." Also present is
Seoane's characteristic irony in "Building Castles in
Spain," whose title is given in English, about a Galician
emigrant who died a complete failure in New York dreaming
of a castle in Spain which, without his knowing, he had
in fact inherited in his absence.

Seoane's second book of poems, Na brétema, Sant-
Iago (In the mist, Santiago), of 1956, is illustrated
with etchings done in metal, a medium that harmonizes
with the medieval content since it recalls the metallur-
gical craftsmanship of the Middle Ages. The poet ex-

plains his intention to transfigure memories of Composte-
la into legends blending present and past (we are remind-
ed of "the soldiers' minstrel's" magical abilities). He
refers to the legendary San Ero of Armenteira who was
charmed by a nightingale in a forest and when he awoke
from sleep 300 years later, nothing of what he remembered
existed any more and no one remembered him. Seoane paint-
ed a portrait of the saint for his close friend José
Otero Espasandín; in the monochromatic oil painting San
Ero has a faraway, serene expression, with the same
strangeness the emigrant must feel upon returning to his
country where he is no longer remembered.

Here again, as in Seoane's first book of poems, the
artist appears insistently as a character, speaking
directly to us in "Exiles" as he draws on a wall figures
he imagines being excavated a thousand years later as the
testimony of a stranger's presence there. Hearing a
distant voice from his homeland, he paints on the walls
of a building in a great city the images that flow into
his memory, surely as the muralist Seoane did, painting
for the people of Argentina figures inspired by his incur-
able nostalgia. Another artist-protagonist is "The Minia-
turist" who while painting illustrations for codices,
sees the figures of farmers and harvesters come from his
brush. Perhaps he represents the commercial or profes-
sional artist carrying out a project who finds that other
images escape unconsciously from his heart. The first
illustration in the book is in fact of a harvester like
those the Miniaturist cannot help painting. Other
artists appearing in the poems are the master of silver
work, the "artist who returns," and the subject of "Self-
portrait in 1255," who wanders among minstrels and vaga-
bonds. For Seoane the past is never preterite; this is
obviously a self-portrait of himself in 1955, insisting
"upon the expression of human faces, / on the lines that
are repeated in the figures of all people" and reproduc-
ing "with the charcoal on the paper, / these new faces in
which always will stand out, / relating one drawing to
another, / the peasant image that springs from my heart"
(pp. 97-98). This beautiful self-portrait in verse is an
eloquent expression of Seoane's aesthetics in seeking the
essential and eternal qualities that unite people rather
than the passing image. For him the common denominator
of his artistic humanism is the face of the peasant that
constantly appears in his work despite changes in tech-
nique and style. Even in Seoane's portraits of individu-

als a spirit of fraternity and community is visible,
perhaps in the slight abstraction or stylization so char-
acteristic of the artist which seems to show that basical-
ly we are all—or should be—peasants.

Still more evident in this book is Seoane's literary
tendency toward irony, often increased by a medieval
atmosphere. The physician Bernardo who heals the poor
and wretched is "helped" by monks who recite prayers to
undermine his work. "The Vagabond Knight" vanquishes the
knight who played the part of Death in the "Dance of
Death," but will himself succumb to death that is not
playacting. There is also irony implicit in the elegant
queen denuded by an angry mob seeking justice and in the
beautiful virgin witch burned to death for her "carnal
relations with the devil," because there are always new
masters and innocent victims. As in The Soldiers'
Minstrel, the medieval world is not far from our times.

The title of Seoane's third book of poetry, included
in his Poetic Works, As cicatrices (The scars, 1959),
is significant in that scars are formed when wounds have
closed or been cured but continue to give visible testi-
mony. In the "Dedication" the poet again adopts a per-
spective of fictionalized self-contemplation observing a
child born in an emigrant home, a child that cries, then
listens and sighs. It is truly a painter's self-
portrait, since the pictorial artist cannot employ the
convenient verbal "I" as the writer can. He has to
project himself in a more objective fashion, view himself
as if he were someone else. In another poem the author
imagines himself in an alter ego distant in time and in
space, as a silver worker named Madamus who decorates
shields and swords of the Teuton kings, loving his native
Galicia from afar and exalting it with his work, "like
emigrants of all times, / of then, / of today" (p. 127).

Here for the first time one notes in Seoane's poetry
the use of a collective "we" that links him to his coun-
trymen, as in "Silencio" (Silence): "We fight for the
community of men" (p. 142), and in "Noso poblo" (Our
country), where he sees his land at the door of History,
unable to enter. In "O pasado" (The past) he expresses a
hope for freedom in the future, a commitment "we remember
always, / even from the grave" (p. 134).

Seoane's verses at times give a staccato impression of
hammer blows that accentuate each ideal ("happiness, /
precision, / clarity, / justice," p. 142) or each abuse
("embargos, / villainies, / inventories, / taxes, /

assessments," p. 144; "collective killings in the
streets, / despoilment, / plunder," p. 137). These
verbal blows have all the vigor of the strong blots of
color, black overmarkings, and bold outlines character-
istic of Seoane's painting. The pictorial accompaniment
to The Scars and the next book, With All the More
Reason, is reduced to a few abstract designs, as if his
poetry now does not have pictorial correspondence. Also
new is allegorical vision seeing Galicia as a ship in a
storm, surrounded by sirens and a "land monster," and the
region's problems as a struggle between man and rats.

A maior abondamento (With all the more reason), as
the title suggests, continues the themes and allegories
of The Scars. Galicia is personified as a ragged old
woman who chases away the crows that alight on the
branches of her trees and on her person, an isolated mad-
woman whom the artist Laxeiro "who saw her in the moun-
tain of Lalín / told us / he never dared to paint" (p.
154). The region is also personified as "O home que
marcha" (The man who keeps moving).

Some poems recall old Spanish novelesque or blind-
man's ballads inspired by real events such as "Verda-
deiro sucedido nun Nadal" (True Christmas happening)
in which a Galician mother dies in the snow trying to
visit her children, separated by order of the govern-
ment because they would not reveal the hiding place of
her guerrilla son, who ironically suffers the same fate
as another son of a saintly mother 1,950 years before.
The subject of another poem, the emigrant Basalo Gómez,
could be another ballad hero, living in a sewer pipe in
Plaza Libertad ("Freedom Plaza"!), hoping for better
times, with a faraway look, the same we see in so many
faces painted by Seoane. Another case, like that of
Basalo Gómez, taken from newspapers, is the tragedy of
Celsa R. I. who, unprepared to fend for herself at the
death of her father and sailor husband, hangs herself,
and the poet asks with biting irony, "Who could care
about Celsa R. I. / in an accursed land of emigrants /
gnawed at by usurers, / oppressed from afar by bureau-
crats?" (p. 181). In the last poem of the volume the
artist-poet Master of Echternach says, "I think: / I
sketch life," explaining that in other times he illus-
trated the Gospels, but that now he knows the Gospels
are in the life he sees around him. Like Seoane, he
finds dignity and heroism in the humble people of all
times.

General Observations

Seoane's definition of drawing is "expressing in one single line that apparently expresses nothing all the passion of the artist," corresponding to the same simplicity, vigor, and clarity we find in his writings (11). His paintings transmit a sensation of freedom in that linear markings do not have to coincide with the outlines of a form and the artist is free to change his style, medium (oil, mosaic, tapestry, ceramics, metal, wood, etc.), and genre (paintings, posters, illustrations, murals), just as different genres—essay, narrative, theater, and poetry—express his love of freedom and human dignity. The characters are the same in his writings and paintings: peasants, sailors, beggars, and countryfolk in their daily heroism that seems to be nothing more (or less) than a form of meditation. We do not find, however, any clear intention of social protest in Seoane's painting, which reflects nostalgia, ideals, work, and fraternal communication, save for occasional exceptions like Trece estampas de la traición (Thirteen etchings of betrayal), satirical drawings inspired by the national trauma of 1936. Irony appears in his Retratos furtivos (Furtive portraits, 1968), pictures in which, like his poetic alter ego, the Master of Echternach, he "sketches life." The rapidly sketched portraits are captioned by handwritten comments like "What a shame! . . . The mental level of a television set," or "A fearsome, ordered character, like a killer," so that writing and drawing are combined.

We may very well ask why social orientation appears only occasionally in Seoane's painting but is the principal impulse behind his literature (12). We suspect the answer lies in a problem that preoccupied another Spaniard, born in Granada, who found himself in Argentina. Francisco Ayala proposed the question, "For whom do we write?", since the displaced writer is deprived of his natural public (13). Seoane was a professional painter esteemed in Argentina where he universalized the Galician peasant whose memory inspired him by depicting him in a dimension that is simply human. His murals in the Municipal Theater General San Martín, the Bank of the Province of San Juan, the ceiling of the Santa Fe Gallery, and other public centers are meant for a broad range of viewers who live in Argentina. In other pictorial activities, in the illustration of books and the design of book jackets, the literary work of others serves as his inspiration.

His literature, and more particularly his poetry, responds to other motives of a personal nature and springs from his experiences as a Galician of conscience. The pictorial idiom is direct and immediate in its impact; line, color, and form are perceived by the observer without presuppositions or cultural preparation, but the printed word involves considerations such as language, cultural allusions, and ideological content which demand a public capable of receiving and understanding them. To a certain point it can be said that Seoane's theater is more like his muralistic art because, being written in Castilian and rooted in the collective Galician past and present, it may be understood by a wide audience. Injustice and class struggle were at the time pressing themes not only for Galicians, but for Spaniards in general and perhaps even more so for Argentines. Seoane's poetry, written solely in the Galician vernacular, sugests that it is for Galicians, not only those like himself, in exile, but also for those who remain in their homeland. In poetry he finds a means of expressing the indignation of a man carrying "the scars" of a personal and collective past, of a Galician who moves between two worlds and hopes for a better future.

Recalling for a moment the ragged old woman beating away crows whom Laxeiro did not dare to paint, we might well ask whether Seoane ever painted her. This image of a "black Galicia" ("black in her rags . . .," p. 154), so similar to the sad, ragged Castilla Antonio Machado depicts in some famous verses, certainly appears in his poems and plays. Unlike José Gutiérrez Solana who shows us the same Black Spain in his paintings and writings, Seoane expresses in literary form the problems of his region as a patriotic and loving obligation reminiscent of the spirit of the Generation of 1898. In his paintings he exalts the humble without alluding to the problems that form the central orientation of his literary creation. Laxeiro, he tells us in "That Old Woman and the Crows," did not dare to paint such a sad vision; neither did Seoane. We do not find in most of his painting an attraction for the grotesque or violent that could link him to the Goya of satirical etchings or to the Picasso of Guernica because he did not generally approach themes of this type with the paintbrush but rather with the pen, leaving eloquent poetical and dramatic testimonies befitting a fine Galician writer of conscience.

Chapter Eight
The Surrealist Worlds of E. F. Granell

Born in La Coruña, Galicia, in 1912, E. F. Granell is an extraordinary example of a writer-painter in the tradition of Surrealism which practices the brotherhood of the plastic and literary arts. His reputation as a painter was firmly established, however, before he came to the fore as a writer, and in fact these talents are joined to that of an accomplished violinist. It was Granell's painting that brought about his first meeting with the Spanish public after over thirty years of exile in France, the Dominican Republic, Guatemala, Puerto Rico, and the United States. He joined the Surrealist movement in 1942, shortly after meeting André Breton, and since 1946 has participated in international expositions of that movement as well as in those of the Phases Group in Paris since 1960. His painting The Last Haitian Night of King Cristophe (1960) may be found in the Museum of Modern Art in New York and other works in museums in Guatemala, Puerto Rico, Río de Janeiro, Santo Domingo, Norfolk, and New York. His paintings were exhibited in the Spanish pavilion at the Biennial of Venice in 1964, and three years later a one-man show in Madrid marked the rediscovery of the painter Granell by the Spanish art public. In the catalog of that exhibit Santiago Arbós Ballesté noted that Granell is "one of the most significant contemporary Spanish artists but his prolonged absence from Spain has resulted in our not knowing or having forgotten him" (1).

E. F. Granell is known internationally as a painter. A brief report on his life and works appears in José Pierre's An Illustrated Dictionary of Surrealism, as he is recognized in many European and American publications, and he was awarded the prestigious Copley International Award in 1960 (2). Granell's achievements as a writer were recognized later than those as a painter, but we discovered that the great poet Juan Ramón Jiménez was quick to perceive in the artist the presence of a talented writer and said so in his book Estética y ética estética (Aesthetics and aesthetic ethics) in 1957, "I

don't know why I think Granell was a writer before
he was a painter. And I think his painting would be
more humanized with the alternation of his impres-
sionist writing. For if imagination is something which
belongs only to man, at the same time everything hu-
man belongs to the imagination. Write, Granell, write"
(3).

One reason for the late rediscovery of Granell as a
writer is that his major fictions appeared after 1959 and
were published abroad, mainly in Mexico, making their
distribution very difficult in Franco's Spain. Then,
too, the Spanish reading public was diffused by exile and
postwar problems, to say nothing of the effects of censor-
ship. Another reason may well be the general reluctance
to accept an already well-known painter into a new cate-
gory of "specialization."

Literature and Painting

Granell's view of the close relationship between liter-
ature and art is proclaimed in the Cervantes quotation he
uses as the epigraph to his book of essays La "Leyenda"
de Lorca y otros escritos (The "Legend" of Lorca and
other writings) in 1973, "History, Poetry, and Painting
symbolize one another and are so similar that when you
write history you are painting, and when you paint you
are composing" (4). There is a definite poetic side to
Granell's painting, particularly in the metaphorical
content. This is underscored by his choice of imagina-
tive titles in accordance with the Surrealists' penchant
for unusual titles, which are literary creations rather
than pictorial since they rely on language. Granell's
titles of paintings often contain literary allusions as
in Teresa of Avila Wonders Whether to Return to Toledo
or Not, The Cid Is at the Right, Garcilaso Exiled in
the Danube, Through the Secret Stair Disguised (a
quote from San Juan de la Cruz), Sharks Like Drops
(García Lorca), and The Daytime Dream of Balso Snell
(inspired by a novel by Nathanael West). Others are
chosen for their auditive qualities, Coffer of Coffee of
Corfú, or for their humor and absurdity, Posthumous
Portrait of Guillaume Apollinaire, Watching Fred
Astaire Dance, and At Last There Is a Sewing Machine in
the Monastery.

Granell's Unique Surrealism

The art critic Santiago Arbós Ballesté, describing Granell's style of painting, comments, "The first thing which draws one's attention is his originality. It doesn't resemble anything; it has no relationship to anyone. It lacks antecedents and references. There is no way to know where it comes from" (5). This same originality marks his literary creations also, remembering that Surrealism can be as personal and varied as people are. Granell's commitment to the Surrealist movement came at an early stage of his artistic career after he met the "Father of Surrealism," André Breton, in the Dominican Republic. For Granell Surrealism is not merely an artistic style of writing or painting but rather an all-encompassing philosophy whose only end is to grant complete artistic freedom to reveal one's own conscience, subconscious, and individuality in a world in great measure blinded by conformity and logic.

Granell's fictions can only be dealt with in the light of his Surrealist intentions and his concept of Surrealism as a spiritual state characterized by a radical nonconformity and quest for unlimited freedom. His writings include lyrical essays, journalism, humorous essays, reviews, literary criticism, novels, and short stories, paralleled in his pictorial art by a variety of media including oils, gouache, watercolor, collage, construction, drawing, and lithography. In both disciplines one notes in Granell's work a progressive degree of abstraction and dehumanization, although in the spirit of the Surrealists (who in contrast to the Dadaists did not attempt to destroy the relationship between word and idea), fundamental human content and concern are always present. No matter how dehumanized the figures may be in Granell's painting, the human condition is still visible and recognizable, though stylized in geometrical shapes, mere suggestion of features, baroque trimmings, mechanical parts, or disfiguring bumps, just as in his writings the characters may seem absurd and their adventures unbelievable, but they never lose their human dimension. Granell's Surrealistic worlds may appear absurd, but only to remind us how absurd is the "real" world we think is so logical.

Surrealistic Novels and Pictorial Counterparts

La novela del indio Tupinamba (The Novel of the Indian Tupinamba, 1959) has the distinction of being the only humoristic novel treating all aspects of the Spanish Civil War. Its humor unmasks the tragic absurdity of the war that wracked the author's homeland and had tremendous international repercussions. A frontispiece shows two fierce aborigines dressed in feathers and armed with spears. Under the photos is the caption, "The Indian Tupinamba on the left, author of this novel, with the editor on the right." The central figure of the novel is the Indian whose name is that of an intensely savage tribe of South American Indians but who in comparison to those who overran Spain during and after the Civil War, is ultra-civilized. He has the very useful ability to take off his head at will, useful because it conveniently prevents others from taking it off by force. It saves him from being killed by a Stalinist chief who lines him up against an execution wall. Fascinated by the "trick," he convinces the Indian to show him the secret of his autodecapitation, to which he accedes, except that he doesn't tell the Stalinist how to put his head back on, which allows the Indian and his gypsy companions to make their getaway.

Curiously enough, Indian heads formed a favorite motif for the painter Granell a full fifteen years before The Novel of the Indian Tupinamba was published. Seventeen pictures entitled Indian Head appear in the catalog of his exhibit in the National Gallery of Fine Arts in Guatemala in 1945. On the cover of the catalog for a show in the Tourism Office of Guatemala sponsored by the Popular University in January, 1947, there is a sketch of a Conquistador with his right hand raised before a naked Indian wearing a headdress of seven feathers, fitting the description twelve years later of Tupinamba "with his rear in the air, as one could see very well, and with a wheel of colored bird feathers placed on his head" (6). The most surprising detail of the drawing, however, is that the Indian's head is separated from his body, foreshadowing Tupinamba's marvelous ability to defy those who would try to conquer his free spirit. The Cubistic rendering of these early pictorial Indian heads, revealing facets normally hidden to the eye, has its literary counterpart in the metamorphosis of Tupinamba in various identities—bookseller, hunter, soldier, farmer, and

Indian—likewise hidden to the "Realist" eye.

The absolutely free spirit of the Indian Tupinamba which refuses to bow to conventionalism and tyranny is illustrated in an adventure in which he and the gypsies are imprisoned in a small room. The gypsy father complains, "Imagine, shutting us up between four walls!," echoing the universally accepted idea of what a room is, but Tupinamba, not about to be a slave to words or conventional concepts, exclaims, "We're saved! This room has only three walls" (p. 85). The prisoners manage to escape through the missing wall, which had been felled by a bomb. The episode has its Surrealist message: How many of us could be liberated by escaping through the wall that conventional thinking erects to imprison us!

The action of the novel not only covers the days preceding the outbreak of hostilities but also the war and its aftermath, including exile to "the Western Republic of Carajá," whose name is a play on an obscenity in Spanish and disguises overt reference to the Dominican Republic under Trujillo. An example of how Granell's humor often borders on anguish is the questionnaire the Spanish exiles must fill out in order to enter the country that will admit only farmers: "Farmer" becomes the only answer to questions regarding name, place of birth, parents' names, the name of the Holy Spirit, etc. Questions as to race, political credo, and marital status likewise elicit the desperate answer: farmer. This incident also invites one of Granell's favorite techniques, enumerating unrelated items in a list that underlines the absurdity of the situation. He explains that Carajá would not grant visas to eunuchs, atheists, Communists, Fascists, Monarchists, dentists, dressmakers, rapists, masseuses, misogynists, astronomers, magicians, tambourine players, etc., and that "since all racial discrimination had been abolished from the country, it was useless to request a visa if one was mestizo, creole, mulatto, Siamese, Syrian, Aryan, Jew or Basque, or belonged to the yellow oriental race or the red Indian race, as well as white, black or gray, all olive shades being equally excluded" (p. 128). Absurd? No more so than some of the ridiculous and arbitrary laws of immigration that exist in more than one civilized country! Certainly no one could accuse the painter Granell of excluding any color from his human repertoire, for he admits figures whose colors are as arbitrary and bizarre as their forms. A counterpart to the random

enumeration technique may be Granell's collages and constructions employing the most diverse materials. The final part of The Novel of the Indian Tupinamba focuses upon the economic, intellectual, and moral deterioration of postwar Spain—with biting satire that has no evident parallel in Granell's paintings.

El clavo (The nail, 1967) may be considered a Surrealist science-fiction novelette. Here we find an outstanding "'ready-made' Surrealist object" in the titular nail that becomes infused with magic, myth, novelty, and transcendence. The novel begins with the "scandalous" discovery of a nail in the western wall of Dr. Pachín's laboratory in the "perfect" society of the United Regulated Territory where nails have long been banned as mortiferous objects blamed for the most disparate ills of mankind; namely, hunger, misery, cold, contagious diseases, hereditary diseases, sinusitis, hoarseness, thinness, usury, cough, itching, nervousness, calluses, allergies, neuralgia, insomnia, logic, gonorrhea, baldness, rheumatism, metaphysics, tooth decay, diarrhea, revolutions, committees, competition, savings, virginity, obesity, numismatics, and a host of other "ills" (7). A further example of the Surrealist procedure of spontaneous association considers generically as "nails": cannons, bricks, shovels, airplanes, ovens, bicycles, hammers, umbrellas, and elevators, which all have in common the potentiality for violence, recalling the Nazi ovens and crimes that take place in elevators. In the novel Granell attacks the cult of science and the suffocating effect of Communism, against which the Pachín family has rebelled by the unspeakable crime of resuscitating a prehistoric relic of violence—a nail.

Some of the elements in this novel that appear in Granell's paintings are the family theme, connotations associated with the color blue, and the Surrealist object of the nail. Families are very important in Granell's fictions, as protagonists in The Nail and in the stories "La moldura" (The molding) and "El aeropuerto" (The airport). If the town of the Naveira family in the novel Lo que sucedió (What happened) were as united as the exemplary family, Granell tells us, it would not have suffered all the problems it did; "nothing is more sacred than family life, which we might deem the collective cell of individual privacy" (p. 30). The family is stressed in Granell's 1956 oil paintings, The House of the Explorer, The Manufacturer's House, and The Gardener's House.

The color blue appears when the Pachín family's house is "aureoled by blinding blue radiations" (p. 68) and in other Granell fictions in the presence of the marvelous. It is a positive color related to water, sky, and air, which in The Nail suggests resistance to the color red implicit in the Spanish red, meaning "network" by which the United Regulated Territory maintains its power, and which, of course, is a term associated with Communism. The color red is often in Granell's paintings a harbinger of death as in his prophetic painting Encounter in the Sea of 1956, with its sea of fire and blood. Blue is dominant in several canvases, notably The Builder of Boxes, The Secret of the Literary Plaza, The Wedding of the Bandit of Córdoba, and The Dream of a Granada Maiden.

The novel Lo que sucedió (What happened), which was awarded the Don Quixote Prize in 1967, relates the story of a student who takes part in a strike at his university and is subsequently pursued by the authorities. He hides in a painter's studio on his uncle's small farm but is found and taken to court, from which he manages to escape with his sweetheart Damiana. It all sounds too logical to be Surrealistic, except for the details: The purpose of the student strike is to protest against anti-strikers; the painter's studio in which Carlos Naveira hides happens to be underground; his uncle plants eleva-tors on his farm; and the judge demands the farm be brought into court as evidence!

In addition to the black-and-white ink drawings which illustrate the text, other Granell paintings reflect similar themes. The cubed "ready-made" Surrealist object celebrated in The Builder of Boxes recalls the marvel-ous elevators cultivated by Uncle Matilde. In The Judg-ment of Paris of 1956, three judges occupy the upper portion of the canvas while below them, underground, is the accused under a horse, just as Carlos Naveira is covered and almost smothered by the farm which has to be pleated in order to fit in the courtroom. The abysses and underground caves of What Happened and the dark well in which the scribe of the story "Jessica" is imprisoned are similar to the underground and underwater worlds of Granell's paintings in which Segundo Serrano Poncela and Claude Tarnaud note an "abyssal" quality (8). The Gardener's House does not focus on the blossoming garden but rather on the seeds below ground with the faces of the family rendered in browns, golds, and reds.

Granell: Illustration from *Lo que sucedió*, courtesy of the artist.

Other paintings seem to cut transversally into trunks,
rocks, and unknown organs, so it is not clear whether we
see interiors of landscape or of the human body.
The scenario of What Happened is Spain and Granell
does not miss the opportunity to satirize. The painter
Concheiro works on an immense picture of Spain's techni-
cal contributions to the world, including such "wonders"
as the wineskin, mystical ectasy perfected, infantry, the
discovery of continents, the siesta and arriving late
everywhere, the eraser—that began as a piece of bread—
the headache as an excuse not to do anything, "sexual
avarice packaged in Donjuanism," the sausage, the auto-
giro, the tortilla, the submarine, etc. An unforgettable
scene is the assembly in which the university provost
addresses the students as a grave is being dug on the
platform—another allusion to subterranean worlds. He
alleges that in spite of Spain's lack of technology, "our
graves are not like the luxurious mechanical ones of
other countries, but nevertheless are as much tombs as
the best" (9). He also celebrates a book which has been
donated to the institution and which turns into a "Sur-
realist object":

> This object, visible, inaudible, ponderable, and
> measurable if we note the number of its pages, lines,
> paragraphs, letters, etc., forms the entity we know as
> book, designation commonly and voluntarily accepted by
> the highest authorities in the matter. In short, here
> is, in fact, a book. Nothing less than a whole book
> as perhaps Unamuno would have said or if you prefer,
> less than a whole book, nothing, as probably Seneca
> would not have hesitated to say. (p. 131)

The provost continues with a protracted description of
the binding and origin of the leather. It is a sad com-
ment on postwar Spain when we consider that the universi-
ty provost sees the book as an object to be contemplated,
touched, and celebrated—everything but read.
Although all of Granell's novels have great universal
significance, there are numerous allusions, both in names
and in anecdote, to Spain. The artist's deep concern
with his homeland is also evident in his painting, from
the 1940s to the present, referring to the conquistador,
the bullfighter, Carlos V, and the Bandit of Córdoba,
all Spanish figures of daring. A major difference, how-
ever, between Granell's painting and writing is that the

social satire apparent in many of his literary works is
not visible in his pictorial work, other than in the
reduction of the human head to diminutive circles or of
human limbs to animal hoofs, perhaps to remind us that
"we still have a good deal of animal body and little,
very little, of human head" (10). His canvases do, how-
ever, attest to the importance of social interaction by
including multiple figures or depicting social discourse
as in The Art of Conversation or several paintings of
the 1970s in which clouds or flowers issue forth from the
mouths of the figures.

Attacking Conventionalism

Although Granell's paintings do not actively satirize
social or political foibles with the intensity of his
writings, implicit in their unique Surrealism is a con-
stant attack on conformity and conventional thinking that
is likewise a concern in his literary works, particularly
in his short stories. One such story is "Federica no era
tonta" (Federica wasn't dumb), among the most extraordin-
ary stories in the Spanish language for its inventiveness
and humor. The narrator professes to be Federica's best
friend and defends her against accusations that she is
stupid. The problem is that Federica suddenly appears
with exaggerated bumps and protuberances in her chest,
stomach, face, and ears which turn out to be caused by
the fact that she had been pregnant and had had a child
that remains inside of her in such a way that the mouths
of mother and son coincide and the little hands protrude
through her ears. Federica's other friends belittle her
for not even being able to do what any woman can do—give
birth to a child in the normal way—but the narrator
claims that a woman who invents a new way of doing such a
timeworn thing is anything but dumb. The situation pro-
vides the opportunity for Granell to poke fun at the
scientists and physicians whose lack of imagination
reveals itself in the repetition of the traditional mode
of birth with few variations and in the technical diagno-
sis that "the genetical compensatory conscious-
subconscious would effectuate itself prior to semivoli-
tive psychic-corporal disposition by means of the
patient's rejection of any idea of assimilation to the
conditioning norms of the vaginal mechanism to the equal-
izing bias, that is, what we have defined as 'the

imaginative-copulative-generative complex' (ascendant)
versus 'assimilative-copulative-generative trauma' (tradi-
tionally descendant)" (11).

The story of Federica is a tremendously humorous
attack on conventionalism, proclaiming the inalienable
right of all people to be the masters of their own bumps,
for, as the narrator asserts, "we all have our defects"
(p. 14). Granell obviously exercises the same right in
his paintings in which figures bear the most unusual
protuberances on all parts of their bodies. Opposition
to uniformity and conventionalism is also apparent in the
fact that parts of the human or animal body that we are
accustomed to see as matching pairs are depicted quite
differently, with limbs being clothed in different ways.
Eyes too are often unmatching and on unequal levels,
especially in the paintings of Indian heads, correspond-
ing to a surprising discovery Granell made afterwards,
that the Mayas submitted aristocratic children to a
strictly scientific process which rendered them cross-
eyed as a mark of their social status.

Another story of special interest to teachers and stu-
dents is "La cámara negra" (The black chamber), set in a
dark classroom in which the students are attired in
black. The bell rings signaling the beginning of the
class with the ritual throwing of the chalk to the pro-
fessor, who is the object of admiration when he catches
it. He traces an impeccable rectangle on the blackboard
and then disappears. In the absence of a rational explan-
ation panic, anger, hostility, and confusion erupt. Sud-
denly the rectangle disappears and the professor appears,
explaining that he had drawn the rectangle so he could
leave the class and reenter. The students feel relieved,
laughing at what they consider a joke, but the professor
again traces a rectangle and disappears through it. The
story ends as it had begun, with the ringing of the bell
to begin the class.

The story has serious implications for academia. The
word cámara means both "room" or "chamber," and "cam-
era," for this classroom is like the dark interior of a
camera, a "box of silence" conditioned by habit and lack-
ing intellectual illumination. The group is hostile
before the unknown and the explanation of the professor—
a veritable Surrealist hero—provokes laughter. It is an
indictment of education that only appeals to the realist
mind, confining young people in a dark camera or chamber
with exit only possible for those who are not afraid to

draw a chalk rectangle and leave through it.

Many of Granell's fictions concern the theme of imagination itself and how realist thinking, logic, and reason inhibit fantasy in the same way that so many of his literary characters find themselves imprisoned in oppressive places or situations. Only Surrealist heroes like the Indian Tupinamba know how to elude such pressure. Granell also reveals scorn for convention in his painting by ironically using conventional art techniques to depict unrealistic worlds. A practice so universal as outlining, for example, is not, as Granell reminds us, realistic since nature does not outline. Yet he insists in Art y artistas en Guatemala (Art and artists in Guatemala) with reference to Mayan art that "as everyone knows, bodies are outlined, just as painters show them, Mayan painters and others, without finding it necessary to say that this outline cannot be seen since painters, because they paint, are the only ones who truly see" (12). The classical mode of communicating perspective through progressive reduction in size, respected by Granell in such paintings as The Builder of Boxes, The Horse Courteous with Women, and Inauguration of the Volcano, is virtually useless since the convention takes place in a completely fantastic world which is impervious to such realistic trappings. Another similarity between Granell's writings and his paintings is that in both, composition is baroque with little open space, yet never superfluous. Each fiction or canvas is a law unto itself, immune to the outside world's rational rules and conventions.

Despite the many similarities in the artist's two modes of creative expression, there are several differences in addition to the previously noted tendency toward literary satire not readily discernible in his pictorial art. Tremendous humorism sparks Granell's fictions, often the humor for which Spanish writers have long been famous—black humor of the "tragicomedy" that combines humor and pathos. The humor in his writings springs from situation, exaggerated logic, linguistic manipulation, surprising metaphors, taking clichés literally, overly technical vocabulary, alteration of logical sequence, acceptance of the absurd, and surprise at "normal" situations. Much of the humor is the result of the relationship between ideas and words, the tools of literary creation, which may be why it is ever present in Granell's fictions while his paintings never strike us as

funny or hilarious, although they do communicate optimism and sometimes sport funny titles.

One pictorial motif reiterated enough to be conspicuous is the horse, appearing in Granell's paintings as early as 1947, but seldom in his writings (13). it is present in the previously cited drawing of a conquistador and Indian and in the canvases Tamer of Horses, The Transmission of the Flowers of the Autumnal Horse, The Veterinarian Chasing Away the Big Fly that Bothers the Horse, The Horse Courteous with Women, Horse Thieves, The Tamer of Horses of the King of Poland, The Judgment of Paris, and others. The horse seems to be a symbol of strength and masculinity akin to that of the nail and its varied manifestations.

Some of Granell's paintings may be considered comments upon his views about art and the artist, as The Seizure of the Poet, suggesting the risk of free expression, and The Characters Come Out of the Clouds, undoubtedly an "explanation" of Surrealist inspiration. In another painting a sculptor frantically chases after a statue that is sprouting green, the color of life and vitality, as it runs toward a body of deep blue water observed by a bull-like boatman. Granell seems to tell us that the creator can no longer control the fruits of his creativity and in doing so he gives us complete license to exercise our own imagination, to match our creativity with that of the artist. All of Granell's work, both in literature and in painting, is a disquieting invitation to the free exercise of the creative imagination.

This exercise of fantasy is not gratuitous in Granell as the eminent Spanish art critic A. M. Campoy perceptively notes in attributing the painter's preference for imagination over reality to an expression of opposition to the morals he observes around him. Campoy sees ethical implications in Granell's desire "to translate the real into a marvelous language, refusing in a virile and moral manner to contribute to the persistence of images of a tragedy" (14). It is significant that the critic refers to the "marvelous language" of Granell's painting, for it is present also in his writings, making him one of the early cultivators of the "magic realism" and linguistic experimentation that mark the "New Narrative" of Spain and Latin America.

Chapter Nine
Four Galician Artists

The literature of the region of Galicia has long been known for two salient characteristics: its regionalism and penchant for mystery and fantasy. The first manifests itself generally in what has been called galleguidad or galleguismo, a spirit of collective consciousness that has led to the expression of common traditions, legends, social concerns, history, and art. In the 1920s writers like Rafael Dieste, Castelao, and Lorenzo Varela worked toward developing the Galician vernacular as a means of artistic expression, a program interrupted by the Civil War but carried on in exile in Argentina. As for the second characteristic, we might say that Galicia's "magical realism" antedates this century and is present in the writings of Rosalía de Castro, Ramón del Valle-Inclán, Alvaro Cunqueiro, Rafael Dieste, and E. F. Granell, to mention just a few of the better-known names. Even those who, like Granell and Valle-Inclán, do not consider themselves galleguistas are marked by this propensity toward what Dieste has called "ontological mystery," which he views as a particularly Galician vocation (1).

To the above characteristics we should like to add another, the willingness to welcome and encourage the confluence of painting and writing in one person, so that the word "artist" may aptly be applied to the writer-painter and painter-writer without ever reverting to the restrictive phrases we encounter in references to the "writings of the painter Solana" or "the engraver Baroja." Dieste, who painted in his youth, was deeply interested in Galicia's painters and writers, while Seoane, as we have seen, often illustrated the writings of his contemporaries, as well as his own. The design of tapas or book jackets is a popular Galician art and those who cultivate one or the other discipline seem relatively free to try their hand at the other. Can it be only a coincidence that in addition to Seoane and Granell, whose work we treat in separate chapters, no less than four Galician artists have achieved recognition in the fields of writing and painting?

Castelao

Alfonso Rodríguez Castelao's boundless commitment to
the support of Galician culture both in Spain and abroad
was inspired by his great love of his patria chica
("little homeland"), which he called matria (a play on
the word patria, literally fatherland, to make it
"motherland") (2). As an unenthusiastic medical student
in Santiago de Compostela, Castelao (1886-1950) began to
draw caricatures inspired by the funny side of life, but
when he became a clinical physician he obviously saw
things differently, as his satirical drawings of those
years would suggest. He left the medical profession
after five years to work as a functionary, caricaturist,
and critic of Galicia's social and political ills, includ-
ing its caciques or political bosses, extreme poverty,
and emigration. After the Spanish Civil War which
brought his exile in Argentina, his works reflect disap-
pointment and bitterness. A late self-portrait depicts a
cadaveric blind man being led by his son; in the back-
ground is the unmistakable landscape of Castelao's native
Rianxo. He had on several occasions suffered temporary
blindness and it may be said that even in exile he was
"sempre en Galiza" ("always in Galicia"), as he titled a
book of essays published in Buenos Aires in 1944.

Castelao's caricatures were not only well known in
Spain and Argentina, but in the United States as well,
where they appeared in several prominent magazines (3).
His intention, as he explains in an essay, is not to exag-
gerate features but rather to express psychological
states with the fewest lines possible (4). Not all his
sketches, however, are based on economy of lines; often
more serious subjects demand more elaborate treatment and
darker tones that appear inspired by Goya's satirical
etchings. He illustrated some of his own works, pub-
lished several albums of etchings, and exhibited exten-
sively, winning a medal for his triptych, The Blindmen,
in a National Painting Exhibition in Madrid.

Castelao, writing in the Galician vernacular, responds
to the inspiration he explains in his prologue to
Retrincos (Remnants) in 1914: while submerging himself
in his life as an artist, he gathers some "dry remnants"
that do not find plastic realization (p. 189). He goes
on to say that personal experiences can be conserved in
the memory much better than bodies in the grave, "They
are things that happen to a person and give pleasure when

they are narrated and believed" (p. 190). He asks that we believe what he recounts but will forgive us if we don't. His writings include essays, newspaper articles, diaries, investigations, travel impressions, stories, a novel, a drama, and what he calls Cousas (Things), a potpourri of several of these genres. Personality seems more important than style. Dr. Ramón Baltar Domínguez points out that Castelao's expression is simple, direct, and precise, revealing an exceptional aptitude for synthesis, both in his written and pictorial creations (Castelao ante la medicina, 37).

It is natural and fitting that critics have centered their comments upon Castelao's galleguidad, in view of his dedication to Galician themes and the fact that he chose to write in the vernacular rather than in Castilian. They have recognized, however, that his amazingly varied works, both literary and pictorial, reveal a strong ethical orientation and social concern which go beyond the regional. His irony, satire, and caricature unmask errors, prejudices, and abuses which are Galician but at the same time simply human. Dr. Baltar perceives three general periods in Castelao's production—an early humorous perspective, a later critical attitude, and finally a serious state of mind. This is true and yet there is something that connects all these orientations and that has not attracted critical attention: a consistent vein of morbidity, a Solanesque fixation with death and the macabre, perhaps rooted in his medical studies, and present from his earliest literary works to the last. It sometimes gives rise to black humor reminiscent of "cruel jokes" contrasting with Castelao's major orientation, since it seems devoid of any discernible social or cultural purpose. These expressions of an obviously personal preoccupation with death provide a glimpse of something he felt and feared. It is present not only in his essentially "literary" works and drawings, but also in his research essays on sculpted stone crosses found along the roads of England and Galicia, published in 1930 and 1949, respectively. He relates these crosses to "the collective tradition of our people—children of death and of the night" (p. 123).

The first manifestation of this macabre vein may be found in Castelao's Remnants of 1914, whose prologue recalls his experience as a doctor in the Great Hospital of Compostela's emergency room where a dying suicide victim led him to observe that the dead are inordinately

lazy, stretching themselves out in any ungainly posture, not even composing themselves to receive mourners. They let themselves be buried and eaten away just so they don't have to return to life. Open the coffin of anyone who has been dead for seven years, he tells us, and all you will find are bones and shoes, but the bones are in the very same position as when the man was buried! "Who would see in this joke the fears I gulped down in the company of a dead man?" he reflects. These fears undoubtedly accompanied Castelao throughout his life and appear in his creations as a sort of memento mori in humorous or serious form.

The short narrative "Un ollo de vidrio" (A glass eye, 1922) is introduced by a Mark Twain quote that "underneath humorism there is always great pain; for this reason there are no humorists in heaven" (p. 169). A gravedigger of the municipal cemetery hands him some papers and a glass eye he found on a corpse. The manuscript contains the "memoirs of a skeleton" who recounts conversations with his skeleton neighbors and several anecdotes that provide the opportunity to comment upon politics, physicians, and vampires (who turn out to be caciques). "A skeleton has to be a humorist," remarks Castelao, "and a Galician skeleton even more so" (p. 182). At the end the narrator-author opens the grave of a friend, leaving him the glass eye and a pen and paper so he too can write his memoirs.

Among the Things Castelao published in two volumes in 1926 and 1929 are some rather macabre selections, one a literary sketch of M. Lavalet who makes a living in Paris by selling human remains such as glass eyes, hair, bones, mummified fetuses, and skin cured for leather. "A Sad Story" is another horrible selection and when the narrator repeats again and again, "Don't laugh, because the story is sad," we wonder how he could possibly think anyone would laugh. It is the story of Doña Micaela who, unable to bring a pregnancy to term, lovingly keeps her five aborted fetuses in jars decorated with their names and dates and with silk ribbons for the girls. She devotes her life to taking care of the jars until a servant accidentally drops "little Adolfo," upon which Doña Micaela expires. Another set of "things" proposes a ten-minute play to be staged in two scenes, the first depicting peasants crying over a dead cow but repeating popular sayings that exaggerate the importance of the cow's death and make the audience laugh, and the second

showing a dead dog placed on a silver platter on a damask
pillow and mourned by a noblewoman and her daughter who
say silly things that make the audience laugh since the
death of a dog is not such a tragedy, explains the
author.

The novelette Os dous de sempre (The same two as
always, 1934) contains a "cruel joke" episode involving
poor, overworked Farruco, trying endlessly to keep his
numerous children fed. Aunt Adega frequently sent the
children a big box of goodies, which they gobble up eager-
ly as a great treat. One day the father finds himself
with yet another addition to the family and his eldest
son, Pedro, annoyed that the morning meal has been forgot-
ten in the excitement, asks his father where the little
one came from. Farruco, just to say something, answers
that Aunt Adega sent it. After some thought Pedro asks
happily, "And when do we eat it?" (p. 210).

Death is the theme of Castelao's farce Os vellos non
deben de namorarse (Old men shouldn't fall in love),
staged in Buenos Aires in 1941 by Maruxa Villanueva
Galician Theater Company, one of the exiles' great cultur-
al achievements. Years later Rafael Dieste recalled the
impact the play had upon the audience—as "a picture that
by its own magic suddenly concedes movement and voice to
its figures"--and the masks, made by the artist, which
served as portraits that saved the actors the effort of
excessive mimicry (5). The play purports to show, as its
prologue announces, how old men who try to outwit death
by belatedly falling in love with young women are actual-
ly courting death. It is a traditional theme in Spanish
literature, treated by Cervantes and Moratín, to mention
only two authors, but in Castelao the accent is on death,
making it even more exemplary than Rodrigo Cota's early
sixteenth-century Diálogo entre el Amor y un viejo
(Dialogue between love and an old man), which merely
points out the old man's physical deterioration. Three
cases are illustrated, the first a pharmacist who commits
suicide when scorned, the second an alcoholic nobleman
who drinks himself to death while the young object of his
affections trades him kisses for land, the third a rich
old man who convinces a young woman to marry him but dies
in a fit of rage because of his own impotence.

Castelao explains that it is a work "imagined by a paint-
er and not a literary man" and that the colored sets are
of utmost importance, referring to the alternating black
and green backgrounds repeated in the three parts (6).

Castelao: *The man who didn't want to die and did*, from Dr. Ramón Baltar Domínguez's *Castelao ante la medicina, la enfermedad y la muerte*, courtesy Sociedad de los Bibliófilos Gallegos.

Black, of course, suggests death while green, used as a
backdrop for the ten country women who appear in each
part, suggests both nature and the "viejo verde" ("green
old man," comparable to "dirty old man"). Other artistic
effects are provided by real actors' heads protruding
through portraits on the wall and through curtains upon
which their bodies are painted. The book is illustrated,
with some figures in color. Despite a good deal of humor
and costumbrista scenes, the play reveals a
preoccupation with death, personified as a character in
two skits. In the "posthumous" epilogue, the three old
men, now skeletons, receive news about how well the three
girls have fared, rich and married to their young lovers.
The emphasis is not so much upon the inappropriateness
of an old man's aspirations to young love as it is upon
death. Castelao's pictorial rendering of negative themes
seems motivated by a desire to criticize and effect
change while in his writings—which also treat social and
political concerns—such themes appear to be gratuitous.
We would conclude that death had for him a personal
horror beyond that of the poverty and misery that he
often attacked in his works. It was evidently one of the
"dry remnants" he salvaged from his immersion in painting
to find its personal expression in his writings.

Cándido Fernández Mazas

Fernández Mazas (1902-42), whose premature death cut
short a promising career as writer and painter was,
according to Sebastián Risco, "one of our most brilliant
artists that with pen or brush contributed—and would
have continued to contribute if his destiny had not been
sheared by an early death—to affirm the personality of
Galicia in the first half of the twentieth century" (7).
He was a standardbearer of the "new aesthetics" in the
1920s in opposition to traditional imitative art and
insisted on a picture of two dimensions, liberated from
the material corporality of nature. Risco characterizes
his illustrations for the book of poetry, Kindergarten
of Francisco Luis Bernárdez, as filled with candor and
simplicity and his colored pencil drawings on black paper
as rising from a background of mystery, "a germinating
and fertile nothingness." After a painting trip to
Paris from which he returned in poor health, Fernández
Mazas published Santa Margorí in 1930 and died a few
years after the Civil War.

Fernández Mazas's disinterest in reproducing or imi-
tating reality is evident in <u>Santa Margori</u>, a combina-
tion of lyrical theater and narrative in which fantasy,
reality, myth, and symbolism coexist. In the first of
three scenes Sister Margori resists Dionysios's entreat-
ies to join him in the forest to enjoy nature and the
present. In the second she is visited by her childhood
sweetheart Ronsel who returns after a long absence and
invites her to enjoy life and love with him, and in the
last she is obviously five months with child, delirious
and dying, attended by a cynical doctor and visited by
the Devil and an Angel in her convent cell.

Some of the characters belong to Margori's fancy,
Dionysios who brings her dreams of the senses, and
Misiú, the smooth elegant Devil, not half so bad as
Sister Teresa, the Bishop's "niece" (euphemism for daugh-
ter), who disguises herself as the angel Moonlight to
trick Margori into signing away her worldly goods to her
and who blesses her with the title of "saint." It is a
strange play, with a medieval atmosphere but notably
contemporary in its allusions. Margori's sainthood is
her agonic struggle between body and soul, eternity and
spring, heaven and hell, renunciation and human love.
The language is extraordinarily lyrical with a unique,
imaginative use of adjectives: "twenty-three ingenu-
ously celestial and tormented years old" (8), "winged,
faeric, eternal embrace" (p. 115), "Ronsel's cosmic
mariner look" (p. 112), "astral, cosmic, eternal affec-
tion" (p. 167).

The visual orientation of the artist personifies sensu-
alism, love, death, and evil in the form of mythological
or fantastic characters. The look of Margori is des-
cribed in visual terms as "horizontal, fainting," and
that of Dionysios as "perpendicular, shameful." Deliri-
um, symbolic dreams, fantasy, and ambiguity lend a poetic
quality and sense of mystery. Ronsel urges Margori to
leave her cloister to discover the miracles of each day,
and although the play is called a parable, the only
perceptible message seems to be that one of life's
miracles is "magic love."

Lyrical elements, however, contrast with others of
irony and cynicism, in line with Dionysios's description
of Fernández Mazas in the play as a fatalist and cynic
who would like to de-animalize man and make him more
human, bring heaven to earth, and stop the purging of
sins. The fairy-tale atmosphere ends before the "fall"

Fernández Mazas: Illustration from *Santa Margorí*, courtesy Armando Fernández Mazas.

of Margorí, followed by visits from the lecherous doctor
and the deceitful sister. With humorous irony Margorí
reflects, "Poor Misiú, your life has been hell," and re-
minds the devil that he is remembered constantly in the
convent when he laments the fact that no one believes in
him, poor devil, since he can only live when there is
faith. Ironically, the nuns believe the stories that Father
Birdie tells them about his heavenly encounters but
refuse to believe that Margorí was visited by an angel.

The accompanying line drawings of "real" and fantastic
characters are done in slender, delicate lines, only
enough to suggest, in the same way that the play suggests
but does not spell out, what has happened to Margorí.
Her ingenuous, lyrical qualities are conveyed beautifully
by the drawings while the doctor, a harsh nun, and the
suave Misiú are more caricaturesque. The book is imagin-
ative and original, yet it is curious to note that the
themes of ingenuous religion, angels, and mariners are
also present in poems by Lorca and Alberti written during
those same years.

Issac Díaz Pardo

Born in Santiago de Compostela in 1920, Díaz Pardo
has been a driving force behind the growth of art and
industry in Galicia in recent years. Frustrated by the
Spanish Civil War in his desire to be an architect, he
studied in Italy for a year and this influence can be
detected in the female figures of his paintings, remini-
scent of the full-bodied matrons of Italian Renaissance
art. The artist's spirit, however, far from leaning
toward art for private collections and patrons, shows
strong social commitment. Early paintings depict sensual
nudes done in bright, warm colors, especially pinks, and
even the shadows are reddish. About 1954 he left for
Buenos Aires where he began the Magdalena ceramic indus-
try, having developed a similar endeavor in El Castro
Ceramics since 1949, in which he himself worked with fine
transparent porcelain and ceramics. Between 1954 and
1968, when he returned to live in Galicia, Díaz Pardo
made several trips to his native land. While in Buenos
Aires, in 1957, he published a volume of two plays in the
Galician vernacular, Midas. O ángulo de pedra (Midas.
The angle of stone), which seems to mark a turning point
in his artistic career.

The first play presents the efforts of the rich and
powerful King Midas to wrench the secret of man's destiny
from the reputed wise man Sileno who revels in wine,
women, and song, preaching the futility of knowledge and
power, erased by death, to his youthful followers.
Scorned by Sileno's disciples, Midas plans to make the
old man confess by means of a potion and discovers that
his happiness is based on wine and women. Midas wonders
whether man's existence is so low that its secret can lie
in a drunkard and perverter of youth. Sileno, deprived
of wine by Midas, is desperate, for without it he is
conscious "and being conscious is being chained at the
edge of the abyss" (9). Midas calls Sileno depraved and
empty; the latter in turn accuses him of hypocrisy and
teaching precepts of theology, caste, patriotism, and
morality that deny the value of life itself. Spare your-
self and go kill yourself, he advises the distraught king
who dies among the phantoms that torment him. Midas
presents a difficult conflict between two equally unsatis-
factory extremes. Midas has wasted most of his life
creating lies and arbitrary laws but falls in love with
Sileno's beautiful but amoral daughter. Sileno is an
infrahuman "flame of vice and sensuality" whose coveted
secret of existence and happiness is rooted in escapism.

The Angle of Stone, whose title refers to the angle
where two roads cross, is about a young man, Antelo, who
preaches against exploitation and, denounced by the Moral-
ist, the Politician, the Usurer, and the Judge, is
hanged. His father, the village schoolmaster, avenges
his death years later by luring the four to a tavern he
now owns and poisoning their drinks. The first of the
three acts corresponds to the day the son is born, when
amid the father's satisfaction we hear the people's com-
ments about their harried lives and a blindman's premoni-
tions. The second act presents the son's preaching and
assassination twenty years later, and the third, the
father's revenge. The scene in which Antelo is hanged on
stage foreshadows Díaz Pardo's later pictorial tremen-
dismo ("truculence"), but is alleviated by a very
lyrical scene when the son's body is taken down from the
scaffold and held by his father as in figures from a
Pietà. In the best Galician tradition of mixing real-
ism with fantasy, Antelo explains his faith to his father
and his hopes that his example will not be forgotten,
after which the father returns the body to the scaffold
where it is found by the townspeople at dawn. They tell

the father, who pretends he is a stranger, that Antelo
was the father of the poor but died without redeeming
them because he would not flee from the powerful when
they came for him.
 Lyrical elements are provided by singing children,
lamenting townswomen, and tavern dancers. One detail is
noted in the crowd of rushing people, that of eyes wide
open, as if traumatized by their problems, and in the
wide-open eyes of Antelo before the truth. Likewise, one
characteristic of Díaz Pardo's art which is very notice-
able is that he paints "expressive childlike faces of
immense eyes" (10). As the schoolmaster announces, The
Angle of Stone is, unfortunately, reality "with a little
theater mixed in." The reality is Galicia's misery, mis-
fortunes, and problems, which are the subjects of a port-
folio published in 1956, entitled Unha presa de dibuxos
feitos por Isaac Díaz Pardo de xente do seu rueiro (A
group of sketches done by Isaac Díaz Pardo of people of
his village). It seems, then, that the writing of the
plays coincides with a change in the direction of Díaz
Pardo's painting, for seven years after the former were
published, the artist exhibited paintings of Galician
countryfolk at work in which the pinks of former days now
yielded to blues (11). A 1965 series of Twenty Nudes of
Cecilia the Acrobat from which social themes are absent
forms a sort of parenthesis, but at the same time the
sensual beauty of woman is a theme appearing in both
plays alongside the philosophical and social concerns
treated there.
 In the 1970s Díaz Pardo finds a blending of both the
literary and pictorial arts in a way that reaches a broad
public, in the romance de ciegos ("blindman's ballad"),
a genre that goes back to the Middle Ages and is particu-
larly associated with the pilgrimages from Europe along
Saint James's Way to the tomb of the saint at Composte-
la's famous cathedral. The blindman's ballads were
recited and also sold in sheets folded into four pages
upon which they were written in verse or in prose. While
some specialists in the traditional Spanish ballad scorn
these popular stories, Julio Caro Baroja sees in them a
valuable reflection of folk values. He notes their
frequent characteristic of tremendismo linked to moral
or religious messages "using a formula known to religious
historians, 'mysterium tremendum'" (12). Around the mid-
seventeenth century a brotherhood of blindmen in Madrid
were granted the privilege of hearing the stories of the

lives of prisoners sentenced to death and composed ballads about them, a practice that despite efforts to restrict it continued into the twentieth century (13). Other characteristics of the genre are regional flavor, fantasy, satire, irony, and moralistic overtones. From the above description we can see that the blindman's ballad is a genre that fits perfectly into Díaz Pardo's concepts concerning the "Social Function of the Arts" as outlined in a 1970 essay on the "Significance and Origin of the Restoration Operation at Sargadelos." There he notes that art was associated with the people and the individual artist's importance was minimized until the Renaissance when art became a privileged activity directed almost exclusively toward private collections. Designing a cheap mass-made art product to "massify and degrade the individual," however, is not a desirable alternative, he tells us, and closes his notes asking "what kind of art is, socially speaking, not popular art?" (14).

Díaz Pardo's blindman's ballads, published individually in booklets or folders, are very handsome tabloids, including musical scores and employing traditional ballad meter with assonant verses of eight syllables. The protagonists are always identified by name to seem all the more real and authentic, although they could be anyone. The drawings are declared to be by Díaz Pardo, but the stories are attributed to the Blindman Zago, which is a pseudonym of the artist himself. The tabloid entitled A nave espacial (The space ship, 1970) is of the more fanciful, humorous variety, about an emigrant couple who make enough money to rent a space ship and manage to "get away from it all" (15). We find the repetition that recalls the traditional ballads: "Manuela married Juan / Juan married Manuela." The black-and-white sketches depict conglomerations of people, nudes of ample forms, faces with huge eyes, and a fantastic space ship.

A theme that preoccupies Díaz Pardo is that of Galician emigration and its effects. The ballad of Paco Pixiñas told by himself (1970) relates the dubious success story of a poor, almost illiterate farm boy, initiated early in the pains of economic injustice, who emigrates to Venezuela where he finally manages to open a store. By learning the art of cheating in business, he becomes rich, a friend of the powerful, and even an investor in property in La Coruña (Galicia). He is very

proud of all the appliances he has ("my home looks like
an electrical plant"), of eating meat twice a day, and
being attended to by fawning servants. His advice to
fellow Galicians is tragically humorous, "that all Gali-
cians in a huge line / abandon their land / and come to
the Americas / as I did one day / to open a store."
There is an introduction consisting of proverbs of a
"Count de Vimioso the Elder" and an ironic epilogue by a
"Celso Emilio Ferreiro" explaining that eating too much
led to Paco's death, his wife had been deceiving him, and
his fortunes had increased as his decency diminished.
Comic-book-style drawings in fifteen frames show such
scenes as Paco gobbling up his meat at an elegant table,
Paco among his powerful friends and protectors, and an
interminable line of Galicians filing into a waiting
ship. Paco Pixiña's name becomes a symbol of this type
of emigrant, whose riches cannot hide his abjectness.

An even more vehement denunciation of injustice is O
crimen de Londres (The crime in London, 1977), about
"the maid who strangled her mistress because of music"
told by Blindman Zago (Díaz Pardo). It is the story of
Carmen Varela, whose numerous family lived in misery and
hunger before the notable "silence of the Academy in the
law they imposed." In order to seek work abroad, Carmen
had to submit to the indignities of an English "mister"
who examined the emigrant girls to qualify them for work
in England as domestics or in more lucrative but shameful
occupations. As a maid Carmen is tormented by the ill-
behaved children and the dirty work she must do, as well
as by daily scoldings from her mistress in a "pluperfect
English" she does not understand. One night she is badly
mistreated and complains to the consul of her country who
advises her to be patient, for the money she sends to
Spain is making it great. That night her irate mistress's
scolding has a "new music" to it which frightens the poor
girl who in fear and desperation strangles her. Ironical-
ly the Academies now take an interest "since the law that
they gave us has been broken." The story of Carmen is
enough to deter any would-be emigrant girl from leaving
the misery at home for another abroad. The fifteen bold-
ly outlined drawings, each one of which fills a section
of two large folders, depict the more coarse and trucu-
lent events, like the strangling of the mistress while
the master is absorbed in his television program. The com-
bined satire of word and picture makes it clear that laws
function to protect the powerful and punish the weak.

Díaz Pardo: Two frames from *O Marqués de Sargadelos*, courtesy of the artist.

The blindman's ballad entitled O Marqués de Sargade-
los (The Marquis of Sargadelos, 1970) has an informative
dimension since it recounts an episode of local history
behind the restoration project at Sargadelos discussed in
the aforementioned essay as a revival of a previously
frustrated path. At the end of the eighteenth century
Antonio Raimundo Ibáñez, the Marquis of Sargadelos,
recognized Sargadelos as an ideal site for tapping iron
and steel resources and set up Spain's first industrial
boilers there. He took advantage of the kaolin in the
area to establish a factory for fine English-style ceram-
ic china. In the essay Díaz Pardo comments that "an
obscure episode of our history put a violent end to
Ibáñez and later on to his industries."
 The ballad purports to tell both the achievements of
Ibáñez and his errors. The singer recounts how the
Marquis, whose portrait was painted by Goya, established
Spain's first boilers in opposition to directives from
Madrid, but imprudently punished workers when problems
arose, thus alienating the people. With the French inva-
sion of Spain the British came to "help," providing an
opportunity for the Madrid government to get rid of the
independent Marquis who had defied its orders. Ibáñez,
"with his eyes wide open," does not see the trap and with
the pretext of the Carnival rite of the symbolic "burial
of the sardine," the crowd seizes him. He is brutally
dragged through the streets by a horse while General
Woster pretends not to know, for "Woster does what they
order him / since he is a good patriot." The angular
drawings show the straight-faced Woster engrossed in the
job of brushing his uniform, the horses dragging the
Marquis, the eyes of the victim wide open in terror as he
is taken by the rabble. Irony, truculence, and the sing-
er's asides and expressions of amazement contribute to
the dramatic impact. The blindman's ballads combine
poetry, music, drawing, and drama and provide Díaz Pardo
with a medium in which to express his concerns for Gali-
cia and its people. He succeeds in modernizing an old
genre to offer fantasy, history, and social comment in a
form at the same time popular and artistic.

Tomás Barros

Tomás Barros (1922), professor of drawing at the
University School of the Faculty of Basic General Educa-

tion at La Coruña, has exhibited widely both in Spain
and abroad in Biennials and individual showings. His
first book of poetry, Gárgolas (Gargoyles), was pub-
lished in 1950, one year before his first exhibition of
paintings. Founder and co-director with Luz Pozo Garza
of the magazines of poetry and criticism Aturuxo (1952)
and Nordés (1975), he has published a total of six
books of poetry, five plays, and essays on subjects as
diverse as astronomy, aesthetics, and literature. In
this brief study we shall refer only to his most recent
poetical works, A imagen y semejanza (In his image)—
winner of the First International Poetry Prize in the
Iberoamerican Writers' and Poets' Guild of New York's
twelfth competition—and Abraio (Amazed, 1978), written
in the Galician vernacular.

The paintings of Tomás Barros have a unique and
immediate impact upon the observer. His canvases of the
1970s often portray groups of figures at work which, seen
as a whole, are a dynamic composition of repeated and yet
varied angular forms, larger in the foreground and small-
er toward the background, yielding a strong sensation of
rhythm. The recurrent alternation of strong and weak
elements, colors, and forms constitutes the inimitable
pictorial style of this artist. Rhythm is also one of
the major "pure categorical elements" that Barros studies
in his book Los procesos abstractivos del arte contempo-
ráneo (The abstract processes of contemporary art,
1965), which presents the development of art as a life
process dialectically motivated by the antithesis subject-
object and producing different stylistic periods (16).
In his discussion of rhythm, he refers to its role in
revealing unity within diversity and establishing the
interdependence of the whole and the part, which as it
increases yields a greater sense of abstraction. Rhythm,
he tells us, came into its own at the end of the final
Cubist period; its processes involve form and color and
each artist elects the particular rhythmical elements he
uses. He cites and reproduces a photograph of Giacomo
Balla's Progressive Lines Plus Dynamic Sequences as an
example of dynamism achieved by alternative tension and
relaxation.

Those who have written about Tomás Barros's painting
have been impressed by his own use of rhythm. Fernando
Mon says, "In the predominance of total rhythm, one of
the most recent conquests of Tomás Barros, the configura-
tion of forms becomes more complex and zigzagging, adapt-

ing itself to the composite theme and extracting within
its abstraction expressionistic values of reality" (17).
J. Lyra Domínguez applauds the "rhythmic harmony of a
vibrant whole" in his "algebraic painting, sometimes
approaching abstraction" (18). Rhythm in Barros's paint-
ings springs from the varied structural repetition of
geometrical form (mainly rhombi) and of color or light,
as underscored by the title of one of his works, Rhythm
of Lights over Mountains. There is also varied thematic
repetition in multiple figures that are recognizable as
human forms despite a considerable amount of abstraction,
using Barros's gauge of the degree of interdependence
between the whole and the parts.

Rhythm, of course, is a concept equally applicable to
literature, defined by Webster as "the repetition in a
literary work at varying intervals and in an altered form
or under changed circumstances of phrase, incident, char-
acter type or symbol," a description which aptly fits
Barros's poetry where rhythm springs from recurrent but
varied themes, images, and structures. His most frequent
images relate to existential concerns: chains (limiting
man); stairs (diversely as hatred, light, spiritual
ascent or descent); and mirrors, labyrinths, and doors
(mysteries). In addition, each image evokes its own
dialectical rhythm of alternation between opposites of
uncertainty and ambiguity, as in "A porta que se abre"
(The door that opens), where the door that frees may
imprison and "an outside . . . might be inside" (19), or
in "La escalera" (The stairs), where the poet says, "I
could never find out / whether I have been ascending
toward the glorious light / or going in descent / to the
dark abyss!" (20).

As the title Amazed suggests, Barros is perpetually
amazed by life's mysteries and uncertainties that produce
rhythmic alternation. In "Las metamorfosis" (Metamorpho-
ses, I, 87-88) he says we never know whether we are
outside or inside, actors or spectators, existing or not,
or whether the saint is a sinner or the living the same
as the dead. He tells us in this poem that truth is
protean and changing, which may explain why he so often
portrays multiple figures carrying out the same task.
Barros suggests a dynamic, ever-changing reality by the
rhythmic repetition of similar yet different forms and
colors.

Another characteristic present in this artist's paint-
ing is intense social consciousness, as in his pictures

Disasters of Wars II (1974) and Shooting (1979).
Likewise, in an essay on poetic expression he affirms
that "poetry has to give irrevocable testimony of its
time, of the injustices and crimes against Humanity,
maintaining in this a commitment with the other arts and
with the progress of the disciplines and sciences of the
Spirit" (21). As Salvador Lorenzana notes in his intro-
duction to Amazed, these poems render testimony of
abysses and holocausts. Barros sometimes poetically
symbolizes these concerns for mankind in individuals such
as Ann Frank, the anonymous man forced to dig his own
grave (In His Image), or in mythological and religious
figures including Prometheus, Icarius, Jacob, and "the
Man tied to the column." He also treats social themes
characteristic of Galician literature in poems like "A
percura dos probes" (In search of the poor), "¿Onde está
o pobo?" (Where are the people?)—with the insistent
rhythmic repetition and variation of this question—and
"Esquencidos" (The forgotten), a tribute to anonymous
heroes and martyrs.

Some differences between Barros's poetry in Galician
and in Castilian may be observed in that the former con-
veys greater simplicity with the increased use of repeat-
ed clauses (as in "Eu non vexo a bandeira" [I don't see
the flag]) and of sustained imagery reminiscent of
Robert Frost in English, in that a dark forest, a door
that opens, or a night that seems like a great open piano
encompass the whole poem in their metaphors. The Gali-
cian poetry also seems more accessible to simple folk,
assuming at times even a conversational tone.

Collective concerns are not always the theme of
Barros's poetry or painting, but even in individual
portraits in both media, the universal is perceptible.
In "Poema a miña muller" (Poem to my wife), the poet
finds "in one only woman / all desired women" (A, 121).
Barros's pictorial portraits of individuals employ
abstraction within his own definition, in the similarity
among details and the whole since face, clothes, back-
ground, and figure are rendered with similar angular
forms and contrasts. Something in his portraits under-
scores the generical rather than the individual and this
is also true of his portraits in verse. The "literary"
part of his paintings, their titles, also implies the
generic, Maternity, Heads, The Thinker, Chessplay-
er, Woman at the River Bank, Woodsman, Portrait,
etc. Parallel themes occur in Barros's painting and

Barros: *Shooting*, courtesy of the artist.

poetry. Paintings such as <u>Prometheus Chained</u>, <u>The Disasters of Wars II</u>, <u>Shooting</u>, <u>The City in the Night</u>, and <u>Chessplayers</u> have their counterparts in poems, as do the solitary men who reflect the theme of existential aloneness in both media.

One might ask whether anything in the poetry of Tomás Barros indicates to the unknowing reader that he is also a painter. Such signals are extremely rare, perhaps an occasional allusion to painting in "this hanging / canvas that is life" (<u>I</u>, 133) or in describing his confusing "each face with that of the Universe, / the living and the painted" (<u>I</u>, 136). We might be tempted to recognize the painter when the intangible assumes linear form in "spirals of shadow and of silence" (<u>I</u>, 93), but on the other hand it is the poet who describes concrete spatial characteristics as intangibles: "That was a village / as long as the wind, / as high as melancholy" (<u>A</u>, 44). Barros's poems are rich in allusions to artists, notably Klee, Malevich, Chagall, and above all Bosch, whose influence upon his portrayal of multiple figures, distance from subjects, view of the dual nature of man, and social and ethical concerns may be noted.

A high degree of Expressionism exists in both Barros's pictorial and poetic works in that they are intimate views of life, reality configured by his particular vantage point and personality. The poetic first person, whether explicit or implicit in the verses, is deeply enmeshed in the lyrical fabric of these social, metaphysical, and spiritual reflections. With regard to the use of color, however, his poetry and painting differ substantially, for in his paintings color is as prominent as rhythm, while in his verses it is minimal. Miguel González Garcés says of Barros's paintings that heavy strokes of pure color are applied to achieve expression by means of color in a fashion reminiscent of the Fauves and Van Gogh (22). José Vilela Conde refers to the painter's fantastic configurations of color which give his vision of reality great expressive richness, and Pablos asserts that "Barros has, preferentially, passion for color" (23).

No such "passion for color," however, is reflected in the poetry of Tomás Barros. Only one poem, "Azur" in <u>Amazed</u>, is dedicated to color, in an Expressionist manner insofar as blue produces sensations that evoke the hangman, cold, glass, captivity, hope, and death unaware. Blue is a very dominant color in a number of the artist's

paintings in true shades of the color or in greenish or
purple shades. One painting is explicitly entitled Reef
in Blues. The poems occasionally mention white, pink,
or blue but are extremely sparing in their coloration, or
assume characteristics that are not visual such as "a
color that kills" in "La lucha de Jacob y el Ángel" (The
struggle of Jacob and the Ángel).

Instead of stressing color, the verses of Barros con-
tinually interplay light and shadows. In "Jugando al
ajedrez" (Playing chess), we encounter light and dark,
which lend themselves better than the expected red and
black to the expression of existential intuitions. Allu-
sions to light appear in titles of paintings, Chiaroscu-
ro in the Library, Sparkles on the Mountain of the Port
(Muxia), Trees Against the Light, and Effect of Light
on the Cliff. Barros's interest in shadow as a poetical
element is evident in his study, "El símbolo de la som-
bra en Rosalía y la poesía" (The symbol of shadow in
Rosalía and poetry), in which he concludes that the enig-
matic term "shadow" is used by Rosalía de Castro,
Cernuda, Unamuno, and Neruda when the poet lacks words to
express that which cannot be formulated or named (24).
Darkness and shadow in contrast to light seem to be used
by Barros in a similar manner in "A sombra no muradoiro"
(The shadow on the wall), "O bosco e fusco" (The forest
is dark), "Ariadna en la penumbra" (Ariadne in darkness),
and in several other poems.

As we have seen, there are a number of parallels
between the poetry and painting of Tomás Barros with
regard to themes and rhythm, but there is little in his
poetry that tells us that he is a painter, something
which perhaps is explained by his statements in "Da
esperencia poética" (On poetic experience): "I don't
think that written poetry is all. But it is given to it
to expose human sentiments in a depth that no other
language can ever achieve" (25). Evidently Tomás
Barros uses poetry to express intuitions that he feels
cannot be communicated precisely the same way in picto-
rial language. That is no doubt why he continues to cul-
tivate both arts assiduously and with great success.

Chapter Ten
Other Writer-Painters

In this chapter we shall treat in briefer form other notable cultivators of literature and painting, recognizing of course that each could well be studied at much greater length. Several writers of books and essays on the subject of art and art criticism actively painted at one time or another but made no professional commitment or public exhibit. Eugenio D'Ors, who wrote about Goya, Picasso, Zabaleta, and the Prado Museum, as well as Rafael Dieste, who taught art history and wrote about Galician artists, are among these writers. Even the great philologist and scholar Ramón Menéndez Pidal is known to have sketched on occasion. Gregorio Prieto located a very simple ink drawing of his depicting cows under trees, as well as a drawing by Miguel de Unamuno of The View from the Balcony of my House which he sent to a friend, a rather elaborate realistic rendering of several buildings skillfully shaded in (1). Unamuno sketched occasionally and also cultivated origami, the art of paper sculpture, closing his novel Amor y pedagogía (Love and pedagogy) with a tongue-in-cheek exercise in erudition, "Notes for a Treatise" on making paper birds, which he called cocotología. Prieto reproduces three oil paintings done by the poet, editor, and movie producer Manuel Altolaguirre (1904-59) of flowers and trees which appear heavily impastoed, recalling this author's intense, vigorous poetry.

The great novelist Francisco Ayala (1906) also painted, but did not keep any testimony of this activity of his youth. His interest in art is evident in El jardín de las delicias (The garden of delights, Barcelona: Seix Barral, 1972), inspired by Bosch's famous triptych. The literary vignettes of the section entitled "Días felices" (Happy days) are amply "illustrated" by photographic reproductions of well-known works of art, or perhaps it is more exact to say that Ayala's narrative miniatures illustrate these universal masterpieces by making them "live" in the personal experiences transfigured fictionally.

135

Miguel Hernández (1910-42), the extraordinary poet
whose life was cut short by the rigors of the Prison of
Alicante during the Spanish Civil War, was fond of sketch-
ing and sent drawings with his letters and poems to his
wife and small son, from prison. A number of these are
reproduced in Josefina Manresa Marhuena's Recuerdos de
la viuda de Miguel Hernández (Memoirs of Miguel
Hernández's widow, Madrid: Ediciones de la Torre,
1980). In a tender poem to his child he says "the world
is your horse" and depicts a simply drawn boy mounted on
a brightly colored globe with a wooden horse's head and
legs protruding from it. Hernández also made toys in
prison and painted them for his son. The bright colors
of his drawings done in the tenebrous world of prison
reveal optimism and hope at least for his child's future,
if not his own, and the flight of his own spirit over the
fetters of misfortune. The intentional infantilism of
these drawings corresponds to many poems of similar inten-
tion.

Santiago Ramón y Cajal

Santiago Ramón y Cajal (1852-1934), the world-famous
histologist who won the Nobel Prize for Medicine in 1906,
was also an accomplished writer and painter. In his book
Mi infancia y juventud (My childhood and youth), he
describes his enthusiasm at the age of eight or nine for
painting with colors he dissolved from colored papers or
cigarette wrappers in order to paint despite the prohibi-
tion of his physician father who considered it an evil
distraction. Determined to find out once and for all
whether his son had talent, the father consulted the only
"authority" available in their home town of Ayerbe in
Huesca, a man who had come to plaster and repaint the
church which had been damaged by fire. Complimented by
the unexpected honor, the workman did not hesitate to
destroy the boy's illusions, and so, Ramón y Cajal tells
us, he exchanged the "magic paintbrush" for the "cruel
scalpel" (2). He did, however, continue to fill notebook
margins with drawings and he was permitted to include
drawing in his course work, where he received encourage-
ment from his teacher León Abadías, who even went to
Ayerbe to try to convince the boy's father to let him
study art. At the age of eighteen Ramón y Cajal took up
photography as a sort of compensation and consolation,

and then went on to become a great scientist and doctor.
He wrote numerous medical books and published hundreds of
articles, but found time for more literary pursuits in
his books My Childhood and Youth, Reglas y consejos
sobre la investigación biológica (Rules and advice on
biological investigation), Cuentos de vacaciones (Vaca-
tion stories), Charlas de café (Café conversations),
El Quijote y el Quijotismo (The Quixote and Quixotism),
and Memorias de mi vida (Memories of my life), in which
he reveals a natural gift for narrative and the cultiva-
tion of a genre rare in Spanish letters, memoirs.
Federico Carlos Sainz de Robles calls Vacation Stories
his best literary work for its "strong notes, psychologi-
cal subtleties, rapid sketches of a masterful hand . . .
brilliant coloration . . . original invention," observa-
tions which seem appropriate for describing paintings as
well as literature (p. 20).
 Cajal never abandoned painting but like many artists
separated from their first vocation adapted it to his la-
ter professional needs. His book Memories of My Life,
1923, contains some early art work and many photographs,
but the author's artistic abilities are mainly employed
in the 110 medical illustrations which appear in the vol-
ume (3), for in his essay "On Scientific Investigation"
he maintains that medical drawings are sometimes superior
to photographs because of the clarity they can achieve
(p. 593). Four watercolors done at the age of eight or
nine are included "for those who are interested in such
bagatelles." One is a realistic picture of a farmer
drinking in a tavern, the only obvious flaw the short
stature which, as is common in child artists, reflects
that of its youthful creator. Cajal's judgment is ruth-
less, noting "ostensible defects of drawing and propor-
tions . . . Note a decisive tendency toward caricature
and the ignorance of Anatomy, tendency that many modern-
istic and futuristic painters of today cultivate systemat-
ically with the ardorous applause of a criticism of cir-
cumstance." The other youthful pictures include the
Hermitage of the Virgin of Casbas, the Loarre Castle
near Ayerbe—which he calls one of his artistic obses-
sions—and a rooster, all done with a light touch and
realistic style of a calibre surprising in such a young
boy. These are only vestiges of a once-promising fine
artist virtually lost in the vast quantity of medical
illustrations whose excellence cannot be disputed. A
strange combination of the fine and medical arts may be

seen in an anatomical oil painting reproduced in Dorothy
F. Cannon's book Ramón y Cajal, published by Ediciones
Grijalbo in Barcelona in 1966.
 In all his writings, whether overtly autobiographical
or fictional, Cajal is a realist. In Vacation Stories
his medical vocation is more obvious than that of the
painter in the proliferation of medical terminology (a
kiss, for example, described as the approaching of
"labial cells" [p. 768]), but occasionally a description
of a statuesque beauty (Inés, of "La casa maldita" [The
haunted house, p. 764]), or a very plastic close-up of an
overly made-up woman in "El pesimista corregido" (The
cured pessimist, p. 825) seems almost painted. In his
El mundo a los ochenta años (The world at eighty
years), a personal testimony of aging, he comments upon
"the degeneration of the arts" and defends realism
against Modernism and Vanguardism, expressing his admira-
tion for previous artists who did not violate the "wise
laws of perspective and movement" (p. 381). He feels
that drawings copied from nature are capable of allegoriz-
ing and communicating sentiments without yielding to "the
leprosy of modern art." In the "vacation story" of "The
Cured Pessimist" the protagonist visits the Museum of
Painting where he is horrified at the decomposition he
finds in the "new art." In The World at Eighty Years
Cajal reflects that if he had made a career of art he
would be among those vilified by the "barbarians of the
last twenty-five years" as academic, classical, and real-
istic. He was probably right and his dedication to
medical drawing no doubt saved him from that.

Juan Ramón Jiménez

 The Nobel Prize-winning poet Juan Ramón Jiménez
(1881-1958) was a painter before a poet and after a brief
period of study in Seville in 1897 cultivated both arts
for several years. Between 1906 and 1912, particularly
during the years in Moguer, his home town, Juan Ramón
was extremely active in both disciplines but subsequently
returned to his art work only occasionally. His poetry,
of course, has been studied in depth by many scholars,
but seldom related to his pictorial pursuits. Angel
Crespo's book Juan Ramón Jiménez y la pintura (Juan
Ramón Jiménez and painting) traces the poet's activi-
ties as a painter, his art criticism, typographical work,

and efforts to promote art (4). He sees Juan Ramón's
love of painting reflected in the synesthesia of his
poetry as well as its chromatism, allusions to art and
artists, use of specialized terminology, and sensitivity
to artistic as well as literary movements. We shall
focus our attention briefly upon two subjects not dis-
cussed in this book, notably Juan Ramón's peculiar icono-
graphy and his personal pictorial style, both in relation
to his poetry.

Most of Juan Ramón's oil paintings in the period in
which he was active as an artist are landscapes or sea-
scapes, in consonance with the natural atmosphere of his
poems. His landscapes communicate a sensation or mood of
stillness, sometimes even melancholy, similar to the
atmosphere of Platero y yo (Platero and I), but
strangely enough, in a painter who favored realism, we
can detect a tendency toward Cubism in one landscape of
Moguer in which wooden beams frame a shed and house
behind it. All the structures suggest the surfaces of
cubes and two square tunnel entrances under the shed form
a cubed interior. His canvases are less "busy" than his
poems of the same period with regard to detailed ele-
ments. In one poem, "Paz" (Peace) of Poemas agrestes
(Rustic poems) of 1910-11, he includes leaves, the sun,
hills, a stream, flowers, and birds before summing up the
mood, while trees, foliage, and water done in a rather
Impressionistic style are enough to fill his canvas. The
few portraits the poet painted are stiff, and beyond the
face nothing seems to interest the painter, but his best
work is done from nature with the same elements so often
found in his poetry.

A bird sketched in a very cursory manner in 1919 is,
as the caption above indicates, in the branch of a green
lemon tree. It is a hesitatingly sketched bird whose
timid, uncertain form is so like that of the surrounding
lemons that he seems to become one of them. We are
reminded of several poems entitled "El pájaro verde"
(The green bird) in which the bird, explicit in the
title, is in the poem a yellow leaf, a lemon-green sun-
set, or sensation of a fleeting presence. The picture,
suggesting a metaphorical equation between bird and green
lemon by the same process of visual ambiguity we have
observed in Lorca, achieves a similar effect, but it is
the only such case we find in available pictures of Juan
Ramón.

Crespo tells us that Juan Ramón liked to sketch

Juan Ramón Jiménez: *In the branch of the green lemon tree,* courtesy Francisco Hernández-Pinzón Jiménez for the Heirs of Juan Ramón Jiménez. Photograph courtesy of Raquel Sárraga, Librarian of Sala Zenobia y Juan Ramón Jiménez, University of Puerto Rico.

houses in which he lived and ideal houses. This motif
appears in a poem entitled "El recuerdo se va" (Memory
departs, 1911-12) in which the poet expresses nostalgia
for a house he has left, "Even though the house is mute
and closed, / I, though I am not within it, am in it
still" (5). Religious themes are also present in Juan
Ramón's poetry and art. Two pictures of Christ, one a
sketch done as a child, another a painting in which the
figure is almost obliterated by what appear to be intense
winds and mist, achieve a feeling of spirituality. In
the second the background intrudes on the figures and in
the first, the sketch is not complete, which often occurs
with Juan Ramón's religious poetry, as Graciela Palau de
Nemes notes (6).

The subject most obviously shared by Juan Ramón's
poetry and painting is the female nude which he culti-
vated when he had virtually given up painting in the
1920s, the same time that the theme is developed in his
poetry. Some of the nudes are sketched in a delicate
fashion that seems in harmony with the nude as poetic
metaphor, but others that accentuate some rather crude
details—which could have remained as undefined as face,
hands, and feet in the drawings—constitute a notable
disparity that deserves some comment.

The lightly sketched nudes of abundant tresses forming
a sort of lyrical mane correspond to the nude that ap-
pears in Juan Ramón's poetry after 1918 with Diario de
un poeta recién casado (Diary of a newly-wed poet) and
Eternidades (Eternities) with its famous poem of "nude
poetry," "Oh, passion of my life, poetry / nude, / mine
forever," which Graciela Palau de Nemes calls the "echo
of an amorous passion that turned into poetic passion"
(7). In 1923 the "nude woman, / running mad through the
pure night" is a metaphor for music, with all the delica-
cy and spirituality we find in the poetic nude of this
period, which makes it all the more puzzling that some
drawings so frankly depict the flesh.

The answer seems to lie in Palau's study of the motif
in Juan Ramón's early poetry and its frank eroticism
modulated in different ways during his years in Moguer,
from about 1906 to 1912, when the obsession of sensual
love dominates his poetry. Palau tells us that landscape
is not Juan Ramón's great theme although it is his pre-
ferred natural atmosphere; "the great theme of the poetry
of Juan Ramón is love; when amorous emotion turns into
amorous obsession, at times in perverse sensuality, the

poetry reflects it" (8). Palau believes the poet's mar-
riage to Zenobia brought out his qualities of kindness
and simplicity and toned down sensuality, blending body
and soul with the spirituality present also in many of
his early poems. After his marriage eroticism is subli-
mated, transposed into metaphor, given ethereal or spiri-
tual qualities, but evidently drawing sometimes reveals
what can only be a subconscious eroticism not fully domin-
ated. Two drawings in particular recall early verses of
nostalgia for the flesh, such as a 1911 poem about Juan
Ramón's sweetheart in France with explicit references to
flesh, breasts, sex, and "rejia caballera" ("regal head
of hair"). In another drawing a dark male figure stands
behind and embracing a nude, both figures largely obliter-
ated by swirling dark lines, recalling his early "Balada
del placer idealizado" (Ballad of idealized pleasure), "I
have dressed in black velvet to embrace you nude." Like
the immodest nude who faces the poet and presents herself
to him in Libros de amor (Books of love, 1911-12), some
of the sketched nudes of the 1920s definitely evoke flesh
rather than spirit, in distinct contrast to the poetry of
the same period in which the flesh is sublimated by
spirituality.

Perhaps one of the reasons Juan Ramón abandoned art
once he found himself as a poet was that his pictorial
style of realism could not achieve the magic of metaphor
—he entitled one book Poemas májicos (Magic poems).
In his drawings a nude tended to be a nude, a bird—even
among lemons—still a bird, a house nothing more than a
house, while his verses could transmute them into a sensa-
tion, a mood, or an ideal.

As for the particular characteristics that mark Juan
Ramón's style as an artist, certain elements contrast
notably with his poetic style. Throughout his poetry,
although more evident in his early work, there is a good
deal of color, as so many critics have pointed out, but
Crespo tells us that from 1924 on "he was more a sketcher
than a painter, which doubtless harmonized perfectly with
his rising career as a typographical artist" (9). It is
probable that drawing was simply a more convenient medium
for the occasional artist, but we think Juan Ramón was
more naturally a painter. An unfinished landscape paint-
ing of his years in Moguer shows an unpainted area only
sparsely sketched in as a bare indication of what might
go there, revealing the fact that more attention was to
be given to painting the area. A poet who was so fond of

color in his verses would no doubt find painting more satisfying than drawing and obviously, when he had the time and will, he painted. The only known painting he did in America, which Crespo says was painted during the poet's residence in Coral Gables, may be seen in the Zenobia-Juan Ramón Jiménez Room at the University of Puerto Rico's library. It depicts light pink and white flowers (petunias?) barely distinguished from a pale yellow background. No outlines are clear; rather the delicately painted flowers blend into the vase of green tones and the background in an impressionistic fashion. The softness of color recalls so many of the poet's verses.

Juan Ramón's style of sketching is for the most part different from his mature poetic ideal of simplicity and clarity, since he seldom uses a clear single line but rather superfluous lines that give an impression of insecurity. He retraces and rectifies outlines, sometimes heavily, but does not erase previous strokes in the same way as he refines his poetry for a final version. He prefers repeated lines to shading and uses short strokes rather than continuous lines.

A rather strange characteristic of a number of Juan Ramón's paintings and sketches is that they are not completed, something that is most evident in portrait paintings and figure drawings. A painting of a girl shows her head quite elaborated but no attention given to shoulders and blouse. The same is true of a self-portrait in which no attention is given to careful execution of the body and clothes. This rarely occurs with his landscapes, with the exception we have noted. In the nudes, the torso is given predominance while hands, feet, and even the face remain undefined or fade into the background. There is a decided sense of interinidad ("temporariness"), perhaps due to the boredom of the artist, not really wanting to polish or finish the work, or to his interest in only certain elements of portraiture or of the nude, in the latter case preserving its anonymity (and universality). It seems too that Juan Ramón had not mastered anatomical studies to the point of being able to render simply and easily the human figure in the realistic style to which he committed himself. In any case, superfluous lines and incompleteness seem little in character with the master poet who sought to denude poetry to its essence. If he did paint or sketch in his maturity it was no doubt inspired by his great love for

art and the occasional desire to "visualize" images on
paper or canvas, images which found their finest expres-
sion in his poetry.

Pablo Picasso

Pablo Picasso (1881-1973), the greatest painter of
this century, also tried his hand at writing, both in
Spanish and in French. Besides poetry and theater, his
reflections on art and life which appear as commentary in
several books of his paintings may also be considered as
part of his literary production. José Moreno Villa, who
gives a penetrating analysis of some Picasso poems in his
book Leyendo (Reading), correctly states that they do
not compare with the artist's paintings in value or impor-
tance and only number about five or six (10). Technical-
ly they follow the Surrealist practice of automatic writ-
ing (an uncontrolled flow of words into the mind), but
they do reveal a great deal of congruence between the
artist's thought expressed in poems and in painting.
Moreno Villa notes the tendency to work in series; Picas-
so does a number of paintings dealing with similar plas-
tic elements just as he does in poetry, repeating such
images as the eye of the bull (and taurine references in
general), a lilac-colored dove, and a knife that jumps
with joy. Moreno Villa's analyses of the poems uncover
Picasso's tremendous vigor and dynamism in a continual
succession of verbs, rapid flow of images, and suppres-
sion of punctuation. Picasso's obsession with gastronomy
(to the point of gluttony, with constant references to
food and tableware), surprised the critic who also noted
allusions to Spanish subjects, elements and objects used
in painting, and cruel or lascivious motifs. Moreno
Villa considers the poems very lyrical and reproduces
four of them identified only by their dates, November 28
and December 5, 6 and 24 of the year 1935. Only the
first is divided into verses; the others, full of unusual
and striking imagery, simply flow continuously.
Picasso's subsequent writings include a farce, Le
désir attrapé par la queue (Desire Caught by the
Tail), written during the German occupation in Paris in
1941, with no plot and obsessive dialogue about cold,
hunger, and love, and a play entitled Les quatre petites
filles (The Four Little Girls, 1950-51), an explora-
tion of the child-mind, a subject which fascinated
Picasso. Both are in French.

Trozo de piel (Hunk of Skin) is the first Picasso
poem written in Spanish to be published as a book.
Camilo José Cela's introduction states that it was
written at the painter's villa in Cannes on January 9,
1959, and given its title by Cela at the artist's sug-
gestion. Although Paul Blackburn's English translation
of 1968 is very artistic, it alters the line strength of
the original and omits some of the frequent mentions of
the participle hechos in the sense of "turned into" or
"having become" which is responsible for achieving a
constant sense of Surrealist metamorphosis. In an
example which Blackburn does translate faithfully, "black
/ grapes of cotton and aloes fat and / very erect
become radishes" (11). There are "predetermined cardinal
points / turned into frog and partridge outside and in"
(p. 7) and "clusters of sar / dines turned into rice
powder and fandangos" (p. 11, with my alterations in
italics).

Picasso's technique in Hunk of Skin is essentially
the same as that which Moreno found in his earlier poem
of 1935, with the continued presence of culinary allu-
sions. Picasso continues to identify the poems only by
dates, to fragment reality in a Cubistic fashion, instill
dynamism and movement in the scenes, and enumerate
objects—and just plain numbers—in a torrent of Surreal-
ist automatism so it may be said that his poetry does not
show the same variety that his painting does. There are
frequent allusions to painting: "writ out with fat brush
above / the fragment of syrupy sky" (p. 9), "mallows /
nailed to the gate of the / corral painted in bands / of
ochre for the fiesta" (p. 11), "the mustard-colored / sky
painted cobalt" (p. 25), "if the dirty brushes were not
scraping hopes and hates / off the palette" (p. 29). A
biomorphic image of Venetian blinds leads to a purely
visual effect as if painted, as the sun projected through
the blinds zigzags in the form of stairways: "the laces
/ hanging between the legs of / the Venetian / blinds
half-open into / the room making / stairways of SUN" (p.
15).

Perhaps the value of Picasso's writings is best des-
cribed in Douglas Cooper's comment about his plays:
"Picasso is, after all, first and foremost an artist and
future generations will not judge him by his activities
as a playwright any more than we today judge the great-
ness of Leonardo by his designs for flying machines or
ballistic weapons" (12). The plays are, he says, an
interesting counterpart to Picasso's paintings in another

idiom and contain allusions to many of the same objects
as are found in his pictures. Picasso's lucid comments
about his painting, so often cited by critics, are, like
his poetry and plays, disjointed and fragmentary, but
form very clear statements which taken together consti-
tute a compendium of his aesthetics. In all he wrote,
just as in all he painted, Picasso's vigorous personality
is present.

Jose Moreno Villa

During most of his adult life José Moreno Villa (1887-
1955) actively cultivated both writing and painting. He
published his first book of poetry, Garba, in 1913,
studied art history, and worked as a librarian and archiv-
ist while writing numerous books of poetry. In 1924 he
renewed a youthful vocation of painting and, impressed by
Cubism's color, imaginativeness, and multiple perspec-
tives, encouraged the movement in Madrid, where he exhib-
ited at the Atheneum and El Retiro Palace. After the
Civil War he settled in Mexico where he worked with the
Casa de España and the Colegio de Mexico. There he
published only two more books of poetry but increasingly
dedicated his pen to literary commentary and study in the
form of essays and to his autobiography Vida en claro
(Life made clear). There he notes in 1944 that in his
seven years in Mexico he has written seven books, painted
twenty-four portraits and several dozen imaginative
pictures, and exhibited at the Palace of Fine Arts and
the Gallery of the University of Mexico.
 Life Made Clear contains some fifteen photographs of
his mature art done in Mexico, mostly portraits. it is
curious to note that during this same period his literary
interests changed from writing poetry to studying writers
and their works, which is comparable to portraiture. In
his book Leyendo (Reading) Moreno Villa seems to consid-
er the writings of past and present authors, like the
face in portraiture, as a sort of window to the soul.
 Moreno does not distinguish between literary and picto-
rial portraiture in describing his analytical methodology
and in fact appears to be talking about painting when he
is really referring to writing, "I look for the most
precise thing and in a form that is evident for others to
affirm something concrete. What pleasure! How these
almost anatomical studies delight me!" (13). With regard

to his essays, he explains that "portraiture is not caric-
ature. One must be able to reconstruct the face or the
soul of the subject with the full attention that each and
every one of his facial characteristics demands. And
this cannot be done except by considering, looking and
looking again and measuring all the elements we have
before our eyes, those which are horizontal, vertical,
and diagonal as well as those of profundity" (Reading,
116). He speaks of the "poetical line of San Juan de
la Cruz," culminating words and forms in Garcilaso,
"poetical construction," "portrait of the personali-
ty," and "the human coloration of the writer" (italics
ours).

Moreno's procedure in Reading is that of a portrait
artist who renders the most essential features without
exaggeration in accordance with his definition of the
pictorial portrait in Life Made Clear as "sum and
remainder of physiological details" (14). He seeks in
each study the word that the poet uses most frequently,
instinctively, and unconsciously so that it comes to be a
characteristic feature of his personality. "We all ought
to have a word like that, tenacious and insistent," he
advises. "We do not know what it is, but it will give
itself away in time. It is the key to our sentiment, the
deep seed of our psyche" (Reading, 45). His method
involves taking copious notes until the word or words
become evident, making him a forerunner of the modern-day
computer "concordance studies" on literary works. These
words (divine in Darío; air, moon, and green in
Lorca; shadow in Bécquer, etc.) are then used to re-
create literary portraits of the authors.

The portraitist in Moreno is evident in Los autores
como actores y otros intereses literarios de acá y de
allá (Authors as actors and other literary interests of
here and there, 1951) leading him to note authors' smiles
and eyes. As a painter who writes, Moreno studies Goya's
letters, Picasso's poetry, and Solana's essays. As a
writer who paints, he praises Manuel Machado and Juan
Ramón Jiménez's interest in art and sensitivity to
painting. Moreno combines both disciplines in his
"Ensayo de quirosofía: Dos tandas de manos mejicanas"
(Essay of chirosophy: Two showings of Mexican hands) in
which he sketches the right hand of well-known Mexican
writers and intellectuals "to later conjecture about
their forms, which is to discover their spirit" (15).

Just as Moreno searches for keys to the personalities

of creative people in their writings, hands, faces, dress, choice of spouse, and even names (in a curious exercise he calls "onomatology"), those of his own personality are revealed in his paintings, which say as much about the artist as they do about their subjects. One cannot help but notice, for example, that all his figures have unsmiling expressions. One may very well ask whether the seriousness of the infantile face in his 1938 portrait of Carlitos Martínez del Río reflects that of the child or that of Moreno, with the still-recent horrors of the Spanish Civil War in his mind. Not one subject has so much as a hint of a smile, and it is significant that he chose to paint his future wife, Consuelo, soon after she had lost her first husband.

Another characteristic of these portraits is the absence of background or props, lending a sense of what Moreno, cut off from his native Spain, calls "interinidad" ("temporariness") in his poetry and life (Life, 177). So too his figures, isolated from any specific environment, with staring, faraway, meditative, or surprised expressions, suggest this sensation of uncertainty and temporariness. Even in subjects who seem relatively relaxed, such as Margarita Urueta de Villaseñor, with her hands serenely crossed on her lap, there is a disquieting effect achieved by the tilt of her head and by dark outlining. She seems more posed than relaxed.

Sainz de Robles's description of Moreno Villa's poetry oddly enough seems to characterize his portraits as well: "Another cause of a good deal of strangeness in Moreno Villa's poetry is the contrast between the themes, which are of great delicacy, and the versification, which is hard, muscular, violent" (16). This may be observed in his portraits of women and of the child previously mentioned. While the exceptional angularity of his 1937 portrait of Consuelo may be explained by the crisis she had just suffered, one cannot help but notice that even the delicate ruffles of her blouse are executed harshly and fiercely outlined. Heavily outlined too is the portrait of Federico García Lorca done from memory, especially the folds of his collar and coat. There is a decided lack of softness in the rendering of figure and dress in all the portraits found in Moreno's autobiography with the exception of that of Enrique Díez-Canedo.

Moreno is aware of his tendency toward contrast within the varied lyric styles of his poetry and in the way he views his life. He explains his youth in contrasting terms of land and sea or north and south and describes

the "terrible internal struggle between the destructive
force and that of good or of perfection" (Life, 200).
He reproduces a poem from his book En la selva fervoro-
sa (In the fervent jungle) entitled "Los contrarios"
(Opposites) which he says is one of his frequent themes:

> Un mirlo se paró en el almendro;
> en busca de lo blanco, lo negro.
> Todos vamos,
> con ansia de complemento,
> si somos tierra,
> en busca de cielo;
> si somos aire,
> en busca de encierro;
> si somos quietud,
> en busca de tormento;
> si somos fuerza,
> en busca de blando misterio.
>
> (Life, 203-4)

> A blackbird perched on the almond tree;
> in search of whiteness, blackness.
> All of us have
> a longing for the complement,
> if we are land,
> in search of sky;
> if we are air,
> in search of confinement;
> if we are stillness,
> in search of torment;
> if we are strength,
> in search of soft mystery.

In another of his most beautiful poems he chooses a struc-
ture that underscores contrast and contradiction, "No
vinimos acá, nos trajeron las olas" (We did not come
here, the waves brought us).
 A similar tendency toward contrast may be observed in
Moreno's frequent practice of outlining in his oil paint-
ings. Occasionally the outline is even color-contrasted
in that a dark object, such as Consuelo's shawl, depicted
against a dark background, is outlined in a light color
instead of the usual dark line, in a peculiar procedure
obviously intended to produce contrast. E. F. Granell
notes that Moreno Villa's canvases bring things to the
surface, where they can be seen clearly, by painting with
light rather than shadows (17).

Moreno Villa: *Portrait of Consuelo*, from *Vida en claro*, courtesy El Colegio de México.

In addition to portraits, Moreno did more purely ima-
ginative works, as indicated by a painting entitled
Corderos al abismo (Lambs to the abyss) or an untitled
picture that he appears to be working on in his study of
three rather Surrealistic figures that seem tied together
by flexible propellers, identified by Granell as "a new
vision of three idols symbolical of the three Graces
dancing flamenco." In another strange landscape done in
oil of stark trees, a solitary launch, and birds overhead
Granell finds "the nostalgia of solitude . . . as strong
as in any picture of Chirico's" and a "longing for clari-
ty." Moreno Villa tells us in his autobiography that he
is in his poetry a visual and reflexive individual capa-
ble of going from reality toward other planes, as evi-
denced in the continual poetic transfiguration of reality
that takes place in In the Fervent Jungle (Life, 192-
93); the same seems to be true of his painting.
 Moreno Villa's poetry is always attentive to the pres-
ence of mystery and chance, showing great sensitivity to
superstition and respect for coincidence. He likewise
expresses his desire to portray spirit and mystery in his
pictorial subjects, but somehow his oil portraits of
others seem less an expression of the subjects' spiritual-
ity than that of the artist. In this respect his oil
portraiture is similar to the poetry of Jacinta la pelir-
roja (Jacinta the redhead), where the presence and per-
sonality of the real Jacinta are overshadowed by the
poet's view of her in the light of his personal relation-
ship. Moreno describes painting as "a job, a diversion,
and an expressive medium at the same time" (Authors,
37). The same might be said of his poetry, literary
studies, and autobiography. Indeed that "diaphanous
sentiment of self anguish" which Granell finds throughout
Moreno Villa's autobiography is projected onto his canvas-
es, resulting in the mystery or spirituality that makes
them so unique.

Ramón Gómez de la Serna

The versatile writer and humorist Gómez de la Serna
(1888-1963) often illustrated his whimsical writings with
caricaturesque, comic-strip style drawings. As is often
true of writers who draw or paint, he was interested in
art and artists, writing "portraits" of Darío de
Regoyos, Picasso, Diego Rivera, Juan Gris, Salvador

Dalí, Velázquez, El Greco, y Solana. His famous gre-
guerías ("epigrams"), published in many editions by
Espasa-Calpe in Madrid, starting in 1940, frequently
employ visual images suggested by letters: "T is the
hammer of the alphabet . . . B is the nursemaid of the
alphabet." "Madame Stäel—with two lovely beauty marks
in her name." Ramón's pictorial activity was not limit-
ed to specific periods in his life as can be seen in
Gollerías (Tidbits), an anthology of "humorous and
illustrated episodes" by his own definition which date
from 1917 to 1946, and include such varied and sundry
topics as wedding portraits, chimneys, musical postures,
seahorses, deforming mirrors, yawns, and hearts (18).
Some of the small drawings accompanying the text are
quite simple while others may involve many figures and
even baroque designs. He blackens some portions and
shades others with lines. His drawings are obviously
done with no artistic pretentions; their purpose is to
heighten the effect of the short essays.

In some cases the sketches in Gollerías are essen-
tial to the success of the piece. In a piece that asks,
"What would you do if you lost your head?," for example,
they make it clear that the author is not referring to
the figurative verbal cliché, as the philosopher and
professor in the selection insist on believing, but
rather to the literal possibility of finding one's head
missing. Drawings of a headless body with nowhere to
place its glasses and of a formally dressed couple, the
lady minus her head, represent the answers the author
receives to his question from people who would be quite
happy not to have to spend money and time on hairdress-
ers, shaving, and toothaches.

"Las plantas truculentas" (Truculent plants) is a
delightful piece about certain words in the dictionary
that are never illustrated because they are too subtle
and difficult to represent graphically. Gómez de la
Serna gives his pictorial impressions of energúmeno
(energumen, "wild person") and estantigua ("phantom"
or "bedraggled person"), drawing upon imagination and
dreams. Another essay presents a "graphic dictionary"
for colloquial expressions he illustrates.

Ramón's personality is readily discernible in con-
trast to other artists who depict similar themes. His
illustration for "Experiencias con una pecera" (Experien-
ces with a fishbowl) show some happy fish who have just
had wine dumped in their bowl, a very different picture

from the lyrical drawings by García Lorca of vases with
fish. He also treats subjects that fascinated his friend
Solana, about whom he wrote a biography, notably the
destrozona ("annihilator") carnival masks, clothes hang-
ing on a line, mannequins in a window, dark-clothed women
who are professional mourners, and decapitation, but
where Solana saw only sad caricatures of the living,
Ramón saw diverse aspects of the human comedy.

Gregorio Prieto

No painter has dedicated himself more to portraying
great contemporary authors in both words and images than
Gregorio Prieto (b. 1900). His portraits of Lorca and
poets of the Generation of 1927 exhibited at the Spanish
Pavilion of the 1964 New York World's Fair reveal his
sensitivity to the spirituality of his subjects. The
poet Luis Cernuda stresses the simplicity and underlying
Castilian realism of Prieto's painting while Enrique
Lafuente Ferrari, director of the Spanish Museum of Mod-
ern Art, admires how he captures the essence and express-
iveness of the model (19).

Prieto and Lorca became friends in 1924, and Prieto
later wrote a number of lucid essays about Lorca as a
painter and illustrated some of the poet's verses in addi-
tion to painting several portraits of him. Prieto's
essays have a lyrical quality that is also evident in
his portraits in which the features appear almost sculp-
ted, being softened and made delicate, spiritualized.
Prieto employs a variety of styles even within a single
portrait. The poet Aleixandre's face, for example, is
realistically executed in careful detail while the book
he holds releases fanciful stars and clouds and the hands
are simply outlined. Prieto's essays are likewise unfet-
tered by any one conventional mode, combining subjective
lyricism with more objective observations. His book
Lorca y la generación del 27 (Lorca and the generation
of 1927) combines picture and text, his own writings and
those of others, his own portraits of authors, and paint-
ings done by other writers.

Rafael Alberti

Rafael Alberti (b. 1902) studied painting formally in

Prieto: *Portrait of Vicente Aleixandre*, from *Lorca y la generación del 27*, courtesy Biblioteca Nueva, Madrid.

his youth but left it to write poetry and many years
later lamented the fact that he had not continued to
paint. He has, however, managed to maintain his interest
in art in interesting ways that combine poetry and picto-
rial expression as only a writer-painter can.

In La arboleda perdida (The Lost Grove) Alberti
tells how as a child in Puerto de Santa María on the Bay
of Cádiz he copied a poster of an ocean liner with such
success that his Aunt Lola gave him a set of oil paints.
He tried to emulate Murillo and Velázquez, whose repro-
ductions he admired, and several years later, after visit-
ing the art collections in Madrid and the Louvre in
Paris, he was so convinced that painting was to be his
lifelong vocation that he abandoned academic studies, to
his family's dismay. Perhaps then he had his first con-
frontation with "literature" in the form of the subtitles
he found on Goya's drawings, impressed by "the discovery
of a literary audacity and daring whose existence I could
not until then have even suspected" (20).

When not copying paintings of the masters, he filled
sketchpads with drawings made from real life but was
unsuccessful in finding inspiring teachers. Alberti
tried impressionism, pointillism, and a few other "-isms"
with the encouragement of Daniel Vázquez Díaz, who
introduced bold innovations in the highly formalized art
atmosphere of Madrid and who urged him to exhibit his
work in 1920. One of the paintings was ridiculed in the
Fine Arts Gazette of Madrid, but Alberti took the iron-
ic joke as flattery. That same year, after his father's
death, Alberti became ill and began reading a lot of
poetry, a turning point for him:

> It was becoming more and more obvious to me by the day
> that painting as a means of expression left me com-
> pletely dissatisfied and that I couldn't find a way to
> include in a canvas everything that was seething in my
> imagination. On the other hand I could put it down on
> paper. It was easier for me to write anything I
> pleased, finding the right form to express sentiments
> that had little or nothing to do with the plastic
> arts. (p. 145)

At the age of twenty, therefore, he decided to abandon
painting and become a poet. He did, however, accept an
invitation to exhibit at the Atheneum as a sort of fare-
well show in 1922, with a varied selection of figures and

landscapes influenced by Vázquez Díaz, explosions of
color with dynamic rhythms, geometric Cubist-inspired
exercises, and "some schematic drawings of dancing
figures, lineal reminders of the Russian ballet" (p.
152). His paintings were more appreciated by writers
than by painters and he was even tempted to renew his
first vocation. Lorca, who had attended the exhibit,
commissioned a painting of himself, and Alberti complied,
telling him that it would be his last work. On seeing
the finshed picture Lorca advised him not to give up
painting even though he was a poet.

Alberti evokes these early years in his magnificent
poetic tribute A la pintura (To painting), written
between 1945 and 1952, in the introductory poem entitled
"1917." He recalls his adolescent madness for a box of
paints, a canvas, and an easel, but invokes that same
madness to enable him now "to paint Poetry / with the
brush of Painting" (21). The third section of the same
poem presents the young painter admiring the great mas-
ters in the Prado Museum, copying their works, and fancy-
ing himself a great forgotten artist. He also describes
the moment of decision:

> la sorprendente, agónica, desvelada alegría
> de buscar la Pintura y hallar la Poesía
> con la pena enterrada de enterrar el dolor
> de nacer un poeta por morirse un pintor . . .
> (pp. 14-15)
> the surprising, agonizing, sleepless happiness
> of seeking Painting and finding Poetry
> with the buried sadness of burying the pain
> of a poet's birth at a painter's death . . .

In a conversation with José Miguel Velloso published
in 1977, Alberti regrets having broken off from painting
prematurely in order to assert himself as a poet with his
Marinero en tierra (Mariner on land) "because when I
wrote my first book, . . . I was really a painter. I
began to write and then people didn't consider me any-
thing. The painters told me I ought to write and the
writers were telling me I ought to paint. It was a very
anguished situation. I am sorry for not having then the
ability, the talent, to link poetry to graphics, to the
plastic arts, as I did later" (22). Perhaps the title
Mariner on Land, alluding to Alberti's nostalgia for
his native Puerto while in Madrid, may also be a marine

metaphor for the artist, out of his usual element, now
writing poetry.

Alberti's farewell to art was by no means final. He
included several line drawings in the second edition of
La amante (The lover) in 1929 which are strikingly
similar to Lorca drawings of the same period (23). The
differences in their drawings parallel those that critics
have observed in their early neopopular poetry. There is
a purposely childlike landscape and a picture of a sail-
or, both reminiscent of Lorca, but in Alberti's sketches,
similarly executed in clean lines, there is obviously
more control and less spontaneity. In an abstract draw-
ing, straight and wavy lines seem placed with an eye
toward composition and effect, apparently not ruled by
chance as so many of Lorca's drawings are. Similar con-
trasts may be observed in their poetry, Lorca's being a
more naturally flowing, spontaneous expression of authen-
tic popular inspiration, Alberti's more cultivated,
controlled, and artistically elaborated. They often
choose the same subjects: sailors, angels, and the bull.
Even the map of Spain, which Lorca incorporated in sever-
al drawings, appears as a chessboard in a door panel
Alberti painted for his friends (24).

Alberti evidently found in poetry the liberating
expression he was looking for and a way to communicate
sound in lyrical songs in verse. Poetry in turn gave
wings to his art by inspiring the stylized illustrations
that complement the poems of The Lover so well. When
he wrote To Painting, his desire to paint was rekin-
dled, "I began to write my poems and I began to paint
again, and to join poetry with painting, but with the
purpose of achieving something I called 'liricogra-
fías' ["lyricographs"] to distinguish them from
pictures" (25). The poems of To Painting celebrate
color, artists, subjects of paintings, line, proportion,
perspective, and the instruments of painting. Poems
about artists and those about aspects of art are careful-
ly alternated. Again it is significant that when Alberti
writes poetry about painting, the presence of the great
masters is constant; their weight can be felt, the same
weight that possibly intimidated the young painter
Alberti. The poems are of varied meter and style,
perfectly adapted to the spirit of each subject, from the
purely Surrealistic enumeration inspired by Bosch to the
very controlled sonnet dedicated to line.

Since line is Alberti's principal element employed in

Alberti: Lyricograph, from *Marinero en tierra, La amante, El alba de alhelí*, Robert Marrast, editor; courtesy Clásicos Castalia, Madrid.

the illustrations to The Lover and in subsequent art
which accompanies his poetry, it is of particular inter-
est to note the importance he accords it as "scaffold and
support of painting" (26) (italics ours), since line is
not essential to painting as it is to drawing. In the
same sonnet he links line to both dreaming and to
poetry. He also calls it calligraphy, pointing precise-
ly to the manner in which Alberti has recuperated his
former pictorial activity. The remaining poems on chiar-
oscuro, shadow, light, and other pictorial elements seem
more closely related to the artists he celebrates in
contiguous poems, but his poem on line seems to reflect
his own preferred medium of expression.

Alberti's so-called "lyricographs" combine poetry and
graphics in a way that is reminiscent of medieval manu-
script art. The poem is written in stylized calligraphy
and joined with decorative design. Several examples are
presented in the tribute published by Litoral in 1976,
reproducing several poems and drawings Alberti had con-
tributed to the magazine over the years. The designs are
purely decorative and, like the poems, contain reiterated
elements which provide rhythm and reflect some of the
images. Another way in which Alberti combines both disci-
plines is by designing covers, like that which appears on
the Buenos Aires, Editorial Losada edition of Entre el
clavel y la espada (Between the carnation and the sword,
1939-40). In "Escrito en el aire" (Written on the air),
the words of nine poems written for nine sketches by Leon
Ferrari are placed on the page to create a design suggest-
ed by the sketches or by the connotations of the words
themselves (27).

Among the drawings Alberti sent from Rome for the 1976
tribute by Litoral are two done in bold black lines
with some darkened areas which depict angels dancing, the
same angels that are so prominent in his poetry, even
beyond the book Sobre los ángeles (Above the angels)
(28). The drawings suggest the same swaying and arched
movements we find in the poem "Ángel Pericet, bailarín"
(Angel Pericet, dancer) from Abierto a todas horas
(Open all hours, 1960-63):

> De tus pies vuela y nace
> la brisa pura,
> y un junco estremecido,
> de tu cintura.

Todo cimbras, te doblas,
te bamboleas,
y es tacón hasta el viento,
si taconeas. (29)

Flying from your feet is born
the breeze so pure,
and a quivering reed
from your waist.

Everything you sway and bend,
and swing,
and even the wind is a heel
when your heels you click.

The picture may suggest dancing movement, but it is
not able to follow the constant motion underscored
by the verbs in the poem or the sound of the clicking
heels.

Alberti evidently found in poetry the medium he needed
to express sound and rhythm, ideas and sensations. His
love for art has remained constant and the vocabulary of.
painting can be found in his verses. His pictorial art
seems not to have changed greatly through the years
although his poetry shows variation and development, but
he has found a satisfying way of linking his art with his
poetry in the "lyricograph" which turns written poetry
into a pictorial art.

Antonio Buero Vallejo

Spain's great dramatist Antonio Buero Vallejo (b.
1916) studied at the San Fernando School of Fine Arts in
Madrid after graduating from high school in 1934, but
interrupted these studies to serve as a medic for the
Republicans or Loyalists during the Civil War. This
brought a death sentence at the conclusion of the war,
commuted to six years of prison, from 1939 to 1945. Upon
his release, he continued to paint, but increasingly dedi-
cated himself to the theater (30). In her book on Buero
Vallejo, Martha T. Halsey discusses the writer's comments
on the relationship between painting and a theater which
penetrates reality but does not lose contact with it.
Buero characterizes painting as the visual mastering of
exterior reality in preparation for the exploration of

inner reality, thus explaining his early preference for
painting realistically.
 The playwright's love for art is apparent in his plays
Las Meninas (The ladies-in-waiting) and El sueño de
la razón (The sleep of reason), about Velázquez and
Goya, respectively. In addition to the theatrical and
literary value of these works, they constitute a unique
form of art commentary, providing an imaginative explana-
tion of many of the artist's pictures, theories, and
intentions, not in the typical essay format, but rather
in unforgettable dramas.
 Most of the paintings and drawings Buero Vallejo
conserves were done prior to 1948, as writing plays took
precedence, although he occasionally painted in later
years. While in prison he sketched and gave away over
six hundred portraits of his fellow prisoners—among them
the poet Miguel Hernández—on any scrap of paper he was
able to find, even a cigarette wrapper (31).
 Buero Vallejo's paintings and drawings do not present
startling parallels to his plays and he acknowledges
little connection between them. They do, however, give
us some insight into the development of Buero as a drama-
tist in the similarities that are present. There are,
for example, some thematic coincidences, often separated
by a period of many years. An early sketch of toga-
attired men and women and several soldiers who appear to
be listening to a blind singer places the figures as if
upon a stage; similar classical inspiration is present in
La tejedora de sueños (The dream weaver) eighteen
years later. Biblical events are depicted in a 1947
drawing of Salome holding the head of Saint John the
Baptist and in the play Las palabras en la arena (Words
in the sand) of 1949. A sketch of men leaving a prison
building recalls Buero's play La Fundación (The Founda-
tion, 1974), though such a scene does not occur in the
play, and a 1946 picture of a man with a violin case
being led by a young boy through a barren city street
reminds us of the blind beggar violinist of El concierto
de San Ovidio (The concert at Saint Ovide, 1962). A
portrait of an older man dated 1964 seems to be a third
pictorial representation of blindness, an important theme
in Buero's theater, which critics have commented upon at
some length. A picture of some men in a railroad station
with a locomotive in the background recalls El tragaluz
(The basement window, 1967), in which the locomotive that
had separated Vicente from the rest of his family is a

Buero Vallejo: Sketches, courtesy of the artist. Photograph by Virginia Fernández and Justo

major motif. The only visual-textual parallel that can
be cited is a sketch that provides a perfect illustration
for Historia de una escalera (Story of a stairway,
1949), and dated only two years before, precisely when
the play was written. With the sole exception of this
picture, Buero's drawings do not parallel scenes in his
plays, although references to similar subject matter are
present.

Perhaps the presence of the future dramatist is
already detectable in the importance he accords to set-
ing in drawings of groups. The dramatic world of
Madrid's stairways, apartments, and streets appears also
in pictorial form, as do the humble people of lower and
middle-class society. The figures often seem set off
from their stark setting, as in the previously cited draw-
ng of the musician and boy seen from behind, so solitary
in the starkness of the buildings toward which they walk,
casting their shadows upon the bare stones of the street.
The outstanding alternation of light and dark which in
Buero's theater achieves metaphorical value is less
notable in his pictorial work but does appear in this
picture, in which two lighted windows seem to promise
hope and refuge, as the light of dawn begins to illu-
minate the two figures from behind. In the sketch which
corresponds to Story of a Stairway again two windows
are filled with light, this time that of the outside
world. Several still-life paintings, masterfully done
with the exactness and realism of trompe l'oeil remind us
of Buero's careful, detailed descriptions of stage decora-
tions.

The dramatist's favored pictorial genre, and that
which offers the greatest similarity to his theater, is
portraiture. The hundreds of sketches he did for his
prison mates attest to his preoccupation and esteem for
human beings and their relationships. Buero's portraits
are executed in a carefully realistic style with the
accent on expression and the intensity of the eyes. The
portraits appear to be about to speak and one feels the
need to supply captions, to say in words what the sad,
sometimes anguished look expresses. The artist's desire
to sketch so many fellow prisoners suggests a search, a
quest perhaps to find the kindred soul of man in the
faces about him or even to discover the self by painting
others. Maybe in these multiple faces the artist was
looking for the one that could express the ultimate human-
ty and reflect his own heart just as his Velázquez in

The Ladies-in-Waiting found in the humble Pedro de
Briones, who served as his model for an ironic Aesop, a
kindred soul, making Velázquez comment, "During these
years I thought I painted for myself only. Now I know
that I painted for you." A self-portrait of Buero
Vallejo with a wistful expression seems to express
Pedro's observation that "only he who sees the beauty of
the world can understand how intolerable is its pain"
(32).

In his pictorial work Buero remained a realist, never
taking that step which so enriched his theater with the
world of dreams, hallucinations, and the imagination,
probably because his evolution as a painter virtually
stopped when the dramatist emerged. Colors are bright
but softly applied, setting off the subjects' face. The
artist's style is extremely neat, of fine craftsmanship,
qualities which likewise characterize his theater. Lines
used for shading are generally parallel, with fine lines
communicating detail in the drawings, which reveal mas-
tery of drawing techniques and anatomical structure.

We may surmise that Buero was not satisfied either
with his own performance as an artist or with painting as
a medium and that he felt the need to animate the two-
dimensional picture. In The Ladies-in-Waiting Martín,
who modeled for Velázquez's painting of Menippus,
announces, "No, we are not pictures. We spit, speak, or
remain quiet, according to the way the wind blows" (p.
12). Buero finds his art in theater, which endows his
"pictures" with sound, movement, magic, and change.

Miguel Delibes

One of Spain's major novelists of this century, Miguel
Delibes (b. 1920), is also a talented artist. He was
well known in high school for his sketches, and when he
was unable to begin university studies because of the out-
break of the Civil War, enrolled in the School of Com-
merce, taking night classes in modeling and sculpture.
In 1941, as Janet Díaz tells us in her book Miguel
Delibes, he began to work for the newspaper El Norte de
Castilla as a caricaturist.

This employment obviously grew out of his youthful
avocation for drawing, and at the same time antici-
pates his tendency to literary caricaturization, obvi-

AUTORETRATO 1975

Delibes: *Self-portrait*, courtesy of the artist.

ous in many works. He has continued illustrating on a
lesser scale more recently, with sketches for the Amer-
ican edition of The Path. An exposition of his car-
icatures in Valladolid, held near the beginning of his
professional drawing experience, was most successful.
In order to earn still more, he also did Christmas
cards . . . (33)

El camino (The Path) was originally published in
1950; the Holt, Rinehart and Winston school edition of
1960 contains copious illustrations, lovely line drawings
executed with a childlike simplicity but with the sure
and steady line of the adult artist. The novel itself is
a portrait of a village seen through the eyes of an
eleven-year-old boy, Daniel el Mochuelo (Owl). In order
to communicate the ingenuous perspective of the young
protagonist in the third-person narrative the language is
simple and humorous. The drawings likewise show a child-
like point of view in the anthropomorphical sun which be-
hind a cloud sports a human face and in another drawing
holds its ears. A train is pictured as it goes up and
down steep mountain peaks that zigzag as a child would
draw them.
 Literary caricature is accomplished in The Path as
well as in other Delibes novels by means of exaggerating
features or gestures and by the use of nicknames and tag
lines, in accord with his pictorial vocation as a carica-
turist. Despite the sustained child's perspective, the
reader of The Path can "read between the lines" to see
the absurdities of the townspeople's behavior, their idio-
syncrasies and hypocrisies. The satirical and ironical
elements of the novel would not be evident in the draw-
ings alone; these simply heighten the effect of the
novel. The artist turns his eye upon himself in a 1975
caricature done with considerable humor and little self-
indulgence. Despite his long-standing interest in carica-
ture, both pictorial and literary, it is obvious that
Delibes's true vocation lies in the novelistic expression
of social, moral, and human concerns in which such tech-
niques contribute to a greater end.

Chapter Eleven
Conclusion

From the considerable number of writer-painters included in this study it may be concluded that the combination of the literary and pictorial arts in one creative individual is not an unusual phenomenon among Spanish artists, although it is hardly universal. It is surprising, however, in an age in which specialization has become increasingly popular. Indeed, many of these writer-painters have at one time or another presented an "image problem" in that critics or the public often demand complete dedication to one medium. For some reason Catalans and Galicians seem to have accepted multi-talented artists quite readily and have welcomed such versatility.

Critics are not the only ones who may distrust dual expression in the artist. Some authors themselves, as we have seen in Lorca, seem less confident as painters than as writers. Regoyos is apologetic about making his debut as a writer, which nonetheless turned out to be an event of considerable impact. Max Aub and Buero Vallejo seem to treat their pictorial work as a hobby, while Ricardo Baroja, Rusiñol, Solana, and Granell appear to be comfortable and prolific in both disciplines. Several artists integrate their textual and visual creations in a form traditionally "acceptable" to the public by either illustrating their writings on occasion, as Baroja, Granell, Delibes, Gómez de la Serna, Seoane, Alberti, and Fernández Mazas have done, or by providing written commentary or texts to accompany their sketches, as we have seen in Castelao and Díaz Pardo. Even when the two arts are not combined, great similarities between works in different media often appear, but at the same time they make the divergencies even more interesting and significant. It would be difficult to determine whether the artist selects the literary or pictorial mode of expression as a response to the innate character of each medium or to his need to express himself in one way or the other at different times. After all, a pen or pencil in hand on a blank surface can take either direction, drawing or writing.

167

Even beyond our examination of specific writer-painters of contemporary Spain, we have attempted to explore the sometimes subtle relationships between the two arts that surpass the more evident parallels suggested by a common terminology of subject, composition, color, and mood. An awareness of how each discipline uses different means to achieve similar effects, such as poetical and pictorial metaphor in Lorca, reminds us that there are poetic elements to be found in painting and painterly elements in literature, enhancing our appreciation of those artists who are both writers and painters.

Notes and References

Chapter One

1. Angeles Prado, La literatura del casticismo (Madrid, 1973), pp. 269-383.
2. Rafael Benet, Darío de Regoyos. El impresionismo y más allá del impresionismo (Barcelona, n.d.), p. 46.
3. Ibid.
4. Ibid.
5. Ibid., p. 39.
6. España negra (Madrid, 1924), p. 8.
7. Emile Verhaeren and Regoyos, España negra (Madrid, 1963), p. 21; hereafter page references cited in parentheses in the text.
8. A. M. Campoy, 100 maestros de la pintura española contemporánea (Madrid, 1976), p. 22.
9. Ibid., p. 24.

Chapter Two

1. Santiago Rusiñol visto por su hija (trans. into Spanish by María Luz Morales, Barcelona, 1963), p. 56. Subsequent references to María Rusiñol are from this book; page references hereafter cited in parentheses in the text.
2. Santiago Rusiñol, Jardines de España (Madrid: Tipografía Artística Cervantes, 1920?), p. 5; hereafter cited in text as JE followed by page number.
3. Marilyn McCully, Els Quatre Gats, Art in Barcelona around 1900 (Princeton, 1978), pp. 13-14. A corresponding exhibit took place at the Princeton University Art Museum and later at the Hirshhorn Museum in Washington, D.C.
4. Maragall in Jardines de España, pp. 17-25, and McCully, p. 128.
5. Campoy, 100 maestros, p. 29.
6. Prologue to Santiago Rusiñol, Obres completes (Barcelona, 1973), p. xxvii.

7. Pages in parentheses in the text correspond to the most recent edition of La isla de la calma, trans. to Spanish from Catalán by María Luz Morales (Barcelona, 1964) which is accessible. The following English translations exist: The Tranquil Isle (trans. Mary Lake, Palma de Mallorca: Ed. Baleares, n.d., and 2d ed., 1936; Ripoll, 1955; and Cervantes, 1959) and a revised edition by Doireann MacDermott and J. F. Llatjós, entitled Majorca, The Island of Calm (Barcelona: Pulido, 1958).

8. José Plá, Rusiñol y su tiempo (Barcelona, 1942), p. 282.

9. McCully, Els Quatre Gats, p. 126.

10. A. M. Campoy and Eugenio D'Ors, see Campoy, 100 maestros, p. 33.

11. El jardín abandonado (trans. from Catalan by Miguel Sarmiento, Barcelona: Tipografía "L'Avenç," 1902), p. 18.

12. Plá, Rusiñol, p. 209.

13. El jardín abandonado, p. 35.

Chapter Three

1. Exposición-Homenaje a Ricardo Baroja, introduction by Enrique Lafuente Ferrari, catalog by Joaquín de la Puente (Madrid, 1957), pp. 8-9.

2. Julio Caro Baroja in his introduction to Baroja's Obras selectas (Madrid: Biblioteca Nueva, 1967), p. 15, which provides ample biographical data; hereafter page references to this author and edition cited in the text in parentheses.

3. El Dorado, edition illustrated with 72 xylographs and 49 sketches (Barcelona: "La Gelidense," 1942). (Pages cited in text are from Obras selectas.)

4. Pío Baroja, La casa de Aizgorri (Madrid: Rafael Caro Raggio, 1909).

5. El Dorado, introduction by J. Raimundo Bartrés, p. 13.

Chapter Four

1. Camilo José Cela, La obra literaria del pintor Solana, 2d ed. (Madrid, 1966), p. 71.

2. Weston Flint, Solana, escritor (Madrid, 1967).

3. José-Luis Barrio-Garay, José Gutiérrez Solana (Lewisburg and London, 1978). Most longer quotations in this chapter are Barrio-Garay's translations, as are titles.

4. Ibid., p. 18.
5. Moreno Villa, Los autores como actores (Mexico, 1951), p. 46.
6. Flint, Solana, p. 140.
7. In Cela, La obra literaria, p. 99.
8. Barrio-Garay, Solana, p. 181.
9. Cela, La obra literaria, p. 35.
10. Flint, Solana, p. 144.
11. Obra literaria (Madrid, 1961), p. 295; hereafter page references cited in parentheses in the text.
12. Gómez de la Serna, Automoribundia (1888-1948) (Madrid: Guadarrama, 2d edition, 1974), p. 743.
13. Barrio-Garay, Solana, p. 143, including the López Ibor quote.
14. A photograph of the painting showing the three sections marked in white is in Barrio-Garay, fig. 192a.
15. Moreno Villa, Vida en claro (Mexico, 1944), p. 166.

Chapter Five

1. Antonio Gallego Morell, García Lorca. Cartas, postales, poemas y dibujos (Madrid, 1968), p. 12. Lorca's friendships with numerous artists are described in Marcelle Auclair, Vida y muerte de García Lorca (Mexico: Ediciones Era, 1972).
2. Gregorio Prieto, Lorca as a Painter (London: De la More Press, 1943) and Drawings by García Lorca (Madrid: Afrodisio Aguado, 1955) which includes the first; Jean Gebser, Lorca, Poète-dessinateur (Paris: G.L.M., 1949); Lorca's Obras completas, volume 1 (Madrid, 18th ed., 1973); Eutimio Martín, "Un poema y un dibujo inéditos de F. G. L.," Insula 33, nos. 380-81 (July-August, 1978):1, 24.
3. Obras completas, Vol. 2, 18th ed., p. 1207. Hereafter pages from this volume cited in parentheses in the text as "2" with other pages in parentheses from volume 1.
4. Gallego Morell, García Lorca, p. 23.
5. See Prieto, Lorca as a Painter, pp. 15-16.
6. Titles translated from Obras completas. Other picture sources in notes.
7. Gallego Morell, García Lorca, p. 23.
8. "García Lorca y el primitivismo lírico: Reflexiones sobre el 'Romancero gitano'," in Ildefonso-Manuel Gil, ed., Federico García Lorca (Madrid: Taurus, 1973), p. 292.

9. E. F. Granell, La leyenda, de Lorca, y otros escritos (México: Costa-Amic, 1973), p. 24.

10. This picture is reproduced in Gallego Morell, García Lorca.

11. "El sonambulismo de Federico García Lorca" in Gil, Lorca, p. 25.

12. Ibid. See also Rafael Martínez Nadal's "El público," amor, teatro y caballos en la obra de García Lorca (Oxford: Dolphin, 1970).

13. In Gallego Morell, García Lorca.

14. Andrew P. Debicki, "Federico García Lorca: Estilización y visión de la poesía," in Gil, Lorca.

15. Prieto, Drawings by García Lorca, p. 59.

Chapter Six

1. Gustav Siebenmann, "Max Aub, inventor de existencias (acerca de 'Jusep Torres Campalans')," Insula, nos. 320-21 (July-August, 1973).

2. Jusep Torres Campalans, trans. Herbert Weinstock (New York, 1962), pp. 242-43 and 299 respectively; hereafter page references cited in parentheses in the text.

3. Estelle Irizarry, La broma literaria en nuestros días (New York, 1979).

4. See for example Christopher Gray's Cubist Aesthetic Theories (Baltimore: Johns Hopkins, 1953), p. 160.

5. Ibid., pp. 153-55, quoting Alfred E. Barr's Picasso: Fifty Years of His Work (New York: Museum of Modern Art, 1946). The statements were made in 1923.

6. Ibid., p. 153.

7. Novelas escogidas (Mexico, 1970), p. 934. It is a pen sketch that says below: "To Luis Alvarez Petreña, his friend, M. A., 1929." The novel was published in three different parts in 1934, 1951, and 1969-70.

8. Paul Waldo Schwartz, Cubism (New York: Praeger, 1971), p. 56.

Chapter Seven

1. In the Revista de la Universidad de Buenos Aires (1962) and Revista del Departamento de Letras de la Universidad de La Plata (1964), respectively.

2. Lorenzo Varela, Luis Seoane (Buenos Aires: Ediciones Botella al Mar, 1948), p. 3. The quotations that follow are from pp. 3 to 8.

3. La soldadera (Buenos Aires, 1957), p. 63; hereafter page references cited in parentheses in the text.

4. Varela, Seoane, p. 3.

5. Rafael Dieste, Homenaje a la Torre de Hércules: 47 dibujos por Luis Seoane (Buenos Aires: Nova, 1944), pp. 8-9.

6. Imágenes de Galicia (Buenos Aires: Albino y Asociados, 1978).

7. El irlandés astrólogo (Buenos Aires, 1959), p. 7; pages subsequently given in parentheses in the text.

8. Julio E. Payró, Luis Seoane, Exposición retrospectiva, 1948-1968 (Buenos Aires, 1968), pages unnumbered.

9. Seoane, Obra poética (Sada-A Coruña, 1977), p. 34; hereafter page references cited in parentheses in the text.

10. Manuel Mujica Lainez, Lorenzo Varela, and Guillermo Whitelow, Seoane (Buenos Aires, 1966), p. 22.

11. Lorenzo Varela, in ibid., p. 17.

12. Observations are based on the large collection of etchings, paintings, books, albums, and portfolios that Professor José Otero Espasandín, close friend of the painter, kindly placed at our disposition, in addition to others provided by Rafael and Carmen Dieste and by María Elvira Fernández de Seoane, the artist's widow.

13. Francisco Ayala, Los ensayos: Teoría y crítica literaria (Madrid: Aguilar, 1971), pp. 138-64. The essay was written in 1948.

Chapter Eight

1. Santiago Arbós Ballesté, Eugenio Granell, un surrealista español en Nueva York (Madrid, December 1974) (catalog).

2. An Illustrated Dictionary of Surrealism, trans. W. J. Strachan (Paris: Barron's, 1974), p. 81.

3. Jiménez, Estética y ética estética (Madrid: Aguilar, 1957), p. 129.

4. La "Leyenda" de Lorca y otros escritos (Mexico: Costa-Amic, 1973), p. 4.

5. Arbós Ballesté, Granell.

6. La novela del indio Tupinamba, 2d ed. (Madrid, 1982), p. 16; hereafter page references cited in parentheses in the text.
7. El clavo (Madrid, 1967), pp. 70-71; hereafter page references cited in parentheses in the text.
8. Serrano Poncela, "En torno a la pintura surrealista de Eugenio Fernández Granell," Panorama (Santiago, Dominican Republic, November 1943), quoted in catalog of Granell exhibit, January 13, 1947, in the Guatemalan Tourism Office; Tarnaud, Braises pour E. F. Granell (Paris: Editions Phases, 1964).
9. Lo que sucedió (Mexico, 1968), p. 154; hereafter page references cited in parentheses in the text.
10. Granell, Arte y artistas en Guatemala (Guatemala City: El Libro de Guatemala, 1949), p. 110.
11. Federica no era tonta y otros cuentos (Mexico, 1970), p. 22; hereafter page references cited in parentheses in the text.
12. Arte y artistas en Guatemala, p. 199.
13. In the story "El hombre verde" (The green man) a horse show is conducted in a bathroom and the horse is under a piano.
14. A. M. Campoy, "Eugenio Granell y el surrealismo en América," ABC (Madrid, December 12, 1975), p. 53.

Chapter Nine

1. Rafael Dieste, "La estética pictórica de Carlos Maside (con alusiones a otros pintores gallegos coetáneos)," Cuadernos del Laboratorio de Formas de Galicia, no. 4 (La Coruña: Ediciós do Castro, 1975), p. 94.
2. José Filgueira Valverde, prologue in Ramón Baltar Domínguez, Castelao ante la medicina, la enfermedad y la muerte (Santiago de Compostela: Bibliógrafos Gallegos, 1979), p. 10.
3. Baltar Domínguez, Castelao ante la medicina, p. 44.
4. "Humorismo, dibuxo humorístico, caricatura," in Escolmo posible, 2d ed. (Vigo, 1975), p. 33. Castelao quotes are from this volume; hereafter pages references cited in parentheses in the text.
5. Dieste, Cuadernos de Escola Dramática Galega, no. 4 (La Coruña, February, 1979), p. 12.
6. Os vellos non deben de namorarse, 4th ed. (Vigo, 1977), p. 119.

7. Sebastián Risco, "Cándido Fernández Mazas," Galicia Emigrante, no. 33 (Buenos Aires, February-March, 1958), p. 6.

8. Santa Margorí (Sada: La Coruña, 1981), p. 13; hereafter page references cited in parentheses in the text.

9. Díaz Pardo, Midas. O ángulo de pedra (Buenos Aires, 1957), p. 34.

10. Miguel González Garcés, Gran Enciclopedia Gallega (Santiago y Gijón, 1974), pp. 82-85.

11. This exhibit is described in González Garcés, ibid.

12. Caro Baroja, Romances de ciego (Madrid: Taurus, 1966), p. 10; information from pp. 7-15.

13. Caro (ibid.) explains that authors like Baroja and Valle-Inclán wrote short plays adapting the ballads of crimes to make them humorous or grotesque.

14. Díaz Pardo, Cuadernos del Laboratorio de Formas de Galicia (La Coruña, 1970), p. 23.

15. This ballad as well as the others mentioned were published by Ediciós do Castro in La Coruña. Pages as such are unnumbered.

16. Los procesos abstractivos del arte contemporáneo (La Coruña: Ediciones del Castro, 1965).

17. Gran Enciclopedia Gallega, no. 41, vol. 3.

18. La Voz de Galicia (May, 1972).

19. Abraio (Sada-A Coruña, 1978), pp. 41-42; hereafter cited in text as A followed by page number.

20. A imagen y semejanza (Bilbao, 1973), p. 59; hereafter cited in text as I followed by page number.

21. "Da esperencia poética," Nordés, no. 4 (1976), p. 40.

22. La Voz de Galicia (April 6, 1976).

23. Vilela Conde, ibid. (March 13, 1976); Pablos, Faro de Vigo (March, 1970). Both quotes are reproduced in the catalog Exposición Tomás Barros, Sala de Exposiciones de la Asociación de Artistas de La Coruña (February 5-15, 1977).

24. "El símbolo de la sombra en Rosalía y la poesía," Nordés, nos. 2-3 (1975), pp. 35-39.

25. "Da esperencia poética," p. 40.

Chapter Ten

1. Prieto, Lorca y la Generación del 27 (Madrid: Biblioteca Nueva, 1977).

2. Ramón y Cajal, Obras literarias completas (Madrid, 1969), p. 59; hereafter page references cited in parentheses in the text.

3. Recuerdos de mi vida, 3d ed. (Madrid: Imprenta de Juan Pueyo, 1923).

4. Angel Crespo, Juan Ramón Jiménez y la pintura (Río Piedras, 1974).

5. Juan Ramón Jiménez, Segunda antología poética (Madrid, 1956), p. 177.

6. Graciela Palau de Nemes, Vida y obra de Juan Ramón Jiménez. La poesía desnuda, 2d ed. (Madrid, 1974), p. 638.

7. Ibid., p. 634.

8. Ibid., p. 383.

9. Crespo, Jiménez y la pintura, p. 81.

10. Moreno Villa, "Claridades sobre Picasso; analizando sus poemas," Leyendo (Mexico, 1946), pp. 129-52.

11. Picasso, Hunk of Skin (San Francisco, 1968), p. 13; hereafter page references cited in parentheses in the text.

12. Douglas Cooper, Picasso: Theatre (London: Weidenfeld and Nicolson, 1968), p. 78.

13. Leyendo (Mexico, 1946), p. 82; hereafter page references cited in parentheses in the text preceded by Reading.

14. Vida en claro (Mexico, 1944), p. 166; hereafter page references appear in text preceded by Life.

15. Los autores como actores y otros intereses literarios de acá y de allá (Mexico, 1951), p. 139; hereafter page references cited in parentheses in the text, preceded by Authors.

16. Ensayo de un diccionario de la literatura, vol. 2 (Madrid, 1964), p. 793.

17. E. F. Granell, "Vida del pintor Moreno Villa," La Nación (Santo Domingo, March 12, 1945).

18. Gollerías (Barcelona, 1968).

19. In Prieto, Lorca y la generación del 27, p. 199.

20. Alberti, The Lost Grove, trans. and ed. Gabriel Berns (Berkeley, 1976), p. 111; hereafter page references cited in parentheses in the text.

21. Alberti, A la pintura, poema de color y línea, 5th ed. (Buenos Aires: Losada, 1976), p. 9; page references for next quote given in parentheses in the text.

22. José Miguel Velloso, Conversaciones con Rafael Alberti (Madrid: Ediciones Sedmay, 1977), p. 161.

23. These and other drawings may be found in Marinero en tierra, La amante, El alba del alhelí, edition of Robert Marrast (Madrid: Clásicos Castalia, 1972).

24. Reproduced in Velloso, Conversaciones, p. 132.

25. Ibid., p. 162.

26. Alberti, A la pintura, p. 62.

27. These appear in Litoral's number entitled "Alberti" (Málaga, 1976).

28. Solita Salinas de Marichal discusses the angel motif in El mundo poético de Rafael Alberti (Madrid: Gredos, 1968), pp. 179-260.

29. Alberti, Poesía (1924-1967) (Madrid, 1972), p. 1126.

30. See Martha T. Halsey, Buero Vallejo (New York, 1973).

31. Personal interview with Chefa Parisi in Madrid, Spring, 1980.

32. Antonio Buero Vallejo, Las meninas (Madrid, 1972), pp. 56, 73.

33. Janet Díaz, Miguel Delibes (New York: Twayne Publishers, 1971), p. 23.

Selected Bibliography

PRIMARY SOURCES

The following is a selection of principal literary texts (collected works when possible) used in this study, in alphabetical order by author. For additional sources and editions see Notes and References.

ALBERTI, RAFAEL. The Lost Grove. Translated and edited by Gabriel Berns. Berkeley: University of California, 1976.

_____. Poesía (1924-1967). Madrid: Aguilar, 1972.

AUB, MAX. Jusep Torres Campalans. Translated by Herbert Weinstock. Mexico: Tezontle, 1958; New York: Doubleday, 1962; Madrid: Lumen, 1970; Madrid: Alianza Editorial, 1975 (illustrated).

BAROJA, RICARDO. Obras selectas. Madrid: Biblioteca Nueva, 1967.

BARROS, TOMAS. Abraio. Sada-A Coruña: Ediciós do Castro, 1978.

_____. A imagen y semejanza. Bilbao: Editorial Cla, 1973.

BUERO VALLEJO, ANTONIO. El concierto de San Ovidio, La Fundación. Madrid: Espasa-Calpe, 1974.

_____. Las Meninas. Madrid: Escelicer, 1972.

CASTELAO, ALFONSO RODRIGUEZ. Escolmo posible. Vigo: Galaxia, 1975.

_____. Os vellos non deben de namorarse. Vigo: Galaxia, 1977 (illustrated).

DIAZ PARDO, ISAAC. Carteles de ciego. Sada-A Coruña: Ediciós do Castro. Titles: O crimen de Londres, 1977; O Marqués de Sargadelos, 1970; A nave espacial, 1970; Paco Pixiñas, 1970 (illustrated).

_____. Midas, O ángulo de pedra. Buenos Aires: Citania, 1957.

FERNÁNDEZ MAZAS, CANDÍDO. Santa Margorí. Madrid: Alcor Galaico, 1930 (illustrated).

GARCÍA LORCA, FEDERICO. Obras completas. Eighteenth edition. Madrid: Aguilar, 1973 (illustrated).

GÓMEZ DE LA SERNA, RAMÓN. Gollerías. Barcelona:
 Bruguera, 1968 (illustrated).
GRANELL, EUGENIO FERNÁNDEZ. El clavo. Madrid: Alfa-
 guara, 1967.
_____. Federica no era tonta y otros cuentos.
 Mexico: Costa-Amic, 1970.
_____. Lo que sucedió. Mexico: España Errante,
 1968 (illustrated).
_____. La novela del indio Tupinamba. Mexico:
 Costa-Amic, 1959; Madrid: Fundamentos, 1982.
JIMÉNEZ, JUAN RAMÓN. Segunda antología poética.
 Madrid: Espasa-Calpe, 1956.
MORENO VILLA, JOSÉ. Los autores como actores y otros
 intereses literarios de acá y de allá. Mexico: El
 Colegio de México, 1951.
_____. Leyendo. Mexico: El Colegio de México,
 1946.
_____. Vida en claro. Mexico: El Colegio de
 México, 1944 (illustrated).
PICASSO, PABLO. Hunk of Skin. Translated by Paul
 Blackburn. San Francisco: City Light Books, 1968.
RAMÓN Y CAJAL, SANTIAGO. Obras literarias completas.
 Madrid: Aguilar, 1969.
REGOYOS, DARÍO DE and VERHAEREN, EMILE. España negra.
 Madrid: Taurus, 1963 (illustrated).
RUSIÑOL, SANTIAGO. Obres completes. Barcelona: Edito-
 rial Selecta, 1973.
_____. La isla de la calma. Translated by María
 Luz Morales. Barcelona: Juventud, 1964 (not in OC
 above).
SEOANE, LUIS. El irlandés astrólogo. Buenos Aires:
 Losange, 1959.
_____. Obra poética. Sada-A Coruña: Ediciós do
 Castro, 1977.
_____. La soldadera. Buenos Aires: Ariadna, 1957.
SOLANA, JOSÉ GUTIÉRREZ. Obra literaria. Madrid:
 Taurus, 1961 (illustrated).

SECONDARY SOURCES

 The following were selected as particularly useful in
providing background information or because they treat
both disciplines or the lesser-known discipline in auth-
ors. For others see Notes and References.
ARBÓS BALLESTÉ, SANTIAGO. "Eugenio Granell, un surreal-
 ista español en Nueva York." Blanco y Negro (Decem-

ber 14, 1974). Stresses Granell's unique humor,
baroque style, and completely fantastic components of
his Surrealism, tracing Fernández Mazas's influence
on his formation.
BALTAR DOMÍNGUEZ, RAMÓN. Introduction to Castelao ant
la medicina. la enfermedad y la muerte. Santiago de
Compostela: Bibliógrafos Gallegos, 1979, pp. 11-50.
Excellent account of Castelao's activities in diffe-
rent fields and classification of drawings.
BARRIO-GARAY, JOSÉ-LUIS. José Gutiérrez Solana.
Paintings and Writings. Lewisburg: Bucknell Univer-
sity Press; London: Associated University Presses,
1978. A masterful, comprehensive study organized by
periods, classifying iconography, with correlation of
writings and paintings. Many illustrations and color
plates; complete bibliography.
BENET, RAFAEL. Darío de Regoyos. El impresionismo y
más allá del impresionismo. Barcelona: Iberia-
Joaquín Gil, n.d. A very complete biography against
the background of the art of his times. Copious illus-
trations and bibliography.
CAMPOY, A. M. 100 Maestros de la pintura española
contemporánea. Madrid: Ibérico Europea de Edicio-
nes, 1976. Contains brief but informative sections on
Regoyos, Rusiñol, and Solana with color illustrations.
CANNON, DOROTHY. Ramón y Cajal. Barcelona: Edici-
ones Grijalbo, 1966. Very complete study of his life
and works.
CARO BAROJA, JULIO. Introduction to Ricardo Baroja's
Obras selectas. Madrid: Biblioteca Nueva, 1967.
Views of his uncle's writing, painting, and life.
CELA, CAMILO JOSÉ. La obra literaria del pintor
Solana. Madrid: Alfaguara, 1966. Cela's 1957 Royal
Spanish Academy speech proposing Solana's significance
as a writer. Treats color, sense perception, and
motifs in his writing and parallels with his painting.
CRESPO, ÁNGEL. Juan Ramón Jiménez y la pintura.
Río Piedras: Universidad de Puerto Rico, 1974.
Traces the poet's activities as artist and typographer
and his ideas on art, with photos. Limited treatment
of his art related to his poetry.
FLINT, WESTON. Solana, escritor. Madrid: Revista de
Occidente, 1967. Establishes Solana's importance as a
writer. Discussion of his view of objects, space,
masks, symbols, irony, and color with some reference
to his painting.

GALLEGO MORELL, ANTONIO. García Lorca. Cartas, pos-
tales, poemas y dibujos. Madrid: Moneda y Crédito,
1968. Characterizes Lorca in his lesser-known infor-
mal writings and sketches; illustrated.
GONZÁLEZ GARCÉS, MIGUEL. "Isaac Díaz Pardo." Gran
Enciclopedia Gallega. Santiago y Gijón: Canadá
Silverio, 1974. Comprehensive biography.
GRANELL, E. F. "Vida del pintor Moreno Villa." La
Nación. Santo Domingo, March 12, 1945. Incisive
discussion of Vida en claro as portrait of a Spanish
era; cites similarities in painting and writing.
GURMÉNDEZ, CARLOS. "Cádido Fernández Mazas." La Voz
de Galicia (August 17, 1975). Contains extensive
information about his life and writings, including
Santa Margorí, an essay on Marx and Hegel, and a
social farce "Los cuernos disparatados."
HALSEY, MARTHA T. Antonio Buero Vallejo. New York:
Twayne Publishers, 1973. Some information about his
painting activity and attitude toward his art.
IRIZARRY, ESTELLE. La broma literaria en nuestros
días. New York: Eliseo Torres, 1979. Analyzes
Jusep Torres Campalans as a literary hoax with refer-
ences to Aub's illustrations.
_____. La inventiva surrealista de E. F. Granell.
Madrid: Insula, 1976. Studies Granell's writings;
concluding chapter considers his paintings.
LAFUENTE FERRARI, ENRIQUE. Introduction to Exposi-
ción-Homenaje a Ricardo Baroja. Madrid: Museo
Nacional de Arte Moderno, 1957. Provides a detailed
account of Baroja's life, friends, painting, and other
activities with excellent catalog descriptions pre-
pared by Joaquín de la Puente and many illustrations.
MCCULLY, MARILYN. Els Quatre Gats. Art in Barcelona
around 1900. Princeton: Princeton University Press,
1968. Excellent background on art in Cataluña; illus-
trated section about Rusiñol with lucid analyses of
the paintings.
MORENO VILLA, JOSÉ. "Claridades sobre Picasso, anali-
zando sus poemas." In his Leyendo. Mexico: El
Colegio de México, 1944, pp. 129-52. Perceptive
analysis of unedited poems of Picasso which are repro-
duced in the text.
MUJICA LAINEZ, MANUEL; VARELA, LORENZO; and WHITELOW,
GUILLERMO. Seoane. Buenos Aires: Ediciones
Galería Bonino, 1966. Three interesting essays on
Seoane's personality, production, and murals, respec-

tively. Contains extensive information on life, bibliography, and illustrations.

PALAU DE NEMES, GRACIELA. Vida y obra de Juan Ramón Jiménez. La poesía desnuda. 2d ed. Madrid: Gredos, 1974. The most comprehensive study of Juan Ramón to date; valuable insights into many aspects of his creative work.

PLÁ, JOSÉ. Rusiñol y su tiempo. Barcelona: Barna, 1942. Good biography but depicts him as a melancholy romantic in contradiction to María Rusiñol's biography and notes few similarities between writings and painting.

PRADO, ANGELES. La literatura del casticismo. Madrid: Moneda y Crédito, 1973, pp. 369-93. Shows Regoyos's influence on Solana and treats ideas related to the concept of "Black Spain."

PRIETO, GREGORIO. Dibujos de García Lorca. Madrid: Afrodisio Aguado, 1950. Contains Prieto's previous essay "Federico García Lorca como pintor," first serious study of this aspect, focusing mainly on color, followed by rather lyrical commentary of specific drawings, illustrated in the book.

RUSIÑOL, MARIA. Santiago Rusiñol visto por su hija. Barcelona: Juventud, 1963. Personal perspective with fascinating anecdotes and conversations.

Index of Illustrations

Index

DATE DUE

DEMCO 38-297